An Introduction to the Phenomenology of Performance Art

T0408528

An Introduction to the Phenomenology of Performance Art

Self/s

T. J. Bacon

Bristol, UK / Chicago, USA

First published in the UK in 2022 by
Intellect, The Mill, Parnall Road, Fishponds, Bristol, BS16 3JG, UK

First published in the USA in 2022 by
Intellect, The University of Chicago Press, 1427 E. 60th Street,
Chicago, IL 60637, USA

A catalogue record for this book is available from the British Library.

Cover designer: Aleksandra Szumlas
Frontispiece: The Lived Body. Buzzcut 2013. Photo: Julia Bauer.
Copy editor: Newgen
Production managers: Jessica Lovett
Typesetting: Newgen
Printed and bound by CPI Group (UK) Ltd, Croydon, CR0 4YY

Hardback ISBN 978-1-78938-530-4
Paperback ISBN 978-1-78938-959-3
ePDF ISBN 978-1-78938-531-1
ePub ISBN 978-1-78938-532-8

To find out about all our publications, please visit
www.intellectbooks.com

There you can subscribe to our e-newsletter, browse or download our current
catalogue, and buy any titles that are in print.

This is a peer-reviewed publication.

For mum

Phenomenology is an exciting and useful philosophy to apply to the understanding, making, problematising and analysis of transgressive art practices such as performance art. It is with great pride that my application of phenomenology is unashamedly radical and queer.

<div style="text-align:right">

My artistic-philosophy advocates for a queer phenomenology.

</div>

My written work is also presented in a way that questions 'acceptable' traditional academic approaches to research modalities. I therefore want this book (in particular due to its focus upon performance art), to reflect the transgressive unrepeatable nature of the art-form, as the introduction suggests, it welcomes different modes of reading and access; inviting a playfulness in allowing the reader to decide upon which mode they may want to read first and in what order. There is a phenomenological resonance here with performance; the reader can open up the book anywhere to encounter their own unique experience each time. There is no right or wrong way in which to do this!

<div style="text-align:right">

Please embrace the potential 'liveness' this book could therefore hold for you each time you encounter it.

tjb (January 2020)

</div>

Contents

Acknowledgements

With thanks to the generosity of Jessica Lovett at Intellect UK, Julia Bauer at Tempting Failure, and Nicola Stammers, Peter Thomas, and Dr Stefanie Sachsenmaier. Gratitude and love go to the support of Jeanette Bacon, Hellen Burrough, and Chelsea Coon. My appreciation goes to the students of Middlesex University, London, and University of Novi Sad, Serbia, for their participation in the development of the exercises featured in this book. Thank you to every artist who took time to speak about their practice for both this book and my doctoral thesis *Experiencing a Multiplicity of Self/s* (2016); your work is beautiful, urgent, and necessary and we hope more people discover your practices everyday.

Finally, a small note of love to Gaia with tummy rubs, and Yōkai with head-bumps, as well as an appreciative purr to Sturdy-Cat, Tiger, and Hank.

Foreword

Enduring Reorientations: Self, Time, and Space in Performance

by Chelsea Coon

Performance is a process to better understand self and the interconnections between all bodies. The matter of the universe is part of the matter the body is comprised of. Therefore, the interrelationship of the body and its physical orientation to immediate spaces are understood in relation to the outermost limits of the universe, which are in a state of continuous expansion. Further, these approximate spaces to the body are experienced through a set of ongoing relations to time. Therefore, through time it is possible for performance to challenge political, gendered, sexual, social, cultural, and disabled spaces among others through questioning the very notion of self.

The notion of self persists in being a significant and timely consideration. In the recent publication *The Force of Non-Violence* Judith Butler proposes a rethinking of the self as relational rather than isolated. Simply put, she questions what it could mean to understand the self beyond the boundaries of a singular body and, instead, in relation to all affective, external factors including space, time, and other bodies (Butler 2020: 8, 11, 15, 16). Ultimately, experiential relations that accumulatively contribute to an understanding of the world through a set of orientations necessarily shifts if the self is reconsidered through an intertwined set of relations. Extending on this idea, philosophers such as Sara Ahmed have also contributed to phenomenological discourse through discussion of queerness and orientations of the body across diverse spaces and times (2006: 8, 9, 13, 57).

The self is a conversation not only at the core of performance art, but is significantly complicated in its extensions of lived experience. In *An Introduction to the Phenomenology of Performance Art: Self/s*, Bacon positions a new framework for better understanding phenomenological application within performance

practices through the lenses of *artist-philosopher* and *practitioner-researcher*. Significantly, the representation of phenomenological concepts through performance case studies in this book have been developed through Bacon's experiential practice, which have been scrupulously formed and reworked for years. To reiterate, it is significant that orientations developed through phenomenological performance are acquired through experiential interconnection.

Structurally, this book is an introductory guide for a practice-led, academic study of phenomenology in performance practice. Through multimodal writing, Bacon examines select performance works to introduce the reader to the notion of phenomenology in performance through positioning the diverse ways in which such work can manifest. Simply stated, a phenomenological framework of understanding performance is not fixed, rather it is in flux. Moving from the social space to the performance space, Laura Shalson in *Performing Endurance: Art and Politics Since 1960* says: 'The artist designs and then endures an unfolding of events that can never be fixed from the start' (2018: 12). Therefore, not only are performance frameworks in flux, but so are the body, time, and space through which performance occurs, thus affecting the way performance is experienced and understood. Within this book, Bacon draws on cross-disciplinary fields, which include: philosophy, performance theory, performance philosophy, dance, sound studies, and more. Further, Bacon represents a diverse range of living artists' performance works which address urgent issues of being a *body* in relation to the particularities of ever-shifting *time* and *space*.

Bacon is foremost an artist whose passionate involvement is consistent in the presentation of xyr's performance works which poetically challenge social, cultural, and gendered frameworks, among others. To reiterate, Bacon's perspective in this book is informed by xyr practice as a performance artist whose works employ long-duration, endurance, extremis, and more. Bacon is situated as a writer and performance artist among both an intimate and expanding cohort of academics that occupy space in both artistic and research outputs.

These interests further inform xyr curatorial work as the director of the London Biennale of International Performance Art, *Tempting Failure*. To the best of any one organization's capacity, Bacon's directorial position has consistently defended the necessity of creating a space for performance works that have: challenging content/themes, contain risk, are boundary blurring/experimental, and typically have not been, or are not able to be programmable elsewhere due to the marginalization of the content, etc. Performance theorist Dominic Johnson in *Unlimited Action: The Performance of Extremity in the 1970's* historically speaks to the importance of boundary pushing performances works as 'performance teaches us that such experiences of extremity also enliven us or give us *permission to become more than what one is or feels one is allowed to be*'

(2019: 14, original emphasis). In Bacon's commitment to creating such a space for the performance community, I am reminded of the words of musician and performance artist Genesis Breyer P-Orridge in a lecture for the release of their book *DISCIPLINE* at the Monty Bar in Los Angeles. S/he explained to the audience the significance of making more art and to create communities that align with a vision towards making the world we wish to live in.[1] Bacon leads this philosophy by example primarily through international community making, challenging local and international perspectives, and through overcoming the reign of obstacles that result from a commitment to showing performance art works that are actively pushing boundaries.

In this book, Bacon proposes examples for how to consider phenomenology through a performance practice and further questions: *Which are the bodies that are permitted the space and time to be seen, heard, and to express ideas through their body, about their body, and significantly, through their experiences in a performance practice?* To answer aspects of this question, the performance case studies Bacon examines are understood through a framework. A constant in this framework is that the performances are delivered through diverse bodies across diverse sites across the United Kingdom. The reader will more clearly be able to see the nuances of the ways in which the performers work across different sites within the United Kingdom including theatres, sound studios, former police stations, open markets, galleries, and more. Further, these performance works provoke and speak to the reality of how contextually loaded spaces are. Of this, philosopher Elizabeth Grosz extends the thought, '[W]e need to understand not only how culture inscribes bodies […] but, more urgently, what these bodies are such that inscription is possible […] We need to understand its open-ended connections with space and time' (2004: 2–3). Necessarily, better understanding the way the body operates in space can serve in a performance practice through utilizing phenomenological strategies. Put another way, through performance perspectival shifts are able to position new ways of seeing, understanding, and orienting (Jones 2012: 173, 177, 239).

Perception and experience are inextricably linked, forming the key for the application of phenomenology through performance. Artists working in performance in one way or another do examine the limits of the body and subsequently the self. In *The Embodied Mind: Cognitive Science and the Human Experience* the following is proposed: '[P]erception is seen as an active process of hypothesis formation, not as the simple mirroring of a pre-given environment' (Varela et al. [1991] 2016: 136). Therefore, the process of hypothesis formation further illustrates how the self is continuously changing and shifting contingent on variables of space and time experienced through a body. Moving on, the blurring of boundaries between self as individual through audience interactions was

acute in the following examples which are discussed in greater detail throughout this book. In Lori Baldwin's *The Village* (2018) there was an implicit invitation for the audience to use psychical force against her body that prompted moment-to-moment navigation of the contracts between the artist and audience. These contracts spoke to gender dynamics, power shifts, and the inscribed, residual violence of the site, as the performance took place in a room located above a public bar, a volatile site of risk for some bodies more than others. Poignantly, self is understood through interrelation to one another. In this work, the responsibility of the collective was clear. As audiences watched her body receive blows, they were equally complicit to the act itself from their 'passive' observations. Here Self/s became manifest. In another example, Anne Bean's *Duet with 5 Strangers* (2016), the artist described being affectively shaped by the strangers who came to her work in vulnerable and human ways. Bean felt a moral responsibility towards these strangers, or in other words a level of interconnection, and this feeling is what actually sculpted the work. Additionally, in Heather Sincavage's *The Burden of This* (2018) the artist carries a large, black sack of faecal matter that matches their body weight through a South London open market to have people 'deal with my shit.' Again, there is the language of the necessity for the performance to be in relation to other bodies to bear witness and to cope with. These artists are similarly concerned with challenging orders of space and time; the way in which the body navigates the constant shifts in lived experience articulated through performance.

To conclude, the experiential is essential to Bacon's proposed framework, which means that even the readers experiential account of such performance documentations creates another version of the performance. Some writing examples included comparison of reflections on artistic responses to their performance works over set durations of time, using controlled frameworks to generate responses that are 'blind,' all developed and facilitated by Bacon. This approach looks at what changes and what stays the same in the memory, which is known to be a flawed account but also a tool through which the body orients to the world. On a personal level, it was surprising to see how much my own responses changed over time since the delivery of my performance *Phases* (2014) where for six hours I walked on a sandpaper circuit barefoot until the soles of my feet wore away, broke, and bled. Notable was how the emotive, immediate response was distanced and replaced with reflections with more clinical language only two years later. Perhaps, it was the extremity of endurance that the work required and as a survival strategy that demanded a distancing in my own relation to the event. My experiential understanding of my performance has changed and arguably is continuing to change even more over time, through my body and its enduring reorientations to space.

Biography

Chelsea Coon is an artist and writer whose work focuses on the shifting interconnections of the body, time, and space. She utilises endurance to reconsider limits of the body primarily through performance as well as installation, sculpture, painting, photography, video, and text. She has exhibited internationally in festivals, biennales, and galleries in North America, Europe, Asia, Africa, and the Middle East. She received her BFA at the School of the Museum of Fine Arts (2012), MFA at Tufts University (2014), and a Certificate of Advanced Studies in Theatre, Performance and Contemporary Live Arts at the University of Applied Sciences and Arts Scuola Teatro Dimitri, Switzerland (2015). Recent writings included her essay 'You Always Hurt the One You Love: Transference, Pain, Endurance' in *Rated RX: Sheree Rose with and after Bob Flanagan* (Ohio State University Press, 2020). She is a recipient of the Australian Research Training Program Scholarship and is a Ph.D. candidate in practice-led research at the Victorian College of the Arts, University of Melbourne.

Author's Note

This book uses a revised version of the author's doctoral thesis, *Experiencing a Multiplicity of Self/s* (2016), published under the name Thomas John Bacon. It features new writing; surveying a more extensive range of artists, drawn from Tempting Failure's London Biennial of International Performance Art, Buzzcut Festival, SPILL Festival of Performance, Berlin's Month of Performance Art, Emergency presented by Word of Warning, Live Art Development Agency, Yard, London, Demure du Chaos, Lyon, Salento, Italy and the Attenborough Centre, UK. This expands the application of the original text while offering new original thought and insight from the author. Some artists featured in the original thesis have been removed, along with detailed accounts of Thomas John Bacon's own performance work for editorial fluidity. The original text held at the British Library and Bristol University still offers useful and applicable peer-reviewed thought on these wider areas. For all other accounts, inclusive of the author's phenomenological findings for performance art, this new (definitive) text should be considered the culmination of this period of research which began in 2009.

Since 2020, the author has dropped the use of Thomas John Bacon and now uses tjb in acknowledgement of their non-binary gender identity and artistic practices. Authorial academic credits still continue under T. J. Bacon. They use the pronouns xe or xem. In this text when illustrating the conceptualisation of a multiplicity they will use the identifier we or our when it is appropriate.

Finally, every attempt has been made to capture the pronouns of all artists featured and were correct as of January 2021.

Introduction

For a practitioner utilising a methodology of practice-as-research at a scholarly level, herein referred to as the practitioner-researcher, academic rigour is demanded when framing any embodied accounts of performance art. I found this rigour through an application of phenomenology. As an artist, curator, and scholar I position my practice within the framework of the artist-philosopher. George Smith's *The Artist-Philosopher and New Philosophy* (2018) traces the origins of the artist-philosopher over the past 2000 years as a notion that has always been present yet rarely considered. Indicatively, we can map this through the artistry of philosophy in stoics, rationalists, nihilists, the psychoanalysts, and the phenomenologists. Smith's conceptualisation of the 'artist-philosopher' applies poetic language to describe and illustrate philosophical constructs in order to widen their accessibility to others. This is something that has evolved through my teaching and has continued through my own practice-as-research. However Smith also argues that 'Western Metaphysics has come to what [Martin] Heidegger describes as "an end" […] He calls for a New Philosophy, conceptualised by the artist-philosopher who "makes" or "poeticises"'(2018: 2). While it may appear egregious or egotistical to adopt the moniker of an artist-philosopher, it is only utilised as a means to categorise my own work as a 'maker' across academia, performance art, and curating.

I offer this book as an introduction to be used by those new to the application of a phenomenology in the study of performance art. But within the remit of my art-philosophy, it simultaneously functions as both a guide and a form of artistic expression through the manner in which it is designed to be read and applied. This manifests through curated case studies of performance art framed through multimodal written accounts, enabling the reader to self-select the order in which they read about the artwork, maintaining a *liveness* for each documented performance art encounter.

I first began experimenting with creative modes of philosophical writing in the essay *Traces of Being: A Document of Absence in Words* (2011) where a conversation between the three artists, Ron Athey, Helen Spackman, and Thomas John Bacon explored the perceptual experience of documenting the absence of a performance. This essay was formatted in a colour coordinated 'cut-up' style allowing the reader to find juxtaposition between each train of thought and conversation or to follow the three linear dialogues from each contributing artist. The doctoral thesis *Experiencing a Multiplicity of Self/s* (2016) similarly utilised multimodal forms of (distinctly coloured font) writing to document a phenomenology of performance art through embodied accounts that distinguished between the sensorial memory and a 'factual' memory. These separate modes were analysed to further a research enquiry into the significance of a phenomenological flesh. The term 'flesh', coined by Maurice Merleau-Ponty (1968), described the intangible element through which the perceptual experience manifests.

Jane Rendell similarly explores the experiential point of engagement through multimodal writing in *Site-Writing: The Architecture of Art Criticism* (2010). Here, Rendell captures specific sites of engagement such as 'material, emotional, political and conceptual – of the artwork's construction, exhibition, and documentation, as well as those remembered, dreamed and imagined by the artist, critic and other viewers' (2010: 1). Influential to the design of *An Introduction to the Phenomenology of Performance Art: Self/s* is Rendell's chapter, 'The Welsh Dresser' (2010: 121–34). This chapter details an object she inherited from her mother; dedicating a single page to each item found contained within the dresser. A photograph of each artefact heads each new page and below each one Rendell wrote in three modes 'the memories that came to mind [...] later add[ing] dictionary definitions of the objects [...] and finally reflected upon them from a historical perspective' (2010: 121). Photography is often considered empirical evidence; Rendell's application doesn't simply dispute this but rather expands the 'reality' of the photograph to consider the 'trace of the now invisible lives of the past' (2010: 121), alongside a frame of references that would expand the 'constellation of memories and associations' (2010: 121) that emerged from each item.

Inspired by Rendell's technique, this book returns to the writing and memories captured in *Experiencing a Multiplicity of Self/s*, selecting the featured artworks to be considered in more detail and offering new pieces for analysis to provide a wider focus across time, memory, and reflection. Each chapter features performance artists curated under the umbrella of a specific theme; multimodal writing creates an opportunity for the reader's own immediate and potentially poetic encounter with these artworks, which Smith highlights through Heidegger's own discussions of a poem by Paul Cézanne as revealing a path ' "Which leads to/a belonging-together of poetry and thought?" [... implying] for Heidegger the kind of poetic thinking that constitutes poiesis, the thinking of the artist-philosopher'

(2018: 260). This poetic-logic is underpinned by my application of a phenomenology (Bacon 2016) and will be explained to allow practitioners wishing to apply this to their own work an accessible methodology that remains suitable for the academically rigorous application of phenomenology in the study of performance.

The multimodal writing in this book explores each artwork through:

> **Embodied Writing** indicated by a lined box with a white background documenting the experiential account of the artist or spectator, utilising the modes established &/or previously reproduced in Experiencing a Multiplicity of Self/s.

> **Contextual Discourse** indicated by a lined box with a light grey background, that reflects upon the performance artwork through a phenomenological lens.

> **Series Notes** indicated by a lined box with a dark grey background and white font, are a reflection either upon the original phenomenological writing published by the author in Experiencing a Multiplicity of Self/s or a reflective dialogue between the author and artist's embodied writing or artist post-performance.

When applicable a fourth mode will manifest as:

> **Definitions, Exercises, or Programme Notes**
> These are indicated by text framed within borders. 'Definitions' will introduce the reader to the key terms of phenomenology (typically drawn from the mid to late writing of Merleau-Ponty) and their application by the artist-philosopher. 'Exercises' are provided for the practitioner-researcher to explore, and adaptations are indicated for each exercise. 'Programme Notes' are how the featured artists have written about or introduced their artwork to new audiences.

As the reader you may select to access the writing in this book in any order you want. You are encouraged to be creative; allow the pages to fall open by chance, or randomly select an artist, theme, or chapter and then choose to follow the modes one at a time, perhaps randomly, or even in a traditional linear manner!

Poiesis is where a person brings something (such as a concept or artwork) into being that did not exist before; multimodal writing allows the artist-philosopher who documents the experientially embodied radical and often unpredictable nature of performance art an opportunity to reflect on a phenomenological poiesis. As performative actions are typically restricted to the ephemeral moment, often held in the immediate encounter, the conscious memory or shared experience of it often seems at odds to restrict discussion and documentation of them to a linear single authorial voice. The genre-defying nature of performance art is therefore appropriately reflected within the performativity that multimodal writing can offer. It can be both document of the original experience for artist and audience member, while also allowing an authorial freedom to you to re/encounter the words on the page.

As the reader of this book, you should feel empowered to rediscover your own immediacy in the unique encounter of the artist's practices held within these pages. You are free to navigate your own encounter/s as you often would be able to when encountering performance art live. This is not only suitable to the transgressive form of performance art held in this book but also to my own poetic-logic as an artist-philosopher; relocating the phenomenological poiesis of authorship away from myself and returning it to the reader. As established in *Traces of Being: A Document of Absence in Words* (Bacon 2011), it is 'unnecessary' to read these modes in a linear order.

Echoed in the multimodal design of *Janet Cardiff: The Walk Book* (Schaub 2005), here Daniela Zyman proposes how the site of an encounter with Cardiff's work is not static (2005: 11); the ephemeral immediacy of her practice unfolds between an 'inner space of the walker [who encounters Cardiff's audio works] and their external environment' (2005: 11). Zyman suggests that this does 'not generate a physical embodiment beyond their performance' (2005: 11). Yet Mirjam Schaub's graphic design of *Janet Cardiff: The Walk Book* successfully navigates this physical absence by capturing an embodied experience post-performance through a décollage of artefacts, photos, subtext notes and postscripts. Even the voice of Cardiff, as the artist, appears in a blue font denoting a shift in register for the reader, as she intervenes in the writing of the collected authors. Encountering these words without direction and in a non-linear fashion becomes the new performance action for each reader, resonant with the original but creating a renewed encounter and further philosophical commentary through the performativity of the multimodal design on the page.

A similar experience is encouraged for your own embodied encounter with the modes here in this book. Phenomenology as a process to articulate the experiential, offers the artist-philosopher a method for documenting, accounting, and analysing embodied experiences while being an academically rigorous philosophical approach to consider the first-hand (typically solo) performance art produced by the practitioner-researcher. Simon Jones suggested replacing the word 'philosophy' with the word 'performance' (2009: 18–33) when paraphrasing Serres and Latour from 'Conversations on science, culture and time' (1995: 86) to suggest that '[n]ot only must performance invent, but it invents the common ground for future inventions'. By demonstrating the interaction that already exists throughout art and philosophy, Jones's words enable the discovery of an echo in Smith's writing when he notes the truism within the phrase 'art of philosophy' stating, 'there is an art to metaphysics, that metaphysics is artful in its method' (2018: 26), but that within this we discover a second way to interpret this, 'For there was a time when thinking, Being and poeticizing were all one and the same' (2018: 26). This is the same poetic logic he noted as poiesis through the Heideggerian writing on Cézanne (2018: 260) and is the same practice-as-research process for both the artist-philosopher and the practitioner-researcher that shall be articulated throughout this book.

The use of phenomenological philosophy in this book comes mainly from the later writing of Maurice Merleau-Ponty, particularly *The Visible and the Invisible* (1968) and *The Phenomenology of Perception* (2002), with additional insight from Martin Heidegger's theories (2009a; 2009b). Performance theory is contextualised primarily in reference to Amelia Jones' studies on performance art, risk, and phenomenological philosophy, such as *Body Art: Performing the Subject* (1998), *The Artist's Body* (2003), as well as her publication in *Parallax*, 'Performing the wounded body: Pain, affect and the radical relationality of meaning' (2009). Sara Ahmed's, *Queer Phenomenology: Orientations, Objects, Others* (2006) alongside *Listening to Noise and Silence: Towards a Philosophy of Sound Art* (Voegelin 2010) and *Embodied Avatars: Genealogies of Black Feminist Art and Performance* (2015) by Uri McMillan also provide a useful application of Merleau-Ponty in the analysis of performance. From the field of performance philosophy, references utilise Suzanne Kozel's (2007 ; 2015) practical application of phenomenology on dance and digital technologies, while further indicative context is drawn from Jane Blocker (2004), Stuart Grant (2012), Drew Leder (1990), and André Lepecki (2006 ; 2010) among others. Further context and application for these texts is located within each chapter that thematically links the artwork of artists

and opens with a contextualisation of fundamental phenomenological theories to be applied in the writing under each heading. These chapters are framed to enhance engagement and ease of accessibility to the reader with both theory and artists curated in demonstration of the artist-philosophical lens. This book's phenomenological analysis emerges through an application of the Interpretive Phenomenological Analysis (IPA) methodology:

> IPA is concerned with trying to understand lived experience and with how participants themselves make sense of their experiences. Therefore, it is centrally concerned with the meanings which those experiences hold for the participants. IPA is phenomenological in that it wishes to explore an individual's personal perception or account of an event or state as opposed to attempting to produce an objective record of the event or state itself.
>
> <div align="right">(J. Smith 2015)</div>

Unlike the traditional use of IPA in studies of medicine and science, the phenomenological writing in this book is not analysed for emerging quantitative patterns but rather for qualitative information that captures the philosophical lived experience of performance. Suzanne Kozel (2015) reminds us in *Process Phenomenologies* that we may find a sense of truth in the confusion that varied accounts create, perhaps as often as in the clarity they may hold since they act as snapshots of the memory of an experience that she terms as a 'phenomenological reflection', which she suggests 'sets in motion a process of translating, transposing or transgressing lived experience into writing. [...] Sometimes a phenomenology first produces drawings, scribbles, murmurs, or gestures. Or a big blank confusion. A nothing that is something' (2015: 54). In *Experiencing a Multiplicity of Self/s* the methodology was structured so that the captured data from the featured accounts (unless noted otherwise) was recorded before an engagement with any subsequent third-party documentation, such as photography, sound recording, or film. This was not a prerequisite of IPA but was established in order to bring analytical rigour to the accounts rather than allow them to be mediated, altered, affected, or otherwise influenced by other documentation. Two modes of writing existed within this framework: a contextualising text that noted everything that happened and a sensorial/emotive text. The choice of what should appear in each embodied account was subjective to the individual. Another person completing a similar task could record the data and the distinction between what was included under either framework differently. It demonstrated that the process was not exclusive but the interaction with the methodology could yield different results for another human. This was the lived experience of the author of each text.

Within a phenomenological context, accounts remain valid even if perception is partial or misremembered. Kozel affirms that the incorrect recollection of an experience is as valid as the precise reflection for a phenomenological study, writing that '[m]emory and imaginative reconstruction are involved regardless of the lapse of time between experience and documentation of the experience, but obviously too much time passing can dull the recollection' (2007: 53). *An Introduction to the Phenomenology of Performance Art: Self/s*, returns to some of the accounts featured in *Experiencing a Multiplicity of Self/s*, looking at changes over time, and/or producing new dialogues either afresh or in response to the original accounts. Kozel proposes the following methodological approach, to make oneself consciously aware of capturing an experience from a phenomenological perspective:

> Take your attention into this very moment. Suspend the main flow of thought.
> Call your attention to your body and what it is experiencing [...] Witness what you see, hear, and touch, how space feels, and temperature, and how the inside of your body feels in relation to the outside [...]
> Take a break (a moment, a day, a week, a year).
> Describe what you experienced.
> Take notes, record sounds or images.
> Initial notes can be a sort of 'brain dump'.
> Do not worry about style, grammar, or relevance at this stage. This stage may occur immediately following your immersion in a specific sensory experience, or it may happen after an interval [...]
>
> (2007: 53)

This indicative checklist highlights the notion of 'taking a break' that this book explores through an opportunity we are afforded in the passage of time between the live performance art action and the juxtaposition of multimodal writing to re/ encounter either the accounts from the previously published body of writing or the experience of the artwork post-performance. Similarly, this is echoed through this book's application of the forward slash '/' as we are exploring the in-betweens, articulating the absences or errors, and the risk of failure in the accounts that occur during such 'breaks' in time. This '/' does not indicate the word, 'or', but instead acts to account for how something may be phenomenologically experienced as in a state of flux. For example, the shifting perception of a Being between points of manifestation and perception may be read as de/re/constructed, not in the Derridean (2009) sense of deconstruction, but rather in the poetic-logic of the poiesis previously mentioned and to be established further through this book. The artist-philosophical expression of 'Self/s' indicates the potential to understand Self as a

multiplicity of binaries in harmonious reciprocity, conflicting flux or oscillating evolution.

Performance art is profoundly personal, often actioned as a response to political, social, cultural, or biographical concerns. Therefore, it often involves significant risks of exposure by the artists who operate through it. Phenomenology is a useful lens through which to consider performance art as it is the study of the appearance of things in existence; it is a philosophy that attempts to address the embodied experience. Heidegger said it was 'to let that which shows itself be seen from itself, in the very way in which it shows itself from itself' ([1927] 2009a: 58).

> **Phenomenology** attempts to detail our understanding of who we are in the world as Dasein (the cognisant Being). For Heidegger, '[u]nderstanding co-occurs with perception, (being-in-the-world) and language follows what is immediately there, as any experience is understood' (Owen 1999: 5). For Merleau-Ponty, it looks to ascertain the significance of experience and perception concerning being-towards-the-world.

This definition of phenomenology provides a starting place that should be considered the outline of a journey that through subsequent exercises and explanations will enable you to reposition your awareness of the phenomenological implications for experience and perception. You will continue to fill in this picture and expand your understanding throughout the course of this book.

Phenomenology does two things when considering what it is to be present in any given moment. First, it is a reduction (Husserl 1931), but it is not a philosophical deconstruction or reductionist. It is an attempt to describe the essence of the moment without losing its significance. Second, when doing this, it wrestles with the paradox of how to do that; to be both present in the experience and simultaneously aware of what manifests to create it, while accounting for yourself and everything that your perception and your presence alter (Merleau-Ponty 1945). Phenomenology enjoys such problems; the consideration of Being, Self; the perception of presence and an understanding of the interrelatedness of all elements of the experiential. For performance art, phenomenology can be a useful way to consider the epistemological experience of the risk that innately manifests through the artform, towards a posteriori (i.e. to consider its origins through our embodied spectatorship, within the artwork as the artist, and outside of it, as audience who may encounter the work over their lifetime).

An Introduction to the Phenomenology of Performance Art: Self/s advances the application of my theories (Bacon 2016) pertaining to the study of performance art. It affirms the position that Being, for the phenomenologically lived body (Merleau-Ponty 2002), though physically manifested as singular, is perceived simultaneously as both embodied and disembodied through multiple Self/s in reciprocity. A poesis of this is expressed through my own non-binary application of pronouns: 'me' or 'my' represent the complete corporeal Being in conjunction with 'xe' or 'xem' to express a non-binary opposition to an essential self. This application of the multiplicity of Self/s (Bacon 2016) asserted authority to theories for a multiplicity (Deleuze and Guattari [1987] 2004) for Self, expanding beyond notions of embodiment and disembodiment as binaries, confirming pluralistic selves within a single Being (Berardi 2009) as in a state of reciprocity, becoming, simultaneity, or flux. In 2016, my research confirmed that through risk and investment, particularly within performance art, the perception of Self/s is evident. Self/s are witnessed through the processes of intertwined or intersubjective: audiences, witness, spectators, documentation, yourself, place, space, reader, and through time, such as in modes of recollection or immediacy. Since that publication, these theories have also allowed me to express my gender identity through performance practice, philosophy and queer existence. In 2020, I came out as non-binary and while the theories I published in 2016 have allowed me a clearer path to understand my queer

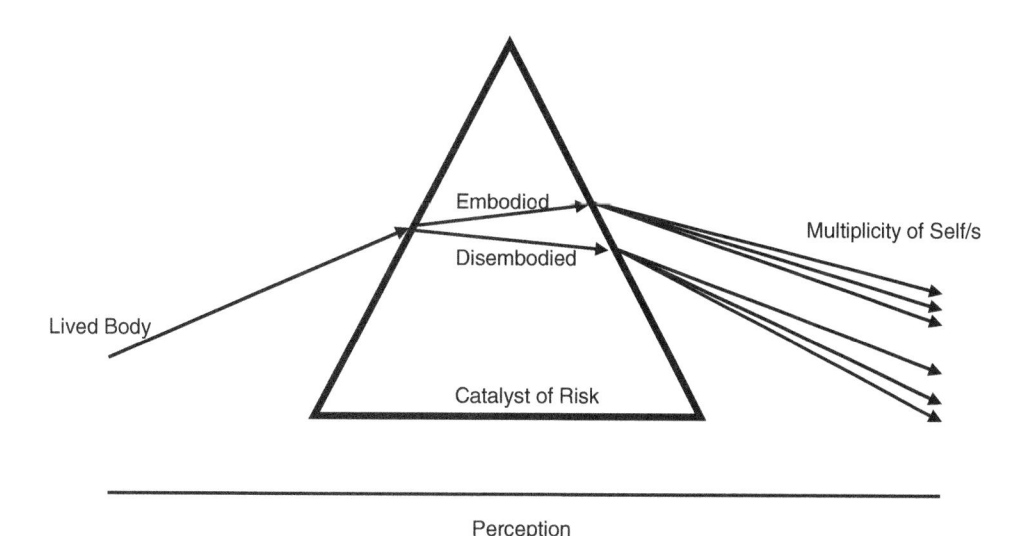

FIGURE 1: A line drawing where a single line passes through a prism. It is split into two and exits the prism as multiple lines that represent a refraction of the whole. Below this is a horizontal line to represent a position of perception outside of the prism.

gender, they continue to also be applicable to a wider phenomenological study of performance art. At the centre of both discoveries is an eidetic reduction (Bacon 2016) that demonstrated the process of perceiving this multiplicity.

> An **eidetic reduction** is a Husserlian (2012) process to describe the essential nature of something. In this instance the artist-philosopher uses it to reductively note what constitutes the formula but that does not prescribe the outcome of all experiences or perceptions which are contingent on the individual.

This eidetic reduction (Bacon 2016) is captured as a formula for perception, illustrated through the following diagram (Figure 1):

It is illustratively analogous with the process of light particles passing through a prism and being refracted to reveal how a spectrum of multiple frequencies (including those seen and unseen to human senses) can be perceived. Reappropriated here, this eidetic reduction shows the perception of the corporeal whole (i.e. the lived body) de/re/constructed in the moment of performance action. Where a beam of light could represent something perceived initially as 'complete', it is substituted with the notion of the artist's lived body (which we will define shortly) before a position of 'perception' (i.e. an audience) who each individually perceive this presence. The being or 'lived body' is a locus for our shared perception. For our purposes, this is the artist's lived body, which exists through a space that Jones notes as

> a hinge or two-sided boundary (that is part of the thing it separates) marking 'Being's reversibility' – [that] Merleau-Ponty theorises [holds] the interrelatedness of both mind and body (the embodiedness of the self) and the reciprocity and contingency of the body/self on the other. This is what Lacan [...] describes as the phenomenology of transference, by which the self is located in the other.
>
> (1998: 41–42)

If you imagine a Being before you, consider how your perception of it projects onto it and in turn it onto you. Through the example of one artist and one audience member we can illustrate our shared perceptions as simultaneously formed of embodied and/or disembodied presence/s. However, it is through a catalyst of risk (the moment of action represented by a prism in the diagram), that the performance artist and 'audience' as other who, investing together through a process of risk, expand the potential perception of a single presence (through this intertwining) as a multiplicity of Self/s.

Self is a construct of both mind and body. Together, they are the two elements that form an essential self, acknowledging an [empirical] embodiment and a simultaneously separate [intellectual] disembodied side as this diagram below illustrates. This is a reading of self that must be acknowledged in the construction of the lived body. However, the third way through a lived body that Merleau-Ponty (1945) proposed required a reductive reading. This was not a disregard of previous thought, but instead an encompassing step to acknowledge that this disembodiment of self is equally interlinked with embodiment. Each lived body is able to perceive constant shifts from multiple perspectives, which enables simultaneous multiples of self to be revealed.

Figure 2 displays how the lived body may be formed from multiple elements. From the perspective of Being, the lived body offers a third way by acknowledging that Being-towards-the-world is an evolution of Being-in-the-world. Together, all elements, along with the traditional constructs of mind and body, may form the singular Being: the lived body.

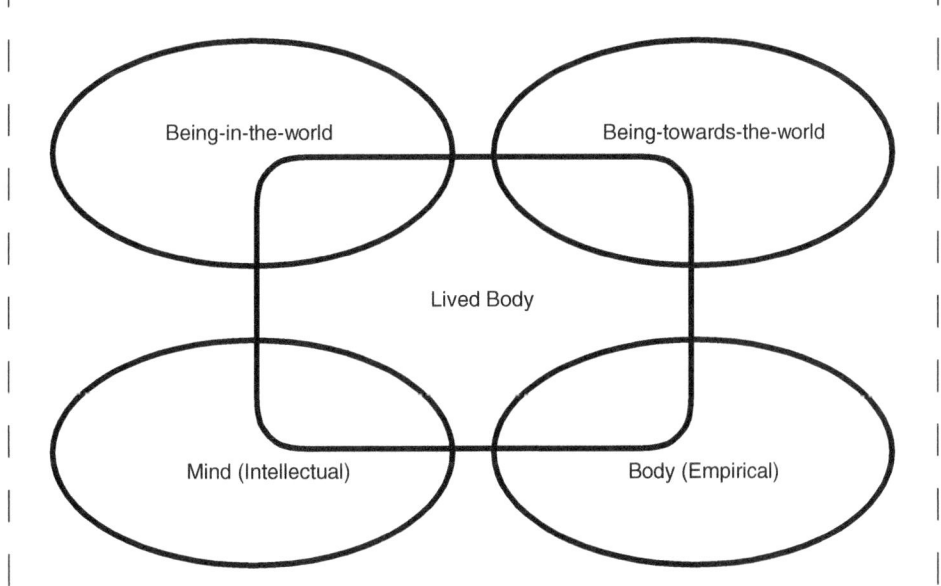

FIGURE 2: A line drawing where a rectangle is located at the centre and at each of the four corners a different oval intersects to represent how each is a constituent part of the whole and can be considered individually or completely.

This is not simply a return to either 'Being and Truth' (Heidegger 2010) or 'Body and Identity' (Deleuze and Guattari [1987] 2004). It is, as André Lepecki (2006) says when referring back to *Self/Unfinished* by Xavier LeRoy, about

Becoming; replacing a series of categories, such as masculinity and femininity, object and subject, or even absence and presence with a series of pure becomings (2006: 40). Indeed, in quoting Deleuze and Guattari ([1987] 2004) from *A Thousand Plateaus: Capitalism and Schizophrenia*, in this regard, Lepecki sums up the process for *Self/Unfinished*, citing the following: 'A becoming is not a correspondence between relations. But neither is it a resemblance, an imitation, or, at the limit, an identification [...] becoming produces nothing other than itself' (2006: 238).

So, when we refer back to Figure 2 and the idea of embodiment and disembodiment, the lived body is present through the becoming of each of these constituent elements. Self/s acts as an indicative term to define the multiplicit occurrences of Becoming that manifest through shifts in the perspective of presence both from within and without a lived body. It is not necessarily the manner in which they interact but that we can consider the uniqueness of each constituent element (see, gestalt). A uniqueness that is not dictated or related to a predetermined category as Lepecki says but simply, 'is'. In 'becoming', each of these elements remains open to the unique perception of an other (Figure 1) and can therefore be broken down into its equal parts.

When picturing the catalyst of risk, as part of the eidetic formula (Bacon 2016), another analogy is useful: when water boils, it becomes volatile at a molecular level causing the molecules to separate. Similarly, a lived body perceived by an invested audience, challenged to the point of potential failure or in engagement with risk, is more likely to be perceived as a multiplicity of Self/s. Tim Etchells, artistic director of *Forced Entertainment*, a contemporary performance company that frequently engages with risk in their practice by deconstructing theatrical conventions, writes,

> To be bound up with what you are doing, to be at risk in it, to be exposed by it. As performers, we recognise but cannot always control these moments – they happen, perhaps in spite of us.
>
> (1999: 50)

It is this sense of exposure through performance that Etchells documented in the responses of others' 'encounters' with Ron Athey's performance *Self-Obliteration* (2010), at the *National Review of Live Art* (NRLA) in Glasgow, that he described as 'at once a place of origin and a point of departure' (2013: 226). Through the phenomenological intertwining of experience/s for audience and artist, we begin to expose a range of perceptions that is theoretically vital for risk as catalyst to manifest within this process of perception. From here, we may begin to question

the far more complicated perception of the performance artist wrestling with presenting a body in modes of performance and aesthetic concern. Performance art offers audiences an investment in risk beyond the theatrical; it exposes the risks in life, it reveals a reality. Dominic Johnson supports this when he asserts that 'performance art is often engaged in the praxis of turning one's life – body and subjectivity – into the stuff of art. […] and life also includes failure, insignificance, invisibility, boredom, and subjection to the ravages of time (and age)' (2015: 3). This exposure is the catalyst of risk that will be mapped throughout each chapter as we focus on understanding the complexities in applying a phenomenology that connects audiences to the performance artist, who present a reality that we know exists in both its immediacy and beyond the performance 'stage' and who reciprocally may invest in the perception of a 'truth'.

The aesthetic and historical dialogues around art and truth are far reaching. Peter de Bolla's *Art Matters* (2001) offers insight into those, but our concern regards the phenomenological complexities entwined within the origins of truth and artwork. Heidegger (2009b) felt that if we consider the artwork in the untouched moment, complete, and do not attempt to place any more extensive reading or intention upon it other than its existence, it could essentially be no more than a thing. Indeed, Heidegger stated, 'The artist is the origin of the work. The work is the origin of the artist. Neither is without the other' (2009b: 143). Regarding the artefact produced by the artist, Heidegger had identified that there was something within these 'things' that made them more than objects, as by their very definition they were artistic in nature (2009b: 143). The created artefact had risen above its simple inanimate thingness. He wrote, 'The work makes public something other than itself; it manifests something other; it is an allegory' (2009b: 145), and imbued within it is an essence of the artist in pursuit of perhaps a question, a desire, even a truth. This book will therefore reconsider this notion for performance artists, who at the time of the action may produce no artefact other than their presence. This queered reapplication will challenge the problematic origins of this theory particular to the Heideggerian – arguably fascistic (Victor Farias 1989) – exclusivity he proposed, by clarifying how the lived body of the performance artist becomes perceived as artwork (Chapter 4 and postface). This will be established by confirming a multiplicit view of Self/s through accounts of the key works featured herein and opening implications (through a material/presence) for the perception of the artist as object and subject; at once disembodied and embodied. When using phenomenology to examine the transgressive nature of performance art, we necessitate a radical queer application of phenomenology. This book will demonstrate this application and guide you to perceiving how the performance artist's presence/s can be philosophically considered as artwork (Chapter 4).

The **lived body** for Merleau-Ponty describes the body of a Being that may be perceived as both subject and object. From a spatio-temporal standpoint, objectively it has mass and form; it occupies space. Equally, the body in this context is subjectively lived and experienced; this simultaneity is important to note. For Merleau-Ponty (1945) this presents, within the singular form, a paradox for empiricism (a physical reality or experience that may be explained in natural or scientific terms) and intellectualism (spiritual/mental experience focussed on the productive conceptualising role of consciousness). To understand this, consider Merleau-Ponty's (1945) investigation into the phenomena of the phantom limb for the amputee who may sense and even feel the presence of a lost body part, against the anosognosia sufferer who unconsciously ignores the presence of a paralysed limb. Each example is useful in the wider context of perception:

> In both cases we are imprisoned in the categories of the objective world, in which there is no middle term between presence and absence. In reality the anosognosic is not simply ignorant of the existence of his paralysed limb: he can evade his deficiency only because he knows […] what he does not want to face, otherwise he would not have been able to avoid it successfully […] [While] the phantom arm is not the representation of the arm, but the ambivalent presence of the arm.
>
> (1945: 93)

Evidenced here is a clash between two different forms of perception: The empiricised object and the intellectualised subject. Applying both views of the physiological and the psychological highlights shortcomings in each. Therefore, an encompassing third way (dimension) inclusive of presence and absence is proposed through the phenomenological construct of a lived body, while also moving our dialogue beyond the Cartesian split between mind and body that these binaries initially imply.

> The patient must be viewed as occupying a middle ground between the two. He builds a self through his past and relies on it in the present and toward a future horizon. When this reliance is disturbed through a handicap, the patient must act (or not act) in some way so that he may continue in his existence.
>
> (Info Refuge 2011, online)

Dance scholars and practitioners have more often than any other form of performance found a connection to their practice through the use and study of phenomenology. In *The Phenomenology of Dance*, Maxine Sheets-Johnstone (1966)

details why dance is frequently analysed through a phenomenological lens due to its focus upon a lived kinetic experience. Here she highlights temporal shifts for the body that is choreographed in the past but affective in the present. Exploring the body objectively and subjectively in the moment of any action she says,

> Only when we see the kinetic phenomenon as an object which is moving, when we reflect upon it, separate or distance ourselves from it, are its inherent spatiality and temporality decomposed. The phenomenon then becomes for us an object or a thing which moves within a given space and within a given time. In the immediate encounter with the phenomenon, whether it be flight of jet across the sky, the stalking of a cat toward its prey, or dance, what appears before us is a moving form which exists within its own spatial-temporal structure. It is therefore clear that in our lived experience of dance, we are implicitly aware of the spatiality and the temporality of the particular moving form which appears before us.
>
> (1966: 28)

In his essay '(Dis)figuring space', Stanton B. Garner (1994) discusses the potential of the performing artist's body to become a multiplicit tool of communication,

> where light, darkness, movement, and position are given equal status to the linguistic text [the] performance field is re-articulated as visual field, and the plays themselves reflect an essentially scenographic conception [...] In Pierre Chabert's words, the body [...] 'is worked, violated even, much like the raw material of the painter or sculptor, in the service of a systematic exploration of all possible relationships between the body and movement, the body and space, the body and objects, the body and light, and the body and words'.
>
> (1994: 54–55)

Here Garner highlights the potential for the body of a performer to become an artistic material. This is particularly useful to the discussion of the performance artist as both artist and artwork, demonstrating the potential for Being to be perceived as both embodied and disembodied, which is the beginning of creating a dialogue around Self that may evolve towards a multiplicity. A position that, as Garner quotes Chabert, develops a language of intersubjectivity for the artist between body and space, object, light, and so on. This expands how the lived body is perceived, as the potential ways in which it can be experienced become multiplied.

Having previously challenged an essential Self and explicated Self/s in phenomenological terms (Bacon 2016), this book furthers the application of this, noting the unique potential within performance for how 'Body art splinters rather than coheres the self' (Jones 1998: 51). Body art is perhaps within the extremis of performance art, but risk is not exclusive to the actions of artists such as Ron Athey, ORLAN, Marina Abramović, and others who have physically intervened in their own bodies. Risk as the catalyst that repositions our perception of an essential Self is found within the complexities of practices that subjectively risk failure. Lisa Le Feuvre summarises such practices as noting '[t]he nice thing about utopias is precisely that they fail. [...] failure is a poetic dimension of art' (2010: 194). The risk of failure is necessary but equal to a shared investment in that risk between audience and artist (see Chapter 4). If the work is simply about risk, then our awareness of this primary cause shifts the dynamic away from its potential as a catalyst. If the risk is distanced from us as the only thing to be observed, then our investment in the action alters. It arguably becomes something else, perhaps more akin to a stunt, due to the shift in expectation. It does not mean that one could not perceive a multiplicity of Self/s in such an act, as risk is only a catalyst. Etchells clarifies the importance of risk in performance practices, writing that it is '[t]he thing we are striving for in performance but not a thing we can look for. We look for something else and hope [...] that risk shows up. [...] Risk surprises us, [it is] always fleeting' (1999: 49). Risk, however, is equally subjective, so where we would discount the risk of an artwork based on our experience, another person could prioritise it. Necessity is in the investment rather than the failure alone. As Etchells clarifies, the need to be aware of risk, in as much as one must be invested, is vital but cannot be at the expense of overplaying the status of risk above any other concern.

> Investment wants us naked, with slips and weaknesses, with the not-yet and never-to-be certain, with all that's in process, in flux, with all that isn't finished, with all that's unclear and therefore needs to be worked out [...] Investment forces us to know that performative actions have real consequence beyond the performance arena.
>
> (1999: 49)

This flux is the action found within experiencing performance art; the unfinished, the made, and of the being made, not only in regard to the artist but also in the reciprocal experience of encountering the work as a spectator. Risk is entwined in an exchange with investment, as Etchells concludes, and this results in an experiential change as 'we are transformed – not audience to a spectacle but witnesses to an event' (1999: 49). A multiplicity of Self/s is found through all Dasein present. This intersubjectivity and intercorporeality is discussed in more detail over the coming chapters (see Chapter 3).

Dasein, utilising the Heideggerian (1926) definition, is a self-aware entity that is able to differentiate between itself and a 'thing'. It is open to the potential of its own inherent meaningfulness in relation to its position to factual or empirical things; it is aware of the 'world' in which it exists. 'Da' in German means 'there' or 'here' (a location) and 'sein' means 'being' or 'to be'. Dasein is therefore a location for a Being within the World, in which it has come to exist, such as the place or moment of performance for an artist. Originated by Martin Heidegger in his early career, the word was an attempt to engage with an understanding of the Being of the human or subject. Dasein, is able to ascertain its ontological difference and has an understanding of Being. At the time when the word originated, this was a sense of being-in-the-world (later to be superseded by Merleau-Ponty's being-towards-the-world) which gave a grounding to Heidegger's early phenomenological notions.

Peggy Phelan writing upon the specific ontology of performance (i.e. the live event) in *Unmarked: The Politics of Performance* noted that 'performance's only life is in the present. Performance cannot be saved, recorded, documented, or otherwise participate in the circulation of representations of representations: once it does so, it becomes something other than performance' (1992: 146). This highlights a potential problem, for as soon as something has passed from the immediacy of the live action, Phelan would argue that this fixed perception of the live action is where performance ends. However, the application of phenomenology in *Experiencing a Multiplicity of Self/s* challenged this, supporting a position that the experience of performance is how our perception of it grows across a much wider period of time; from anticipation through journey to pre and post encounter and the shifting memories or conversations after the event. Performance art lives outside of, and through, its own immediacy. As Kozel (2007) noted, memory and imaginative reconstruction expand, blur, and alter the performance. Phelan argues performance art is an immediate experience and Kozel affirms for phenomenology that each experience does not limit itself to an initial interaction, therefore we propose that immediacy is fluid over a period of time. This is also true of performance and is echoed through the multimodal structure of this book, providing opportunities to multiply encounters with immediacy and memory, both for the performance artwork and the dialogues that surround it. Here we find an alternative interpretation within Heidegger's 'truism' that was originally written in regard to the traditional practices of painting and sculpture:

Art is the origin of the artwork and of the artist. Origin is the provenance of the essence in which the Being of a being essentially unfolds. What is art? We seek its

essence in the actual work. The actuality of the work has been defined by that which is at work in the work, by the happening of the truth.

<div style="text-align: right">(2009b: 182)</div>

The immediacy of the encounter with performance art forces a revaluation of Heidegger's words upon the location of the artwork. As immediacy unfolds across the spectrum of time, an artwork's provenance becomes 'witnessed'. Self/s are revealed through this unfolding: a recontextualising of Heidegger's use of 'truth'. These truths hold a subjective value through the unique position of each individual's encounter with immediacy, creating what we will refer to through this book as truth/value within the origin of the artwork. Something that Nigel Stewart describes by quoting Sheets-Johnstone as 'forcetimespace' to acknowledge how one captures in writing the phenomenology of performance (in this context, dance), stating that the 'image reaches fruition only when systematic reflection generates express (poetic or figural) forms of writing and the systematic and expression are combined in consciousness' (2001: 46). Reflections between artist and audience are a shared state of experiential perception that the reader will re/discover through the freedom to encounter the multimodal writing in the subsequent chapters.

1

Embodied Experience

The theoretical notions established in this chapter foreground the importance of perception and experience for the application of phenomenology in the study of performance art. We shall begin by using embodied experience accounted through the memories of the artists who performed the works featured herein. Some of these are also accompanied by accounts from the embodied experience of the spectator in order to introduce the reciprocal relationship that exists between these two positions of immediacy (see introduction).

Perception is fallible; you may recall moments in your life of not noticing a colleague on the bus despite apparently making eye contact, or failing to find your door keys, and after frantically searching for them, you discover they were where you

Exercise 1

Did you know you have an absence in your vision? Look around you now. There is a blind spot, but you are likely to be unaware of it. To discover it, you'll need a black marker pen and some white paper.

Start by making a small black dot with the marker.

About 7 inches to the right of that dot make a plus sign (+) equal in size to the original dot.

Now, with your right eye closed, hold the paper in front of you.

With your open left eye, focus on the plus sign and slowly bring the paper closer to you without shifting your focus.

The dot will eventually vanish from sight.

If you open both eyes that blind spot is still present, but your brain is filling in the absence. Perception is a construct. Eye-tracking software

has observed how the eyes constantly shift through micro-movements in everyday life. Our brain constructs the experience of what we perceive through a neurological process.

Adaptation: Though harder to reproduce without advanced auditory systems, it should be noted that when a sound is briefly interrupted by a silent gap it will be perceived as discontinuous. This was highlighted in the paper by Riecke, Opstal, and Formisano (2008), who also noted that when the gap is filled with noise, the sound may be perceived as continuing through the noise.

left them all along. This construct does not invalidate those experiences but rather makes them more intriguing for phenomenology as we cannot assume universality when encountering any event. Neurological difference through medical condition or disease, age, or dis/ability (physical or unseen) only further enrich the possibilities of perception, which should not be considered as restricted to sight but rather open to all of the senses. The multimodal writing in this chapter and subsequent ones encourage you to explore these 'in-betweens' and invites you to access your reading of them in linear and non-linear approaches. When choosing to do so, note the immediacy of your encounter and how your own embodied experience changes in response to the artworks. In the introduction to her writing, documenting the activity of conscious perception through dance, Anna Pakes wrote,

> The performance, even the [art]work itself, are constituted in the process of being seen, noted, reflected upon, and described. It is a creative account in forming one image [...] out of the available range of perceptual materials, sense data, and linguistic resources at the writer's disposal [...] The experience of [...] performance, as of any object with material existence, is inevitably perspectival: what we see, or otherwise experience is one aspect [...] But this attitude of reflexive awareness in relation to how objects and actions appear could, in principle, be adopted in the face of any performance, once the fact that we see what we see (or otherwise experience what we experience) ceases to be taken for granted.
>
> (2011, 34)

Pakes's account for the immediacy of this reciprocal relationship highlights how we must prioritise our awareness of our embodied encounter with performance as both artist and audience. When Pakes speaks of experience as perspectival reflexive awareness, she validates a multiplicity for variation within any experience.

Thematically the performance art selected in this chapter focuses upon pieces that hold indicative enquiries around identity. Three subsections

across (1) Identity, Sexuality, and Gender, (2) Cultural Contexts, and (3) Health and Dis/Ability, are designed to navigate the artworks, rather than the entire practice of the artists. These are not exclusive fields or frameworks but provide a means of examination, with particular attention to embodiment and disembodiment within the experience of the specified artwork. Each artist was requested to reflect on their position, writing in a phenomenological (sensorially aware) mode. They were also encouraged to write in a secondary mode that would note everything that contributed to this experience and could analytically account as having the potential to activate the phenomenological flesh. Some of this writing is used in the analysis while for others it started the dialogue or interview that is featured.

Flesh, a term coined by Merleau-Ponty (1968), is used to describe the intangible through which the perceptual experience manifests. Michael Lewis and Tanja Staehler remind us that '[a] body is made up of elements, thus inhabiting an intermediate position [...] The style of water [...] is not captured in its chemical formula but concerns the way in which it can undergo consistent transformations from ice to liquid to steam, reserving nevertheless its watery character' (2010: 204). The analogy of the elemental is useful to the definition of flesh as it signposts a sense of permeability and change; of cause and effect, or as Merleau-Ponty notes, an intertwining. If for arguments sake, we took elements of embodiment and disembodiment to be representative of subject and object (aware of the potential for the reverse to be true as well) then it is flesh that sustains both of these dimensions as connected. We perceive a lived body through a flesh that surrounds and permeates space, body, and the experience. This sense of reciprocal intertwining is evident in Merleau-Ponty's *The Visible and the Invisible*:

> [I I]e who sees cannot possess the visible unless he is possessed by it, unless he is of it, unless by principle, according to what is required by the articulation of the look with the things, he is one of the visible, capable by a singular reversal of seeing them – he who is one of them.
>
> (1968: 134–35)

Meaning that perception is only possible because we are part of an intangible flesh; something which arises in-between the visibles. Importantly, visible, and indeed invisible, should be considered as an analogy towards perceiving rather than implying a process locked specifically into the realm of sight. It is therefore plausible that the possibility of bridging the gap between perceiving and being perceived would be inexplicable if it were not already part of the perceptual landscape. This is the basis for connecting the perception of embodied and

disembodied Self/s towards an intersubjectivity or intercorporeality as part of an analogous perceptual landscape of the lived body.

If for argument's sake, we took the perceived embodiment and disembodiment of an artist to be perspectives of (interchanging) subject and object, then it is flesh that sustains the connection of these dimensions. We perceive a lived body through a flesh that surrounds and permeates space, body, and the experience. Perception is only possible because we are part of an intangible flesh; something which arises in-between the *visibles* (Merleau-Ponty 1968). The embodied experiences discussed in this chapter manifest through flesh.

Recalling that the visible and indeed invisible are analogous to perceiving rather than implying a process explicitly locked into the realm of sight, Figure 3 illustrates how flesh exists in the moment of experience between two living subjects or objects.

Figure 3 indicates how gestalt reduces and prioritises an individual element at a time between two positions of perception reciprocally.

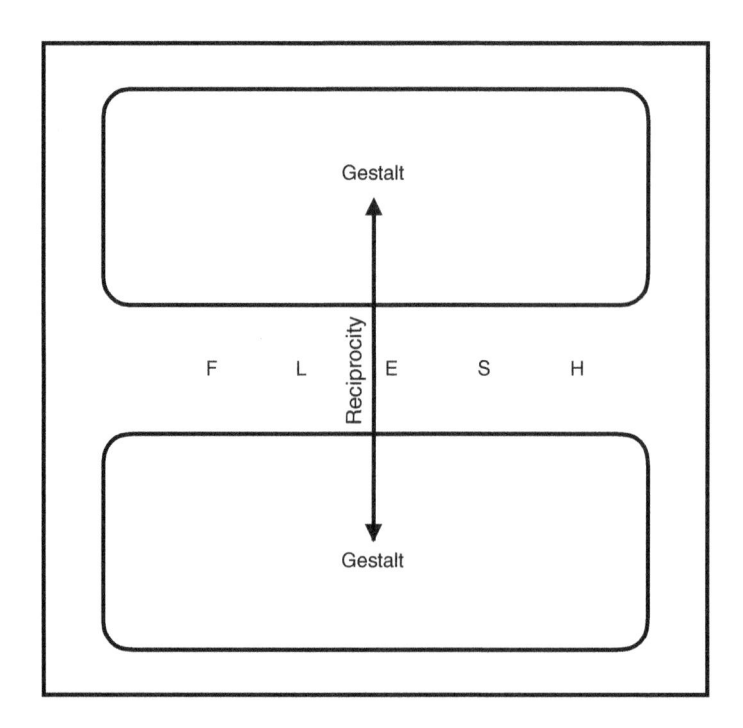

FIGURE 3: A line drawing where a large square contains two rectangles parallel to one another. The two rectangles are connected by a vertical line with arrows at both end to represent a conduit between both positions.

Gestalt is a non-exclusive focal point. Within the theories of perception gestalt acknowledges how various elements make a whole but will focus upon one at the reduction of certain other fields of the perceptual experience by reducing them to the background. This concept was explored by Jean-Paul Sartre (1957) as well as Merleau-Ponty in their thought post 1945.

When speaking of gestalt, it is important to accept that it does not explore the singular at the cost of the whole. Through gestalt, we may ask what makes the whole or even how these parts come to be. It explores, for example, how one element may not exist without the other, hence the indissolubility of the whole.

Flesh allows for reciprocal shifts between points of gestalt in perception (see Chapter 4). Flesh therefore connects: it is not a collection of visible elements but arises in between the ephemeral. This is essential to these phenomenological accounts of performance art. Each qualitatively captures experiences which will further demonstrate how spectator and artist act as positions to perceive (embodied and disembodied) perspectives of Self/s through the flesh of each experience. Usefully, Merleau-Ponty refers us to what he calls his 'old term [...] Element' (1968: 139) to develop the definition of flesh as neither matter nor spirit. Gestalt allows us to acknowledge what makes up the whole Being, while flesh links these elements in a network of relations that are perceptible in their significance. Therefore, these accounts while useful are particularly significant to the immediacy of an experience whenever it occurs.

Supported by the eidetic formula (Bacon 2016) illustrated (see Figure 1), this is not attempting to define specific phenomenological outcomes but rather acknowledge variations in embodied experiences of performance art. Stuart Grant notes that where phenomenology provides 'direct address to questions of politics and language, it [ultimately] aims at a very different level of ontological and existential explication [...] a fundamental-transcendental level of cognition, perception, intersubjectivity and being which would apply to all humans' (2012: 10). Phenomenology, as mentioned in the introduction, is not reductionist or essentialist but rather, in the Husserlian sense, reductive (Hemberg 2006: 5) as it attempts to define the experience of a world as simply as possible. This is distinctly different from discovering a universality for embodied experience. However, the attempt at reducing experience to its sum parts has a relationship to intentionality, and when writing further on phenomenology, Pakes points out that this structural approach lends itself towards 'embodiment and temporality as well as the directedness toward a content (intentionality) characteristic of certain kinds of thinking (perceiving, remembering, and imagining, for example)' (2011: 35). Therefore, a methodology that utilises multimodal writing

retains within its artist-philosophical design an openness towards re/perceiving, re/remembering, and re/imagining the embodied experience of performance art.

Exercise 2

This exercise offers you a suggested methodology to try. However, we encourage you to find a method that ultimately suits you the best. The following are not rules, but when deciding upon your own process, consistency is important to maintain academic rigour! This is one way in which to capture 'experience' through phenomenological accounting:

1. When you know you need to capture a phenomenological account that holds your embodied experience of an artwork, attempt to not be influenced by any documentation, such as photos, video, or sound recordings. The rationale for this is that when media seems to show us something else, we tend to distrust or invalidate our own experience. It is important not to be swayed by such influences, even if your experience lacks the factual accuracy that a film, for example, may otherwise suggest. Therefore, ensure that you do not engage with such documentation before completing the next two steps.

2. Within a set time frame from the end of the encounter (either as performance artist or spectator), write two accounts. The first is a 'factual' narrative of the chronology of everything that happened. Attempt to write this in a style that omits any embellishment or emotive language.

3. The second written account should attempt to capture everything you felt, emotionally and from a sensorial perspective through that same experience.

4. Leave these two accounts to one side for a set period of time – such as 7 to 28 days. This will create the necessary distance (i.e. emotional, spiritual, rational, etc.) needed before rereading them. It is useful when reading to really think about the mis/alignments between the two. Try to make additional notes and responses to those points as well as the absences, the in-betweens, or gaps that may emerge.

5. Now it is time to engage with documentation. How does it in/validate the account? Embrace those in/consistencies. Why do you think they exist? Capture your responses.

These five steps are the basic elements to building a method, but when they cannot be completed in that order for whatever reason, for example, when speaking with an artist they often have witnessed documentation and have

the experiences of others' anecdotes within them, acknowledge this disruption to the process. If surveying others inform them – for example, for steps 2–3 – to provide a written response within a set time period. We suggest 40 minutes per statement, and they should not attempt to prepare with what you may be asking them to do. Their blindness ahead of the questions will enable you to capture a genuine embodied reflection. You want to be able to capture the most immediate response possible; it may be 'inaccurate', but usefully so, as it will be informed by that person in that moment and not altered through the perception or documentation of others.

Adaptation: The method in which the reflection is captured could manifest beyond the written form into audio accounts, text-based live chats, even through the use of sound, abstract noise, image, painting, or drawing. The key is to ensure consistency in your approach to enable a process of comparison between accounts as well as adaptation to your own and others' needs.

Identity, Sexuality, and Gender

In witnessing another, you witness yourself as well. Through notions of identity, we project ourselves in reciprocity with the receiver of the image creating an evolving loop of perception through each immediate encounter of becoming. Indeed, as we orientate ourselves through these experiences, we start to position Self/s in correlation to other Self/s, a placement that resonates with Sara Ahmed exploring how to find your way when she proposes the notion of 'feeling at home' where she states that 'it is important to consider how "finding our way" involves what we could call "homing devices." In a way, we learn what home means, or how we occupy space at home and as home, when we leave home' (2006: 9). Home implies a starting point; we learn what it means when we not only exist within it but also when we are outside of it. Ahmed (2006) writes beautifully on queering this navigation and analysing it through phenomenology. But what this notion of a home provides is a locus, a placement that perception manifests and moves through. Through this we will discover resonances between Self/s and identity, sexuality or gender through the artists in this subsection. It is important here to note the intersection that studies on gender, queering, and sexuality have in correlation to our phenomenological enquiry. From Luce Irigaray to Judith Butler, the complexities have been considered in-depth, while Jones (1998) has built a dialogue for implications towards performance and Ahmed (2006) has connected the field to a queer phenomenology. When introducing an excerpt from Butler's *Gender Trouble: Feminism and the Subversion of Identity* (1990),

Colin Counsell and Laurie Wolf make a significant point for the implication of our study here, suggesting that:

> Butler's theorisation of gender and sexual identity [...] demands a revision of the very philosophical assumptions on which more orthodox views rest [...] [such as] our everyday conception [that] the self is fundamentally dualistic, insisting on the distinction between body & mind and granting the later primacy.
>
> (2001: 72).

Here an essential Self – akin to an essential identity – is revealed through Butler as a fiction (Counsell and Wolf 2001: 72). However, Butler grounds her exploration of gender identity through materialism (i.e. the body and its actions), with consideration for

> the gendered body [as] performative suggest[ing] that it has no ontological status apart from the various acts which constitute its reality [...] In other words, acts and gesture, articulated and enacted desires create the illusion of an interior and organising gender core, an illusion discursively maintained for the purposes of the regulation of sexuality within the obligatory frame of reproductive heterosexuality.
>
> (Counsell and Wolf 2001: 72)

Our application of phenomenology builds upon this by also considering the reciprocal relations; the metaphysical – an often-debated correlation and in/distinction between both phenomenology and metaphysics (Zahavi 2003) – and how phenomenology allows us to consider that such performed identities manifest in relation to the presence of others. This evolution of thought allows the useful application of Butler's notions of performed identity, performed gender, and performed sexuality, but considers it concerning how performance is experienced, manifested, and held between those present.

Co-opting Merleau-Ponty's writing, we can illustrate this further by returning to our eidetic formula (Bacon 2016). We replace Merleau-Ponty's original description of an object with that of a prism. This prism does not represent the body or Being itself, but the moment of action in which the perception of a lived body's presence is oscillating in a catalyst of risk. This is the locus of immediacy with the embodied experience of a multiplicity of Self/s:

> I open my eyes on to [the prism]; and my consciousness is flooded with colours and confused reflections; it is hardly distinguishable from what is offered to it; it spreads out, through its accompanying body, into the spectacle which so far is not a spectacle of anything. Suddenly, I start to focus my eyes on the [prism] which is not there yet, I begin to look into the distance while there is as yet no depth, my body

centres itself on an object which is still only potential, and so disposes its sensitive surfaces to make its present reality. I can thus re-assign to its place in the world the something which was impinging upon me, because I can, by slipping into the future, throw into the immediate past the world's first attack upon my senses, and direct myself towards the determinate object as towards a near future. The act of looking is indivisibly prospective, since the object is the final stage of my process of focusing, and retrospective, since it will present itself as its own appearance, as the 'stimulus', the motive or the prime mover of every process since its beginning.

(2002: 278)

At the heart of this, we find a reciprocal relationship between the perceived and perceiver, causing an embodiment through presence/s upon one another. This is evidenced in Dominic Johnson's interview with Genesis Breyer P-Orridge; a trans/fluid/entity that exists as living art (2003: 67) beyond death. This saw Genesis evolve into a multiplicity of corporeal identities, including holding within their Being a deceased partner, Lady Jaye Breyer P-Orridge, who remained a part of their unified presence/s. They recalled:

Identity is something that begins from the moment you are conceived [...] Before you [are] even [born] there is an influence of relatives you've never met [...] things your parents want to have happen [...] investments in what you're going to be, and it just gets worse from then – school, peer groups, you're a boy so you have to hang out with boys and do boy things.

(2003: 70)

They acknowledged how origins are informed and shared through others, through hegemony, and how for them this can manifest through choice as a Being who remained in constant flux through both the creation and presence of objects, music, and installation and even the mundanity of domestic living (2003: 67). This echoes a similar 'fiction', of a performed gender, raised by Butler but highlights the experiential as part of the process of origin. P-Orridge – who passed away in early 2020 – concluded this interview by confirming this was part of a 'fictional structure' (2003: 70), upon which we are able to recondition 'if you want to rebuild your own identity and write your own story' (2003: 70). This is the 'act of looking' mentioned by Merleau-Ponty (2002: 278) which we can apply through the immediacy of the encounter with performance art: origin begins through one another, which resonates with Ahmed's (2006) 'finding your way' towards a queered perspective.

Exercise 3

Who are you? Using a new notebook, set yourself the task to respond every day at the same time an answer to the question: who am I today?

Be confident in knowing your answers are only for your eyes, you could choose to write or draw but ensure you fill the page.

Remember the question is asking you who you feel you are at that particular moment every day. Try to not to prepare an answer but just give an instant response.

It is ok to be fluidly different every day and if you don't have an answer, try to find a way to express that absence rather than leaving the page blank.

Adaptation: Try this same exercise by drawing a representation of who you are each day. From the figurative to the abstract, don't overthink your illustration, be impulsive.

Lori Baldwin

Artist image 1: *The Villages.* Tempting Failure 2018. Photo: Julia Bauer. Image features the audience member, Linsey Gosper. Website: https:// www.iamloribaldwin.com/ the- villages.

Lori Baldwin's (she/her) *The Villages* sets the conditions through invitation and rules for an intimate encounter between artist and audience. Her programme notes describe it as

> a request, an experiment, a proposal [...] The piece offers an alternative intimacy, that can be experienced in and through a specific frame. *The Villages* explores what happens when BDSM practices are carried out in a public performative setting; when we deal with our bodies as they are in the present.[1]

Embodied Writing

I stood on the stage and I waited … The audience came in slowly, choosing their seats. I practiced holding the space, breathing, inviting being seen. I wasn't sure when I should begin … I took a step towards the microphone and began the introduction text. My voice was shaking a little, … I admitted to being nervous. While delivering the text, I started to undress.

The audience looked at me expectantly, openly, I didn't encounter a bored or dismissive face. I switched into a performer autopilot – I know this piece, I know what I have to do. A lot of it is waiting, patience. Bre athing. At some point the first audience member broke the ice and came to join me. It's a relief. To know that you won't be standing there left hanging; the hardest one is the first one. She slaps me, I'm happy.

The background soundtrack was playing. I don't remember how long I waited for, but I don't think it was very long. People started coming, one after another … Before I reached the halfway point, a woman came on stage, undressed, and stood next to me. It was the first time this has happened in a performance. We slapped each other. She stayed on stage for a very long time.

Contextual Discourse

The gestalt elements of an essential self that we perceive through Baldwin's *The Villages* (2018) straddle the real and the contrived. Baldwin performed this work of violence and consent in a venue complicated in its relationship to alcohol, violence, and domesticity: a theatre above a traditional pub in South London. Baldwin described the work as setting the conditions for an intimate encounter, noting how it explored connections between 'subversive and explicit power dynamics and the physical actions that accompany them (TF 2018). Dialogues arising from BDSM subcultures became immediately entangled in the exchange of this room – in essence a smaller bar above the main pub, complete with red curtains, faux velvet, ornate brass lamp fittings, and a slightly stained red carpet. The venue's resonance towards violence is undoubtedly subjective, possibly offensive to implicate, and reductively could be associated to an archetypical site of alcohol-fuelled domestic

drama. Therefore staging this work here manifestly opened this conversation and began to queer the space around us, as Merleau-Ponty notes,

> If we so contrive it that a subject sees the room in which he is, only through a mirror which reflects it at an angle at 45° to the vertical, the subject at first sees the room 'slantwise'. A man walking about in it seems to lean to one sider as he goes. A piece of cardboard falling down the doorframe looks to be filling it obliquely. The general effect is 'queer'.
>
> (2002: 289)

The flesh of the space began to be queered as much as any action or the individual/group can shift in perspective. Baldwin's incongruity brought forth a dialogue of disruption, queering the control of the space's traditional use away from a patriarchal hegemony towards a BDSM subculture. A space that she incongruously, as a gay woman, began to hold power over. As noted by Ahmed, Merleau-Ponty is not using queer in regard to sexual orientation (2006: 67); there is, however, an etymology in the word to that of space and, '[p]henomenology helps us to consider how sexuality involves ways of inhabiting and being inhabited by space' (2006: 67).

The catalytic effect of risk – a shared investment in our orientation to the action of work - brings forth a gestalt-like focus to the presence of an artist's Being in front of an audience. It is useful when perceiving Baldwin to consider her engagement with risk as a reciprocal conduit; audiences cannot remain passive during *The Villages*, even non-participation while present to the act of the slap opens a dialogue of complicity or repulsion. How Baldwin's Self/s manifest through *The Villages* unfolds through this dialogue. Ahmed notes that 'Judith Butler (1989) offers an essential critique of Merleau-Ponty's model of sexuality by showing how it presumes a general or universal orientation toward the world' (2006: 67). Baldwin's action and shared exposure to risk – equal to the audience's own exposure – destroys an essential self. 'At the same time that we acknowledge this risk of *universalism*, we could queer Merleau-Ponty's 'sensitive body', or even suggest that such a body is queer in its sensitivity 'to all the rest" (2006: 67). Each encounter queers our orientation of the experience at hand; each shifts a shared perception of Baldwin's

Self/s and the participants before us, revealing new Self/s, not only for Baldwin but also for us in our reaction to the changing space and interactions before us.

Series Notes

A performance space is a contrived environment; our investment develops through actively understanding this context with the real risk of performance art before us. Joining Baldwin, as she welcomed the audience into the space and explicitly explained the rules of engagement for what was to follow, we accepted the space she created. Recognising the urgency, oddity, and perhaps awkward incongruity of holding this performance there, we quickly became invested, not only in the emerging story but also in the artistic risk to perform in a heteronormative space. However, the work transcended its contrivances of incongruous staging and developed its own immediately appreciable life.

The artwork created a space where audience members were invited to come on stage and slap Baldwin. It is important to note that she had clearly established the rules of this relationship at the start of the performance. We were allowed to engage with her if we wished and could, with an open palm, slap her anywhere on the body except the face, though we should consent to receive the same reciprocally. As the author of the artwork, Baldwin designed accessibility to invest in the risk of the act to avoid it from becoming derailed – absolute risk and investment that is as urgent to the lived body of the artist as it is to the other and the flux of the flesh through which we combine, what we may refer to as an intercorporeality and intersubjectivity. However, when the performance did nearly derail was during one interaction with a woman who, causing concern to the onlookers, would not leave the stage. Standing before Baldwin, she punched the artist in the chest and slapped her face: she broke the rules! When asked to recall this moment in her phenomenological writing, Baldwin said, 'She slapped me without holding back; I was scared she didn't know her own limits, so I didn't want to slap her too hard. Her energy was reckless and innocent.' As an onlooker it felt in the moment gratuitous; it didn't feel innocent but rather had with it an intent. Could this person have wanted to test the extent of

the invitation that had been given, to defy the rules, or simply break the performance? Maybe she was just confused or didn't understand, but what it did create was an awkwardness, in much the same way as a fight breaking out in a pub might make you want to avert your eyes, perhaps intervene or simply gawk. Though the performance began hesitantly, it was this moment of confrontation, witnessing Baldwin not succumb to failure, but rather foreground our shared investment through her navigation, that allowed the performance to achieve something in our perception of who the artist was. Baldwin's control brought focus; she held the space, affirming her guidance for all present through the situation as action unfolded Self/s.

Anne Bean

Artist image 2: *Duets with 5 Strangers.* Tempting Failure 2016. Photo: Julia Bauer. Image features the stranger, Richard Green.

Anne Bean's (she/her) programme notes extensively detail the origin of *Duets with 5 Strangers* in the following way:

> In the 80's I did a performance at *Chisenhale*, in which I had invited a friend, Chris Miller, artist/philosopher, to interrupt me at an arbitrary point, chosen spontaneously by him, so that the audience would think he was a stranger trying to join in. I wanted the performance to evoke uncertainty in what was actually happening. It provided a rich variety of responses including embarrassment, anger, verbal and physical interventions, disquiet, laughter and puzzlement. I often thought about future strategies to find a way to work with an actual stranger, immediately and in front of an audience.
>
> In early 2016 I asked the first stranger to enter my space, *MoCa* Trowbridge, Richard Green, if he would make a work with me in London at Tempting Failure

Festival later in the year. I said we would not discuss it at all and we would not meet up again until we met on stage. He agreed.

I then asked the organisers at Tempting Failure to invite 2 people who didn't know me as well asking them to invite a random busker. I also asked the artist/ musician Jem Finer to invite a friend, whom I didn't know.

Anne went on to write,

Duets with 5 Strangers is about the making of work. [...] the fear, the anticipation, the focus, the hopes, the hopelessness, the desires, the passion, the absurdity, the perplexity, the reaching, the rawness, the bewilderment, the questioning, the laughter, the connectivity, the buzz, the fizz, the heartfelt, the soulful, the pathetic, the shifts, the drifts, the uplifts, the needs, the drive, the ego, the authentic, the LIVE. I will bring nothing but my own body to the space [...] the material of the work for me will be entirely the stranger ... my awareness of their awareness and sensing their awareness of my awareness ... the focusing, [...] our antennae searching for clues [...] psychically probing each other and outwards into the space of the audience – taking them with us on this unknown flight. I would like the work to grip and stir and disturb and challenge all of us in the space and to create an intense witnessing and engagement by the audience that in turn feeds the participants in this unknowable sharing, [...] this ontological gamboling – this awareness of awareness.[2]

The strangers in order of appearance were:
Lucy Hutson, Dominika, Alex Brenchley, Richard Green, and Robin Bale.

Embodied Writing
I was standing at the back of the stage and waiting for the first person to appear. I recognised that here was someone who was nervous but willing to open up. I was aware that any vague apprehensions of being challenged were changed to a sense of embracing the person, as a Being. We shared some funny moments, and I was in tune with the attempt by both of us to be present to what was happening. The next person had a guitar and seemed at ease, so the performance unfolded into a more musically constructed work but with an underlying sense of opening up personal stories. I was aware that the young violinist who followed was anxious

and at this point I felt that a collaborative work that allowed her to be solo was best, so I tried to step back and encourage that. With the next person appearing from the audience I felt 'at home' in his presence and that an improvisatory relationship would be fully received, sonically and otherwise. The last participant was the one who made me wonder many times if I had set up inevitably an imbalanced situation in which the other person was struggling, and a great sense of caring overcame me.

I went through many emotions during this performance. I hadn't expected to feel as though I should put people at their ease rather than challenging them. I had presumed that anyone accepting this situation would be tough and, in some way, combative but this wasn't the case, so it went to a much more human level, an existential place of frail ab surdity. It was complex in that I felt I was holding onto not allowing myself a certain heightened letting go except at moments, as I felt an unanticipated sense of responsibility to people as vulnerable human beings. This tenderness that I mentioned before, actually was very com forting and any expected abrasiveness was hardly present.

I see my body as material [...], I am very aware of my body as flesh and asking what is it that directs this flesh to be writing this – the fingers dancing on the keyboard seem out of body – almost of their own volition while another layer remains a voyeur, semi-paralysed in wanting to change all that has been written, seeing it all as only the symptoms of event [...] longing to capture more accurately, more pristinely the onslaught of and contradictions of, memory [...] as consciousness is harnessed to flesh.

Contextual Discourse
Writing in *The Visible and the Invisible*, Merleau-Ponty described flesh as not matter, mind, or substance, but rather

> to designate it, we should need the old term 'element', in the sense it was used to speak of water, air, earth and fire, that is, in the sense of a general thing, midway between a spatio-temporal individual and the idea, a sort of incarnate principal that brings a style of being wherever there is a fragment of being. The flesh is, in this sense an 'element' of Being.
> (1968: 139)

Flesh is therefore intangible. It facilitates an intercorporeality vital to perception between any Being (see Chapter 3). This intercorporeality is beyond sight, allowing for reciprocity to take place between any lived body, through element or action, to expand the potential of what may be experienced by any given perceiver. So, when conducting a second interview with Anne Bean on her performance of *Duets with 5 Strangers* (2016) it was apt that she spoke experientially of finding herself through another, saying 'as soon as the first person came out [on stage] [...] I jumped from inside myself to inside them and actually that was very disturbing'. Moving beyond the paradoxical implications of a single Being (as a receptor) who may touch her own hands, Bean could, therefore, be considered through the following analogy by Merleau-Ponty.

> If my left hand can touch my right hand while it palpates the tangibles; can touch it touching, can turn its palpation back upon it, why, when touching the hand of another would I not touch it in the same power to espouse the things that I have touched in my own?
>
> (1968: 141)

Transposing the idea of touching to any form of 'touch' as physical, elemental, sensorial, or emotional, between multiple Beings, Bean's performance illustrates further how perception resonates and fluctuates in strength between the giver and the perceiver. Anne Bean performed through five encounters without preparation or knowledge of who would be presented before her. Chaos and chance are in a disorientating flux in all of Bean's work: expanding a becoming from without within, where the notion of the interior and exterior experience of presence/s become merged. As Bean says, in *Self Etc.* when interviewed about this performance, '[w]e are each other's archives and legacies' (2018: 179). Flesh does not hegemonically order the delivery of artists' perceived presence/s to the audience but instead is an intangible conduit, offering means to access perception beyond sight and in reciprocation between the unique position of the artist and the unique position of the spectator. Position implies inclusivity of, and yet beyond, spatiotemporal or proxemic dynamics for each Being. Indeed, as Jones explicates, our position through flesh 'enacts or performs or instantiates the embodiment and intertwining of self and other' (1998: 38). While Merleau-Ponty reminds us that our position in flesh acts

[a]s the formative medium of the object and the subject, it is not the atom of being, the hard in itself that resides in a unique place and moment: one can indeed say of my body that it is not *elsewhere*, but one cannot say that it is *here or now* in the sense that the objects are; and yet my vision does not soar over them, it is not the being that is wholly knowing, for it has its own inertia, its ties.

(1968: 147).

So when considering the interaction between Bean and her five strangers, flesh should not be considered as having mass or a specific space to fill but rather as part of a reciprocal conduit or *element* as Merleau-Ponty prefers to refer to it, that imbues us, as much as the world in which they/we inhabited. Bean held this through chance and the risk of failure 'aware that any vague apprehensions of being challenged were changed to a sense of embracing the person, as a Being'. She allowed the moment/s to exist, no matter what, which is how flesh becomes vital to the phenomenological exchange between everything in the world and why it allows us to perceive a multiplicity of Self/s in action both through intercorporeality and intersubjectivity.

Series Notes

A sense of reciprocity evolved our perception of Self/s through the flesh of the environment, Bean, and her accompanying artist/s, as well as our position as audience, invested in the experimental construct of the action. Bean recalls feeling a sense of responsibility for the other artist in each encounter, 'seeing me through that other person's eyes'.

Intersubjectivity was originated in the writing of Edmund Husserl, and in the most simplistic sense it acts as a bridge to objectivity, where the experiential may be held across multiple subjects, the other, or even things. Self/s can be found across multiple points and objects, even artefacts. An easy way to conceptualise this is to visualise how we may account for the presence/s of another when witnessing the impression of footsteps left in the snow.

Intercorporeality was proposed by Merleau-Ponty as a means to expand the Husserlian notion of intersubjectivity further via a complimentary concept rather than a replacement. In its most simplistic sense, intercorporeality acts as a bridge to subjectivity, where corporeal presence/s merge between one's own body and that of the other. Intercorporeality contains a perception-action loop between multiple Beings, whereby felt responses, experiences, memories, senses manifest through one another. The easiest way to introduce this concept is to recall the infectious nature of yawning among people.

Series Note

The flesh of the temporal moment holds the intangible intercorporeality and intersubjectivity that may exist through an osmosis of perception via these subjects, space, and other. When watching Bean actively work to perform with the other five artists as strangers live before an audience, there was the usual mix of responses one would expect, from being awkwardly nervous to overconfident, humorous, or challenging. The performance had been promoted as a 'strategy towards incising biopsies of consciousness' (TF 2016) however, there was one encounter that was curious in its complete collapse. It was with Richard Green and he is documented by Bean as saying,

> The only rule I gave myself in the performance was that I was not going to speak. I had the piano to speak through, if necessary. My reason for this is I believe I have a second self who is betrayed every time I open my mouth. He is a troubled, unhappy child, desperate to be heard, but with no words. I wanted to give him the stage, it seemed like the ideal setup, as you made such a generous open-ended offer in the performance criteria … I had found myself in a rather stuck, catatonic state, which rather limited my options, but if I had been a more experienced performer, I might still have found a way to initiate more (albeit probably hostile) interaction with you on stage. I don't regret that, but it could be said the performance was perfect just as it was. A vignette, which stays with me, and maybe the audience too. … It was a challenge for me to stay away from language, intensely uncomfortable, but it opened a door for me. This is where I need to go – although I shouldn't need a stage for that.
>
> (Bean 2016)

His break in the flow of the performance looked ostensibly defiant to holding the moment with Bean, yet his turmoil was becoming exposed.

Bean said he 'was the one who made me wonder many times if I had set up inevitably an imbalanced situation, in which the other person was struggling.' However, his decision to allow a particular side of himself to lead the interaction was not disenfranchisement nor a panic attack, but rather the complete and utter exposure to the potential to fail rather than lead. In our follow up interview, Bean said this,

> [H]is main concern was not to enter a knowable space for himself, but it [...] put himself in a real jangled space, where if you want to go into unknowability and you want to stay at present time, you're almost stifled, you're almost frozen. Every movement becomes; where's it coming from, what's directing it? If I played this note on a piano, what made that happen? Everything gets so questioned that you are sort of having a mini breakdown because you're unable to structure thought at that moment.

Everything in these moments between Green and Bean became agitated. The very biopsy that Bean had allowed the space to create provided the catalyst required to expose Self/s through flesh 'an ultimate notion, that [...] is not the union or compound of two substances, but thinkable by itself' (Merleau-Ponty on flesh 1968: 140). This does not imply an omnipotent force but rather a shared reciprocal space, an 'inter-corporeity' (1968: 141) as the audience and artists perceive together and create a shared psychogenic landscape. So, when we witness an unfolding risk, where seemingly the entire performance may fail before us, where two artists come together in the moment, and one of them evidently begins to break, this breach of the status quo opens up our reception to the judgement of that experience. Bean most recently said of this moment that 'even though we've had these lengthy conversations, I think it's still almost unknowable to both of us what happened'. As Ahmed notes, 'moments of disorientation are vital. They are bodily experiences that throw the world up, or throw the body from its ground' (2006: 157). Phenomenology allows consideration of the evolution of these experiences after the event (Kozel 2007), but it is through the moment and into the future that lends itself towards the perception of an expanding possibility for a multiplicity of Self/s. 'Disorientation could be described here as the "becoming oblique" of the world, a becoming that is at once interior and exterior, as that which is given, or as that which gives what is given its new angle' (Ahmed 2006: 162) as Being continues to be queered or be queer through immediacy of the experiential.

Rosana Cade and Will Dickie

Artist image 3: *The Origin of the World*. Tempting Failure 2016. Photo: Julia Bauer.

Rosana Cade (they/them) and Will Dickie (he/him) created a 24-hour performance installation. The programme notes for the piece inform us as follows:

> [T]he performance takes place in a fully turfed room that has echoes of both a spiritual sanctuary and a scientific lab. Sound, light and video technology emerge from the earth. Two live tortoises roam freely across the floor. Audiences remove their shoes, carefully enter the space and take a seat on the lush grass. A man sits looking towards the projected image of the vulva surrounded by his DJ and LX equipment, slowly rotating a small shaky egg. He receives messages from a female voice which guide his selection. At times he becomes immersed in the sound, creating rich atmospheres of loops, effects and textures.
>
> A woman sits behind the man. Their eyes never meet. She holds the space. She is in communication with the tortoises. They control what happens next. She

41

manipulates her lip syncing labia to the sound, voices and musics. The atmosphere shifts regularly from humour and hysteria, to a quieter more thoughtful place.

The breadth of thought, extreme duration, cyclical structure, repetition, and magnified imagery creates a non-linear experience of time. In that space deeper thoughts are provoked and given room for contemplation. We are attending to our contemporary relationship with the planet. By presenting the vulva as mouth piece and oracle, we are confronting the ceaseless desires of our male dominator culture to measure and control nature, to create order out of chaos. Those tensions are framed with a feminist perspective through the confrontation of the wet, unpredictable, and fleshy reality of the human body.

Taking the vulva as object of meditation reimagines what that body part signifies. This work is not about sex. It is about the unimagined beauty that manifests when we look back to the unseen spaces of our origins and home.[3]

Embodied Writing

Cade: Before halfway, I think most audience members in the room were asleep and I could hear a lot of snoring, and I was just struggling so hard to stay awake […] My back was sore, every bit of my body [was] resisting […] I don't know if there's just this one part of me that actually doesn't want to fail, but I think what happens in a space is that something will shift, something will suddenly become interesting again [… In this performance] maybe one of the tortoises would start moving or […a] text might just take us somewhere else […] I'm not in my body and my mind is trying to absolutely resist everything…

Dickie: Edges of sleep. Wonder. Dizziness. Determination. Excitement. Boredom. Paranoia … Confusion.

Cade: I have no idea like how long we had slowed down Om's with the vagina; that's the time when I think I just became a bit lost in the image, space and environment. […] something happened where the whole piece had shifted, it hadn't been planned but it's just what happened.

Contextual Discourse

As previously reconciled, we may *subjectify* or objectify the perception of an essential Self through the conduit of the encounter (i.e. through space/place/aesthetic/other). *The Origin of the World* (2016) was a 24-hour durational piece by Rosana Cade and Will Dickie. They described it in their own joint words as a

> Performance experiment involving labia lip syncing to male voices explaining the beginning of life and time. Through repetition, cyclical rituals and giant images of a talking vulva, the performance is a queering of the idea of origin and linearity, and an undermining of patriarchal creation narratives.
>
> (TF 2016)

We shall interpret their shared experience towards a dis/assembled body as symbolic of Korper and Leib.

Korper means 'physical body' (categorisation) and **Leib** means 'living body' (lived experience). They allow us to build upon the theories of gestalt and flesh, alongside the embodied and disembodied elements that form Self/s. As Drew Leder writes, 'Cartesianism tends to entrap the human body in the image of Korper, treating it as one instance of the general class of physical things. Yet the body understood as Leib [...] reveals deeper significance of corporeality as generative principal' (1990: 5).

For Merleau-Ponty (2002), writing in his *The Phenomenology of Perception*, Korper was an interpretation of the body reduced to an organism that simply exists and nothing more. Leib posits the body as a knowing essence with a soul of sorts, here there was a spilt between the two, even though they were both related to the same Being (Figure 4), though Leib, like psychoanalytic or postmodern notions of identity/subject, can be arguably displaced or disembodied. Leder, writing in *The Absent Body*, explicates this further, exploring how for the lived body, the (embodied) Self could be viewed through an integration of Korper and Leib combined if 'the body is restricted to its casual-physicalistic description, those aspects of self, involving cognition and intentionality are commonly relegated to a substance called "mind." [...] Yet this [division] is precisely what the concept of the lived body subverts' (1990: 5).

Leder felt that a Korper interpretation of the body reduced it to its basic classification, whereas Leib considers the body to be an entity which experiences itself and its environment, sharing some similarities with the Heideggerian definition of Dasein. However, Leder moved from the split of interpreting the body via one or another and instead proposed that the Korper body became an aspect of Leib bodily experience (Leder 1990: 6), stating that '[i]f the body as lived structure is a locus of experience, then one need not ascribe this capability to a decorporealised mind' (1990: 5). This supports the intention that the singular Being of a lived body includes aspects of both being-in-the-world and being-towards-the-world, and can reciprocally hold Self/s, both embodied and disembodied.

Contextual Discourse
Cade and Dickie offer a manifestation of a Korper/Leib symbiosis, open to our interpretation, unifying two presences in the form of one metaphorical body. This Leib-like essence provides audiences with a sense of harmony. The de/constructive nature of the action of this durational performance highlights how these manifest through a plural presence: two Korper bodies.

As their presence/s perceptibly break away, merge, and mutate over the 24 hours through one another, so do the receptors of other; the flesh of the space reciprocates or conflicts with the actions of these person/s performing. A multiplicity of Self/s is perceived through witnessing, not only from audience as other, but through the performers as other to one another. Self/s exist simultaneously, not in hierarchy but rather through reciprocity and flux. The risk from the extended duration may cause a catalytic shift in the perception of these. Cade and Dickie enacted a ritual of chance: randomised repetition of cyclical sequencing for 24 hours. Cade's labia lip-sync of patriarchal dialogues, mixed by Dickie, created a stark commentary. Beyond the physically apparent gender divide, the performers shared an ontology, yet their bodies held a history within them that is starkly different. Recalling Ahmed, though reading them as individuals, 'It is interesting to speculate what Judith Butler might mean by "the field of heterosexual objects." How would such objects come into view through acts of foreclosure?' (2006: 87). In their calm encounter, attempting to hold the performative space under the immense pressure of action and duration, they relied upon one another; they invested through an intracorporeal stasis, sharing not only something of

each other in what they created but the experience as a whole, echoing Ahmed's further reflections on Butler,

> We might consider the significance of the term 'field.' A field can be defined as an open or cleared ground. A field of objects would hence refer to how certain objects are made available by clearing, through the delimitation of space, as a space for some things rather than others, where 'things' might include actions ('doing things'). Heterosexuality in a way becomes a field, a space that gives ground to, or even grounds, heterosexual action through the renunciation of what it is not, and also by the production of what 'it is'.
>
> (2006: 87)

The small turfed room was alive through the action, creating a humidity of breathing, living, plants, animals and humans: the flesh was palpable in which Cade and Dickie sat, while a tortoise wandered freely; cut vegetables were strewn around to feed it , while a projector filled a wall with the image of Cade's lips and dialogues of emancipation were corrupted by the sermonising words of patriarchal voices – a field through which the traditional heteronormative hegemony of their language was challenged. The intersubjective nature this space created, touched all who were present, as everyone there contributed to the energy it held.

Series Notes
This queered space shared Self/s: embodied and disembodied. It was the most unique environment we have ever encountered in performance. A place that was at once tranquil and exhausting, not only through the duration of the act but also in the narcissistic, conceited and obnoxious language that Cade had to subvert through their own syncing while simultaneously holding a space that could become cleansing; filled with the sweet smell of grass, the tonality of frequency from Dickie, and at times an escape – a place where through the twilight hours of 1 a.m. to 4 a.m. people escaped to sleep while Cade and Dickie continued to perform. Cade said of this, 'That experience of really coming up against such barriers was one of the most overwhelming, the most overriding things that

I remember about the whole experience and that was quite amazing, regardless of the content of work.' They shared a multiplicity beyond this, that in the moment of performative encounter – an artifice, where we stand before others to share something of ourselves; our happiest or darkest moments, our secrets, our lies, our desires and failures – we see everybody's reaction to encountering an experience at risk of failing.

Beyond the fatigue of emotive, physical and psychological risk caused by duration, we complicitly bore witness to the transgressive nature of the ritual, attempting not to fail. Cade even recalled the sense of 'being in the middle of this room with all these people looking and thinking everyone thought it was shit'. This was not the case, but subjective perception may twist our encounters within each experience. In fact, the work held a 'reality' of truth through action. Its authenticity was as beautiful as it was desperate – a response to the suffocation of the patriarchy and a desire to keep surviving.

In a subsequent conversation, Cade recalled how the twentieth-hour-induced paranoia and hallucination took hold, noting the 'reality' of the moment when a close friend left the space after apparently speaking ill of the work in the presence of Cade and Dickie.

> I really went on a rant in my head. [Post-Performance] it was one of the first things I said to Ivor [Cade's partner], 'I'm really pissed off with her ... she was just there just slagging it off, while I'm exhausted in this thing.' To which Ivor said, 'No she loved it! We've talked about it. She loves the work!'

A separation, removed from the experience of others, Cade's internalised commentary demonstrates how perception is a manifestation of 'reality', which was echoed in the performance itself, as misogynistic language is juxtaposed with mediated images. Here the complicity of violence upon the female body as an object is exposed and the performance artists give of themselves, their Self/s, to act as the conduit for each witness. As Merleau-Ponty speculated, 'I will never see my own retinas' (1968: 146), and in this same way, the individual (artist or audience) will never perceive their own presence of Self/s fully, as each multiple (of what was once an essential Self) is encountered through the 'reciprocal insertion and intertwining of one in the other' (1968: 146). Through an intercorporeality and intersubjective reciprocity of flesh, world, and other, each Self/s perceived is unique and in the Being of the receptor

as much, if not arguably more, than the mind/presence (Dasein) of the originator (i.e. Being performing, or spectator viewing).

World and **Being** are used by various phenomenological philosophers with subtle variation. They can, however, universally be considered to essentially locate our studies of perception in a single given place. For Edmund Husserl (1931), under whom Heidegger studied, world was not just a binary list of collected entities but, like an encyclopaedia or thesaurus, it designated relations or references, giving context to its beings and subjects. For Husserl, we find ourselves existing within this context; we do not bring it about, but we do give meaning to it. For Heidegger, Dasein must exist within its world, a system of references that constitutes a place for Being within them. Here, in order to have an individual way of being, things, including Dasein, need to be part of an interrelated totality and be differentiated from all else within a given world. For Heidegger (1926), this structure allowed for an individual thing/Dasein to be perceived in a context. He addressed the particular case of Dasein, conscious of itself in the world, and wrote,

> That wherein Dasein already understands itself in this way is always something with which it is primordially familiar. This familiarity with the world does not necessarily require that the relations which are constitutive for the world-as-world should theoretically be transparent. However, the possibility of giving these relations an explicit ontological-existential interpretation, is grounded in this familiarity with the world; and this familiarity, in turn, is constitutive for Dasein, and goes to make Dasein's understanding of Being.
> (Heidegger 1926: 119)

It is important to note that there can be multiple worlds, for example, a performer exists in a performance world or what for now we can assume to be an aesthetic field. These worlds are defined as singularly complete in order for Heidegger's early definition of Dasein to work; they are, being-in-the-world (e.g. the aesthetic of a ballerina performing a *pas de deux* belongs to the world of ballet). Merleau-Ponty, whose influences alongside Heidegger included Husserl, felt phenomenology must evolve from merely being-in-the-world. He recognised that even though we seek to continuously make sense of the world, there is a paradox at play in the very nature of our world itself: that of living change and shifting contemporary

thought. Merleau-Ponty felt that the world can never be fully brought to conscious immanence or transparency (Taylor Carman 1999). There is always an excess to that which can be visibly perceived, a remainder of the unintelligible that cannot be accounted for. Therefore, in starting to address this (though not resolving it), world for Merleau-Ponty (1945) holds all that we can perceive (seen and unseen). Our existence, in this sense, becomes disclosed as being-towards-the-world.

This realignment shifts from the certainty that saw Heidegger's Dasein as the centre of its private world experience and moves towards an exploration of how we perceive in order to discover Being, not only our own, but others as well. This does not mean that Merleau-Ponty abandoned the phenomenological concept of world as a context of references in order to replace it solely with a totality of perceivable objects, but rather that he saw it as a meaningful way to reference between subject and object as part of the whole experience.

Each world is not fully transparent, and so to be understood or defined we must acknowledge that it metaphorically harbours opacity, resistance and shadows (i.e. the unseen, unknown or undefined). Therefore, it is our experience of existence, or Being within it, that creates a transcendence of perception-toward-the-world. This shift can be understood in simpler terms, using an astronomy analogy of the understanding of Earth's evolving position in our solar system: Heidegger's assumptions are akin to thinking that world places Dasein at its centre (i.e. the Sun revolving around the important Earth), while Merleau-Ponty alters this placement and we move from being-in-the-world to being-towards-the-world (i.e. the Earth's significance in the solar system, while still vital, shifts as we now find that in fact we are one of many orbiting satellites in the solar system). Similarly, one could still assert that Dasein is at the centre of what it perceives, but that its important significance has altered; Dasein is now reciprocally open to a subjective, perhaps embodied, or intersubjective perception/awareness.

Series Notes

Flesh in the context of this performance holds an intangible intercorporeality and intersubjectivity that exists through a reciprocal osmosis of perception via subject, space and other. Flesh is the unseen element through which perception of presence evolves. However 'flesh is an ultimate notion, that [...] is not the union or compound of two substances, but thinkable by itself.' (Merleau-Ponty 1968: 140). This does not imply an omnipotent force but rather a shared reciprocal space, an 'inter-corporeity' (1968: 141) as the

> minds of many perceive together and create a sense of shared landscape. This shared landscape was the phenomenological world within Cade and Dickie's *The Origin of the World*. However, this is not designing a shared consciousness either, as the result would be futilely reductive rather than expansive. The world here is the one where we discover elements of the other through being-towards-the-world.

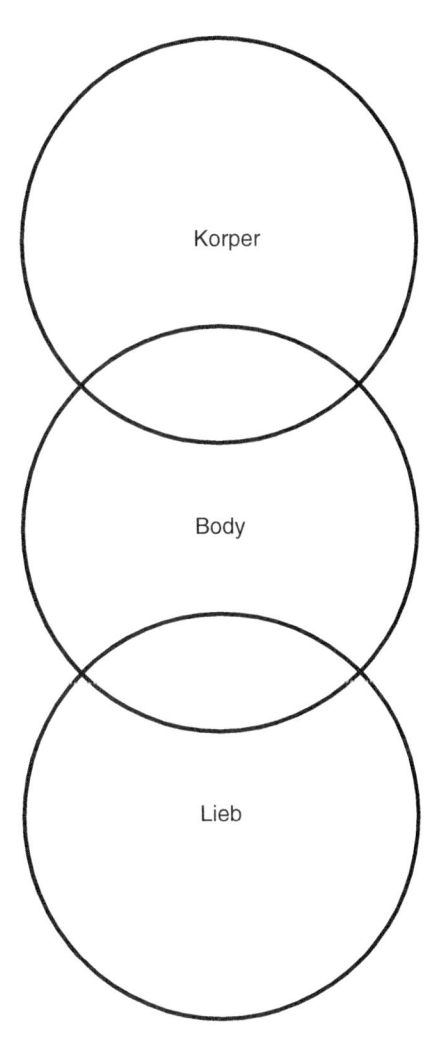

FIGURE 4: A line drawing of three overlapping circles stacked vertically to consider how the middle circle is connected to both but the outer circles can only be connected through their relationship to the middle circle.

How our experiences create a psychogenic landscape, how they are witnessed, influence or conflict one another is unpredictable, but by enacting a presence that discovers itself through relationship to others in *The Origin of the World*, we can acknowledge minutia variation upon Self/s perception. Through Leder (1990) we are reminded that Korper may become an aspect of Leib experience. Each evolves though risk, as their unified presence blurs together, so through a shared state/action, a Korper (perhaps intersubjective) body is imbued with a Leib sense of shared awareness. Variation in accounts between Cade and Dickie or our own experiences as viewers demonstrates this fluidity of flux for Korper/Leib as illustrated in Figure 4.

Relief. Confusion. Affection. Tiredness.

(Will Dickie on *The Origin of the World*)

Esther Marveta Neff

Artist image 4: *The Scraping Shape of the Socially Cyclomythic Womb.* Tempting Failure 2016. Photo: Julia Bauer.

Esther Marveta Neff (they/them) utilises their programme notes to simply describe the materials and action as follows: 'Cut-out plywood uterus shape with assistance of two audience members + jigsaw. Failed sewing, postcards, thread. Attached tattoo needle to cervical end. Contraption rocked against the abdomen to tattoo teardrop shape by audience.'[4]

Embodied Writing

tjb: I wanted to start by asking you a little more about your use of a 'creation/making' process within this work. It felt extremely open and

generous, which imbued the space with a sense of 'becoming' and was very fluid for the communal encounter.

Neff: I think this is something we [performance artists] address a lot, in terms of what is planned beforehand or intended as an aspect of perceived authorship/authority and what can be left open. This echoes conceptions in anthropology of the raw versus the cooked. [...] but I think I am more interested in embedded relationality which really pertains to your (Bacon 2016) work and also the concepts behind Tempting Failure (as a methodological intention). That there is this third option, 'between' or as phenomenal synthesis (Hegel 1976) to closed or open controlled or chaotic ordered/disordered, subjective objective [positions] that may be embodied as processes of (p)articulation. That acts and processes are socially substantiated through particular articulations

tjb: The in-betweens are really fascinating.

Neff: Yes, some think about this as transcendent in some sort of way, others think about it as 'theatrical'. I guess I sort of lean towards theatrical because of my background and obsession with language [...]

tjb: Do you see this process as pulling apart, questioning or challenging, or as fusing and finding symbiosis?

Neff: I think it's both and that is pretty much what performance feels like (from within it). But to what extent do we choose what/how to pull apart and how/what to fuse/find?

tjb: It's a language we find ourselves often within, contemplating the paradoxes.

Neff: Indeed! There are affects and consequences to each deliberated (included/excluded or invested/ignored) elements of language: memes and symbols as well as recognised emotions, perceptions and sensation. We are sort of (de)liberating as we perform and thereby acts and actions are materialised.

tjb: The trance state of your performance felt like this shared crescendo. The material of space was created, the tools were created, and the chanting created alltogether. An 'elevating' manifested as we communally tattooed you, impregnating your body with the ink. It was like nothing I have felt before in a work.

Neff: Wow thank you! I had planned to do the group chanting as it is a pretty regular element of my work but thought I would need the tapes to remind myself of time. I have a very poor sense of time passing inside

a performance, so tapes are kind of a temporal crutch that it turned out we didn't really need. I haven't used any (tapes) since.

tjb: You mention in your accounts an awareness of time but also a loss – I think you used the phrase blacking out. Could you unpick that a little more?

Neff: Yeah! This really scares me! Does it ever happen to you? I think it might be a brain thing (whatever 'brain thing' means) like perhaps [neurologically] the situation [is read] as somehow traumatic and trying to preserve [oneself] … for example, during a car accident, rape, or the like … but it's strange because in no way do I experience performing as frightening or bad and it's not quite the same as a 'trance' state in which some slight astral projection or alternate lucidity might materialise.

tjb: Perhaps it is the intensity, in how 'present' our bodies become?

Neff: Yes, it could be like an eclipse of consciousness. Does it happen to you though?

tjb: Yes, time feels more like it folds […] there are acute sharp moments that feel very burnt into recollection, but also a sense of phasing. I was asked about trance by a student doing research last year, who was very into Modern Primitive (Juno and Vale 1989) notions, and I found it quite difficult to respond to as there are undoubtedly moments of transcendence for the body but also a need to disrupt that, to be as present as possible – to exist on the knife edge.

Neff: Yes, the spiritualist or essentialist lens on this can be perhaps clouding (a notion of being above, below or beyond seems like an additional interpretation that bears other modes of interrogation) while being 'more so here and now' can perhaps allow not just internal experience, but also the entanglement of ontological perception with intraconsciousness.

Contextual Discourse
When Esther Marveta Neff performed *The Scraping Shape of the Socially Cyclomythic Womb* (2016), they created a uniquely inclusive, nurturing and growing space for all present, moving spectators beyond the role of a passive audience to an embodied position of participation. Position implying inclusivity of, and yet beyond, spatiotemporal or proxemic

dynamics for each Being. Indeed, as Amelia Jones explicates regarding body art, our position through flesh 'enacts or performs or instantiates the embodiment and intertwining of self and other' (1998: 38). Neff described this artwork as assembling '[u]nsubstantiated perceptions, reclaiming parallels between menstrual cycles and abilities to communicate, transfer, and share sensual, mental, and somatic phenomena in order to dissemble essentialist and pathologizing notions of womanhood and madness'(TF 2016). Neff surrounded the space with photos, sawing into MDF chipboard to manufacture what would become a huge ovarium shaped hand-poke tattoo device to be held by the audience as we guided a needle into Neff's torso, tattooing their skin together through rhythm, chant and song. The actions offered an immediate exposure of the artist's biography without being explicit, but what it uniquely created was a space that generated a heady, sometimes disorientating presence of becoming, resonating with Ahmed's words on the non-residency of queer,

> As I have suggested, for bodies that are out of place, in the spaces in which they gather, the experience can be disorientating. You can feel oblique, after all. You can feel odd, even disturbed. Experiences of migration, or of becoming estranged from the contours of life at home, can take form.
>
> (2006: 170)

Through the flesh of the space held by Neff and our participation in reciprocity, we are at once lost and found.

Reciprocity is often referred to in phenomenological terms. For example, as flesh permeates and surrounds not only each Being but also their worlds, there is a need for reciprocity in all aspects of interrelatedness. Conceptual reciprocity is easily overlooked in regard to its significance, but it is central to all eidetic reductions in phenomenology for Merleau-Ponty who wrote thus: 'There is a "reciprocal insertion and intertwining" of the seeing body in the visible body: we are both subject and object simultaneously and our 'flesh' merges with the flesh that is the world' (1968: 138). Highlighting the need for reciprocity through the experience of perception, Merleau-Ponty later notes where existence begins and ends for a presence is without limit. Considering gestalt and reciprocity through flesh, the perception

of the lived body through a 'reciprocal insertion and intertwining' (1968: 138) of perspectives of perception holds more than an essential Self, as an artist's presence 'merges with the flesh that is the world' (1968: 138). Drawing upon the potential intersubjective and intercorporeal nature of Self/s, there must be an acknowledgement for reciprocity as any Being or object is permeated by the world in which it exists and is affected by a multiplicity of perspectives of perception.

Contextual Discourse

As we gathered to hold the wood to collectively hand-prick Neff's skin, Ahmed's words resonate with the encounter: 'At the same time, it is the proximity of bodies that produces disorientating effects, which, as it were, "disturb" the picture, or the objects that gather [... around] the shared object' (2006: 170). Through the chanting and singing we found an encounter with bitter absurdity and hilarity as a giant deformed-ovarian device made of synthetic 'wood' (composed of compressed fibres) culminated in the tiniest needle. A prick that we ritualistically swayed collectively into the body of another human, intervening into their subjectivity, and reciprocally objectifying them as both meat and mother.

Series Notes

Flesh does not hegemonically order the delivery of a perceived presence from the body of the artist to the eyes of the audience, but instead is an intangible conduit, offering means to access perception beyond sight and in reciprocation between the unique position of the artist and the unique position of the spectator. While Merleau-Ponty reminds us that our position in flesh acts

> [a]s the formative medium of the object and the subject, it is not the atom of being, the hard in itself that resides in a unique place and moment: one can indeed say of my body that it is not *elsewhere*, but one cannot say that it is *here* or *now* in the sense that the objects are; and yet my vision does not soar over them, it is not the being that is wholly knowing, for it has its own inertia, its ties.
>
> (1968: 147, original emphasis)

Flesh should therefore not be considered as having mass or a specific space to fill but rather as part of a reciprocal conduit, or *element* as Merleau-Ponty refers to it, that imbues us, as much as the world. A world that unlike any other performance action we have experienced in recent years, *The Scraping Shape of the Socially Cyclomythic Womb* created a poignant and sublime sense of re/birth in its ritual, as discussed in our subsequent conversation with Neff, revisiting our memories of the artwork:

Neff: I really like Karen Barad's (2007) conceptions of fleshing [...] that meaning-making and matter-making (materialisation) are arrays of processes [...] The flesh is some-thing already. I'm not as keen on the vibrant matter extrapolations.

tjb: This for me was material – ephemeral and tangible – but more than that, as we essentially went beyond witnessing you; we were witnessing the experience of us all together.

Neff: How together and not together something is, diffracts materiality though. I feel some trepidation towards holistic/unifying/essentialising frames [...] because of their sociopolitical implications. I think maybe we feel an infinity/affinity of (p)articulations, but not in terms of a coherent experience-object.

tjb: Certainly, but in terms of embodied experience – where you could have been witnessed as a central figure – it felt far more inclusive and democratic (perhaps reciprocal is a better word).

Neff: Yes, we each have our own experiences regardless of [de]hierarchisation, [de]authorisation and [de]spatialisation arrangements. I think it's a good question (certainly one that interests me as a form of research-as-performance). Does shared action/task make our matter-and-meaning processes more similar/shared? Are there forms of realisation which occur when movements are collectively embodied? Which, for example, are not possible when bodies are embodied more discretely.

tjb: Absolutely!

Neff: The question simply would just be, how is becoming a collective, embodiment? And it is sort of ridiculous though too because we can only answer to it through performances, which happen one time [...] What can be concluded from any single performance? I really love it that you're writing on these 'experiential traces', both empiric and non.

tjb: Originally my inclination was going to be to ask more about the origins of the work ... But now because of our collectivity, does it render the origin moot: is the loci of being present, actually more important?

Neff: Well, contextual origins probably can't be moot ... emphasis on presence is probably not a categorical imperative especially if it excludes semiotic dialectics of course because we are located bodies, we are never historically or politically neutral like, 'whiteness' is an element of materialisation even if it's not directly recognised by me or any other present body/bodily (in a performance by me, or you, say), and because we do set up situations, scores, processes, actions and tasks that are rooted in context, significance, past experience, cultural identity and so forth, you could probably argue that my performance is owed (in some causal manner) to my childhood on an organic farm home school by a lesbian mum and surrounded by hippies or whatever aspect is remembered of one's past [...] For the proposal I said this was owed to my miscarriages ... but are these elements of causal owing to be given primacy over presence? Or do they explain away instance?

tjb: A multiplicity of Self/s becoming perceptible in performance or action would therefore seem appropriate here.

Neff: Yes! And this navigation seems especially embodied by performances in which the participants do simultaneous tasks ... There's a whole other can of worms here regarding autonomy of the task – perhaps and whether this allows multiple Selvings [*sic*] to occur and so on?

tjb: Inviting an audience to become so integrally involved in your performance felt like the action moved us past a place of security and was as challenging of who we perceived ourselves to be in those moments as it was in potentially transforming the very skin of your body (as well as in many other ways). Do you recall much of those around you?

Neff: This is where the alētheia (Heidegger 1927) of the potentially autonomous flesh-field comes in, [... as] the sheet of plywood as an object is where the performance started: when multiple people hold or carry or move a sheet of wood, you can feel all the weight shifts and movements of each person holding it, and in this case, the sensations get channelled and narrowed literally into a needle-tip into my body.

As articulated by Jones, when positioning an opposition to an essential self, it is noted how an embodied and disembodied self simultaneously

exist for the performance artist, which echoes our intervention in the corporeality of Neff:

> The performative self, whose meaning and significance is not inherent or transcendent but derived 'from the whole scene of [her] action,' dramatically overturns the Cartesian self of modernism, which construes the body not as enacting the self but as a brute object or hollow vessel given meaning only through the animating force of consciousness that presumably can transcend it. The *lived body*, Merleau-Ponty observed in his 1945 [2002] *Phenomenology of Perception*, is not discrete from the mind as vessel but is, in fact, the 'expressive space' by which we experience the world [...] Phenomenology interprets and produces the self as embodied, performative and intersubjective.
>
> <div align="right">(1998: 39, original emphasis)</div>

Merleau-Ponty's phenomenology provides a transcendental level of perception (Stuart Grant 2012), towards intersubjectivity for the body artist. Neff's reciprocal intertwining demonstrates this as their actions become both intersubjective alongside the intercorporeal immediacy of the encounter. As Jones concludes,

> Merleau-Ponty's writings seem singularly interesting in relation to body art in that they articulate an understanding of intersubjectivity as dramatically *intercorporeal*: as embodied as well as contingent [...] There is a 'reciprocal insertion and intertwining' of the seeing body in the visible body.
>
> <div align="right">(1998: 40, original emphasis)</div>

Vital to the emergence of alētheia, a term as appropriated from the Greek for beautiful by Heidegger (1927) to explore the phenomenology of truth, which Neff queers through the complications of a disorientating process (Ahmed 2006), to highlight a sense of unravelling.

Niko Wearden

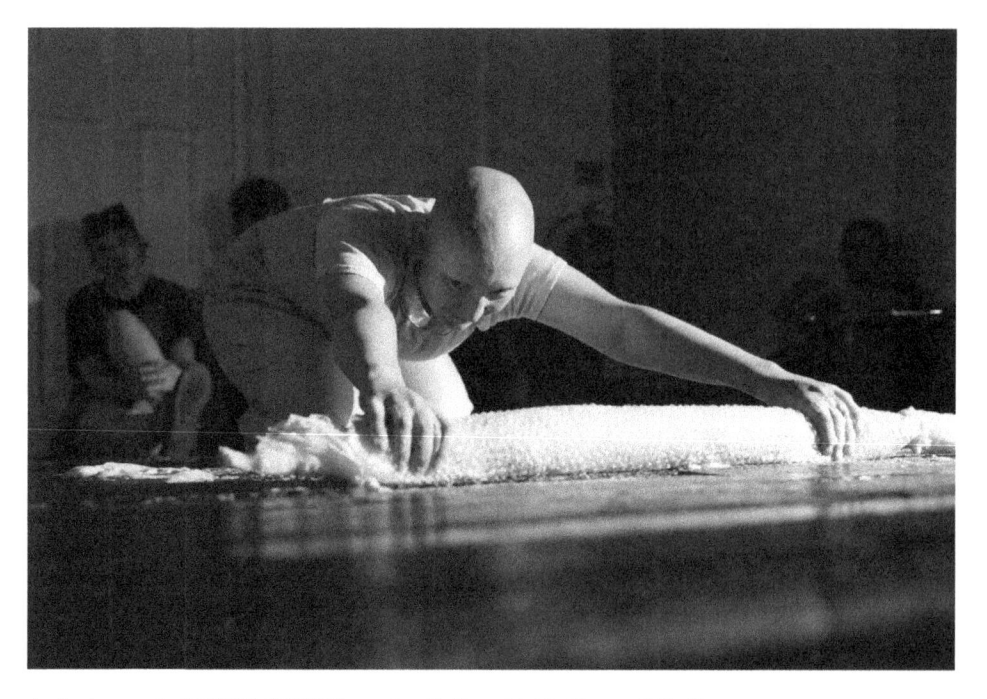

Artist image 5: *SELKIE SKIN*. Tempting Failure 2018. Photo: Julia Bauer.

Niko Wearden's (t h e y) programme notes began with the dictionary definition of 'felt' as a kind of cloth made by the rolling and pressing of wool before poetically opening this further. T h e y wrote, 'Something about the sea. A general muddle of yearning and un-belonging. Heading north.'[5] T h e y concluded their notes with reference to the myth of the Selkie.

Embodied Writing
This relationship [was] loving, caring and fluid [...] my body and the material become together, as my body causes a transformation of the material properties of the physical materials I work with in the space,

but also the sensations in my body move and shift and I am transform ed in a way, like the materials.

Contextual Discourse

Though writing on Black feminist artists, it is useful to cite Uri McMillian here, to invoke the term 'avatar'. A queer white trans artist, Wearden had a similar sense of *avatar production* (2015: 12) through *SELKIE SKIN* (2018). McMillian established the term to be cogent of alterity in performance practice. 'Avatars, as alternate beings given human-like agency, are akin to second selves [... to] create, inhabit, and perform' (2015: 12). Wearden shares their fluxing identity at a point of transitioning between avatars: an exploration of t h e i r own mineness.

Mineness is a simplistic expression of Self; a 'basic precondition of what the Cartesian tradition calls consciousness' (Lewis and Staehler 2010: 88). However, what typically exists as an essential self unfolds through past, present and future for Dasein in what Heidegger calls projection and thrownness; hence the importance of time in relation to Being in his work. This potential awareness of perception allows Being to exist. Without self-perception (mineness) none of this can *be*, that is, as Dasein understands the concept of Being, it results in that Being [*is*] *being* at all. This is a sense of mineness, which was a firm fixture of Heidegger's early thought. Lawrence Cahoone relates this back to Dasein on a practical level, suggesting:

> The paradox in Heidegger, common to philosophical narcissism in general, is that Dasein cannot be identical to other beings, Dasein must be absolutely distinct, and yet there is no set of characteristics, no nexus of traits, no content of either Dasein or worldly entities, beings, or phenomena which can justify their distinct existences. Lacking an existential integrity which would distinguish them, Dasein and world, worldly entities, or phenomena represent a dichotomy of indistinguishables, and consequently the two factors become paradoxically or asymptotically equatable.
>
> (1988: 138–39).

To phenomenologically understand mineness, there must be a way to measure something against itself; to deconstruct a perception against. Cahoone identifies here a problem in this early stage of Heideggerian thought on Dasein as while it is aware of itself, there is nothing to distinguish its individuality. The only constant for Dasein is self-awareness, so in his later writing, Heidegger moved away from mineness as defined by particular significance toward instead Dasein in the context of its world, opening the potential for Being to be unique to an individual and not a predetermination of existence. Therefore, Dasein may consider its Being in the same sense that it is consciously aware of it. Or in simpler terms, it is the potential possibilities that are appropriate to them within the context of the world in which they exist. As Cahoone states (1988: 138–39), Dasein has a sense of appearance, whereas other worldly entities or things approach their place in the world with a lack of distinction. This is what Heidegger termed being-in-the-world, where Dasein are able to place themselves at the centre of the world, identifying their position as significant in relation to all other entities.

Merleau-Ponty's work then expanded the idea that our existence is experientially perceived as being-towards-the-world (1945). His writing began the pursuit of a 'third way' (1945), a place where subject and object, activity and passivity, autonomy and dependency, combined to form the whole: a complementary theory of reciprocity. 'This third way presents itself as a passage, as a transition, which leads neither to a beginning nor an end' (Waldenfels 2012: 90). An entity's possessive self-discovery of its Being, through exploration of the perception of itself, and its world, may be called the 'lived body' (Merleau-Ponty 1945).

Contextual Discourse

Mineness here is not used to dismiss Wearden's enquiry as reductive but rather highlight the gestalt of t h e i r journey through a series of avatars in moving towards a representative lived body in this performance. This was Wearden's alētheia of becoming that recalls Genesis Breyer P-Orridge reflecting upon commencing the *Pandrogeny Project* with Lady Jaye.

The mutual orgasm can be a transcendent experience where two people seem to become one. Another way you can have that experience is to create a baby [...] We didn't want to have a baby, but we did want to create a new being that represented the two of us, so we took each other and started to analyse how we could play with that sense of Positive Surrender, and create a new dynamic being.

(Johnson 2013: 68)

Niko was navigating t h e i r own Self/s towards a becoming, as they ritualistically enacted a process of making and unmaking felt in *SELKIE SKIN*.

Series Notes

Wearden's writing on the origin of the Selkie Seal, which inspired the title for this performance, resonated with notions of change, describing it as a

> creature found from the Highlands and Islands of Scotland, through the Faroes and up to the high arctic of the Nordic countries. The Selkie sheds their skin on land to appear in a human likeness. Only by means of the skin may they return to the water.
>
> (TF 2018)

Bathed in blue light, Wearden washed and pressed wool into felt before deconstructing back into its raw materials. Wearden created a navigation for their avatars through action-as-process, constructing a new skin for a new body and leading the audience through their mineness from an essential Self, towards-being-in-the-world and sharing their lived bodily experience. In later reflection t h e y said, 'The audience were travelling with me through my work. I felt like I could relax into the work, trust the audience and feel carried through the space.' The immediacy of this processing of transitioning was held through song and warmth from the artist and echoed through the de/construction of the felt artefact, 'A kind of cloth made by rolling and pressing wool or another suitable textile accompanied by the application of moisture or heat, which causes the constituent fibres to mat together to create a smooth surface.'

> (TF 2018)

In 'Of fevered archives and the quest for total documentation' Angela Piccini and Caroline Rye (2009) highlight five points that they have extracted from Alain Badiou's, *Handbook of Inaesthetics* (2005) on the value that the experience of an art/creative phenomenon holds as truth:

1. Art itself is a truth procedure (2005: 9);

2. Art is rigorously coextensive with the truths that it generates (2005: 9);
3. Philosophy is the go-between in our encounters with truths, the procuress of truth (2005: 10);
4. Art sets itself up as an inquiry into the question of its own finality (2005: 11);
5. [...] a work is a situated inquiry about the truth that it locally actualises.
(2005: 12)

Through the action of processing the material, Wearden symbolically processed their own lived body as material, enacting an alētheia – a truth/value through artistic practice. In continuing our conversation together, Wearden has reflected thus:

> I have all the felts I have been producing with each of the performances [...] I hold the soft, fluid energy of each space in my body and I try to carry that through my daily life as well. As my felts accumulate, I feel the sensation or motion of the work in my body shifts too. Memories of performances blur together but also particularities of each performance also exist in my memory, specific to one context or another.

Wearden's *SELKIE SKIN* is demonstrable evidence of the artist as artwork, connecting Piccini and Rye with art as a process and inquiry, leading towards what they highlighted as a truth procedure.

Exercise 4
1. Write a personal artistic statement in the first person. This should be two to four paragraphs long.
2. Now rewrite that statement two more times. One should be in third person and the other in second person.
3. Print them out (if they are typed electronically) and put the three physical copies away from your eyes for five days.
4. On the sixth day reread all three statements. Which do you have a closer affinity to? Ask yourself why and make notes on your responses.

5. On the seventh day take your favourite statement and attempt to write up to four variations of this where you change your use of pronouns. For example, he, she, we, xe, xis, them, t h e y and so forth.
6. What changes? How can you project yourself? How do you perceive yourself? Is there a sense of embodiment or disembodiment?

Adaptation: A variation of this task is to record yourself speaking the statements. At first this may seem easy but it can be tricky to speak freely yet precisely in the moment. Therefore, you may want to practice what you will say first before recording.

Cultural Contexts

Phenomenology seeks to acknowledge the sum parts that form a perception. The consistent flaw within this 'cut diamond' of experience is the individual who is perceiving. Experience is both empirical and conceptually rational. The individual's perception is affected by an intersectionality of cultural contexts it encounters through the worlds it inhabits, both in the immediacy of the moment and in the histories it holds. The individual Being can never fully perceive themselves, or fully understand their own subjective bias or neurological distinctiveness in regard to how they 'see' the world around them.

Experiencing a Multiplicity of Self/s (Bacon 2016) confirmed that through performance art we encounter our Self/s through the perception of others. We may re/discover Self/s anew through the exploration of their responses (i.e. fundierung).

Fundierung, was a term originated by Husserl, but latterly appropriated by Merleau-Ponty, *whose application is the only way it is used in this book* (Chapter 2). Fundierung, in the Merleau-Ponty way, denotes perception as shared between two Beings so that there is feedback between both. The originator of the experience (e.g. the performance artist) is 'not primary, in the empiricist sense, and the originated [e.g. an audience] is not simply derived from it' (1962: 351). We may also rationalise 'through the originated, that the originator is made manifest' (1962: 351). This is the experiential cycle of perception.

For Marisa Carnesky's *Jewess Tattooess* (2008) she recovered her flesh through physical acts upon her body, as Gina Bouchard noted 'These marks [tattoos] reclaimed her body as her own, from social prohibitions against the female, from religious taboos as a Jew and from various legal strategies adopting the "no property principle"' (2013: 134). Heteronormative and patriarchal contrition has often been absent in the history of female or non-white bodies. This corruption of materialism leads to an abstraction of woman as object; a fetishisation of form that is divisive and controlling. As Donna Dickerson explains, 'All bodies are at risk from commodification, but women's bodies are most at risk. Not only are they richer in "raw materials" than men's bodies; women are also more routinely expected to allow access to their bodies' (2007: 25). Through the Orientalism of the other, we find similar dialogues of hegemonic control emerging for non-white peoples. Bouchard states as follows:

> Seemingly innate rights to physical integrity, to agency over one's body [...] and the 'property' [...] have come under serious stress at the turn of the twenty-first century [...] As a cultural practice focused on 'the exploration, use and examination of the human body,' Live Art is uniquely placed to respond to, challenge and intervene in these debates.
>
> (2013: 129)

Considering the fundierung within performance art practices that encounter dialogues of race, culture and wider intersectionality, it is therefore useful when challenging hegemony or attempting to unpack dogmatic, patriarchal or other normative forms of suppression. Reintroducing McMillian's (2015) notion of avatars, we may witness how performance extends beyond mimesis (12) highlighting and stretching the 'subordinate roles' of these Beings. McMillian explicates this through Howardena Pindell's *Free, White and 21* (1980) who first showed this video artwork at the *A.I.R. GALLERY* in an exhibition called, *third-world women artists in the United States*. In this, Pindell adopted multiple avatars following what she concluded had been 'another run-in with racism in the art world and the white feminists' (McMillian 2015: 153) to draw attention to her mistreatment between subordinate and dominate positions of control. Susan Kozel reminds us of the placement for phenomenology, establishing the need to expand towards a theory of affect.

> Phenomenology is well established as methodological approach for capturing, questioning, sharing and even problematizing sense experience, but affect exists in a different spectrum from the senses. [...] It is most commonly reduced to emotion, but philosophical thought contributing to the area of affect theory reveals it is much more subtle and expansive than human emotion... Phenomenological process do not just describe what is there; they create meaning and deepen experience.
>
> (2015: 69–70)

When we apply a theory of affect to open dialogues around dystopic cultural issues and the examination of fundierung, this is traced through the risk of failure within commentaries that embodied practices and the use of avatars create.

Exercise 5

How do we witness truth? How do we witness value? Are we consciously aware of fundierung? This task will ask you to work with a partner.

Explore a routine 'exchange' between two people that you can reduce to a basic component. This could be a smile that communicates 'hello' without speaking and says everything about how you're feeling at that moment in time. But for simplicity, we suggest starting with a handshake.

1. Map the action in your mind before even beginning. Consider the intention for every gesture. To capture an embodied experience of this we suggest taking time to do this before each variation or 'phrase' in the action. Be present within yourself and note how intention shifts when unspoken as part of navigating your reciprocal exchange
2. Now run the handshake in the following ways: (1) At normal speed (2) With an exaggerated emphasis on the power dynamics/status (3) In reverse (4) Over ten minutes – capturing every nuance of detail. This is not an exaggerated 'slow motion' but rather slow in the sense of focus through action.
3. How does your perception of truth in this 'exchange' shift through each variation?
4. How do you perceive value through these variations?
5. What did you project upon your partner? And what was your perception of them? Compare your notes with your partner; does reciprocity affect truth/value?

Adaptation: This task suggests the application of touch to explore a routine exchange between two people, but if this is not immediately possible, consider how we encounter another through other senses or gestures. For example, have you ever recognised a person from a distance through the way they hold their body when they walk, or perhaps, have you wandered into a room to encounter another's perfume sillage when they are no longer physically present? Explore the steps above with such variations in mind.

The line between my body and the material within the performance is blurred – often the material used in my work, is my body [...] There are definitely times when the audience forget that a human being is in front of them.

<div align="right">

– Jamal Harewood on *The Privileged*

</div>

Jamal Harewood

Artist image 6: *The Privileged.* Spill Festival 2015. Photo: Guido Mencari. Website: https://harewooo.com/work/the-privileged/.

Jamal Harewood's (he/him) programme notes ask,

> Have you ever seen a polar bear in the flesh? Been close enough to notice just how white these magnificent mammals are? Here is your chance to get up close and personal – remove your shoes, coats and bags, as you are about to encounter the Arctic's whitest predator, with black skin. Join a well-trained member of staff as we enter the polar bear's natural habitat and experience this animal like never before. Be one of the privileged few to say they have pet, played with, and fed a polar bear as if you were one of the Arctic keepers.[6]

Embodied Writing

I lay there on the floor in the bear outfit, waiting for the audience to come in, sit down and open the first envelope. This takes a while as there is nothing informing them of what to do, so we both end up waiting.

The audience soon open the first envelope and begin reading out the information contained within it.

Waiting patiently until three envelopes are read out was enough time to get into the mindset of what I need to do and become throughout the performance.

I'm ready.

The audience learn their fate and what is going to happen over the next hour – a self-led animal encounter experience with a polar bear. They shake me gently, repeatedly saying, 'Cuddles'. I eventually rise and start introducing myself to the audience.

Contextual Discourse

When writing on Orientalism, Ahmed deconstructs the notion of *towardness*. She proposes that within Western hierarchies, the object-ification of the other manifests through a sense of repetition towards a thing, which in turn creates subjectification for the phenomenological world, 'The orient is then "orientated"; it is reachable as an object given how the world takes shape around certain bodies' (2006: 120). Unfortunately, this has a history of corruption for women and non-white people, which in many instances continues today. As a commodity, the object-ification of the body is overt. Luce Irigaray (1985) wrote about this in reference to the female body and it is applicable to the Black body as much as female or queer bodies,

> uprooted from their 'nature' they no longer relate to each other except in terms of what they represent [...] according to the "forms" that this imposes upon them. [...] For them, transformation of the natural into the social does not take place, except to the extent that they function as components of private property, or as commodities.
>
> (Counsell and Wolf 2001: 61)

Performance art can disorientate this, questioning hegemony through queering bodies and spaces 'out of place' (Ahmed 2006: 160). Jamal Harewood's series of performances under the title, *The Privileged* (2014–18) opened up such intersectionality through the fundierung of the other and the complicity of White privilege (or the wider sociological status quo) in facilitating acts of repression. Dressed as a polar bear named Cuddles, Harewood had designed a series of provocations to task an audience in the active participation of 'caring' for the animal, dehumanising and objectifying the figure, where subtle changes in the pronouns used (in instructions provided) could guide them towards eventually denying 'it' fried chicken. From 'beast' to an undressed Black man, the traditional 'White space' of galleries and performance art venues were challenged, as 'the body of colour might disturb the picture – and do so as a result of simply being in spaces that are lived as white' (Ahmed 2006: 160).

Series Notes
In a subsequent conversation, Harewood noted that

> [t]he line between my body and the material within the performance is blurred – often the material used in my work, is my body. I use my body alongside the written word to generate conversation around difficult or taboo subjects. Although my body feels like a vital part of my material, I would say it is still quite an indistinct connection, as the line between my personal, physical body and the fictional, polar bear being, is blurred for the audience. There are definitely times when the audience forget that a human being is in front of them.

Harewood's recollection of his avatars reveal how the performance artist 'transmute[s] their simulated identities into transhistorical figurations' (McMillian 2015: 12). From disarming humour and awkward performative interplay, audiences would interact with a body that Harewood had allowed them to actively see as other, as object. When asked about distinct differences between his memories and those of the participants Harwood said,

Despite us all being in the same room, doing similar things, our memory of the action differs as everyone takes on different roles. The roles have us focusing on or experiencing different aspects within the piece – I focus on embodying an animal and reacting to the audience's reactions, while the audience tend to focus on the instructions, the bear in the room and possibly avoiding getting dirty socks, amongst other things.

A range of responses from audiences has seen grieving hysteria, hilarity and walk-outs. The distinction of projection and thrownness between originator and originated exemplify the fundierung of perceived Self/s through Harewood.

It should be noted that, as documented in some reviews and online blogs, the privilege of participation did not always result in the complicit denigration of the artist. At times there was refusal and negation to participate. Neither outcome is an indictment of racism upon the participants, but where conscious objection manifested, the outcome is neither a failure nor a success; it is merely an alternate result in an anthropological/ontological encounter with risk and perhaps says more about the possible intersectionality represented in each performance space.

There is trauma here, but rather than wrought through with viscera (Chapter 2), it is societal. As Harewood notes, each performance exists with him and the audience's shock at the encounter is revealed in its immediacy, not only in performance action but also through its aftermath. It is here, phenomenologically speaking, that the post-performance immediacy of the artwork extends, commentaries and reflections unfurl. In later iterations Harewood held the space post-performance through conversation and debrief. As a shared experience, the intercorporeal nature of affect between all present, effects the way we may understand ourselves and others through a space. Jones, writing about physical harm, noted the connection between audience and artist and stated that 'the wound as having occurred in an actual body – and thus potentially occurring in our own body in the future – [...] makes the wound signify' (2009: 51), something of ourselves in the other. This speaks to the psychological impact a work such as *The Privileged* has upon shared states of perception through fundierung. Harewood was the intersectional loci, but the universality of the societal wound is shared no matter the colour, heritage or culture of those present.

Exercise 6

This exercise asks you to become 'somebody else'. Not an impression or caricature, not even a character but simply to change something about the way you appear that allows you to reinvent your identity.

The change does not have to be a grand illusion. It may just simply involve wearing something different or perhaps adorning yourself with a change in make-up style, glasses or the application of fake facial hair.

It is important not to adopt a different race and not to cause offence in any way. The changes should be subtle so that what you are doing is creating a new variant of your own Self.

Now go do something mundane in a public space. For example, visit the supermarket, ride the bus, have a coffee or visit the launderette.

When you return, reflect upon your embodied experience. What did you notice about how you existed in relation to the world around you?

Adaptation: If you are unable to complete this exercise without assistance, it is important that whomever you are with continues to treat you in the same way they normally would. It is important not to 'act-up' but to instead exist in the moment and remain present; your embodied observations need to remain free of theatricality.

Regina José Galindo

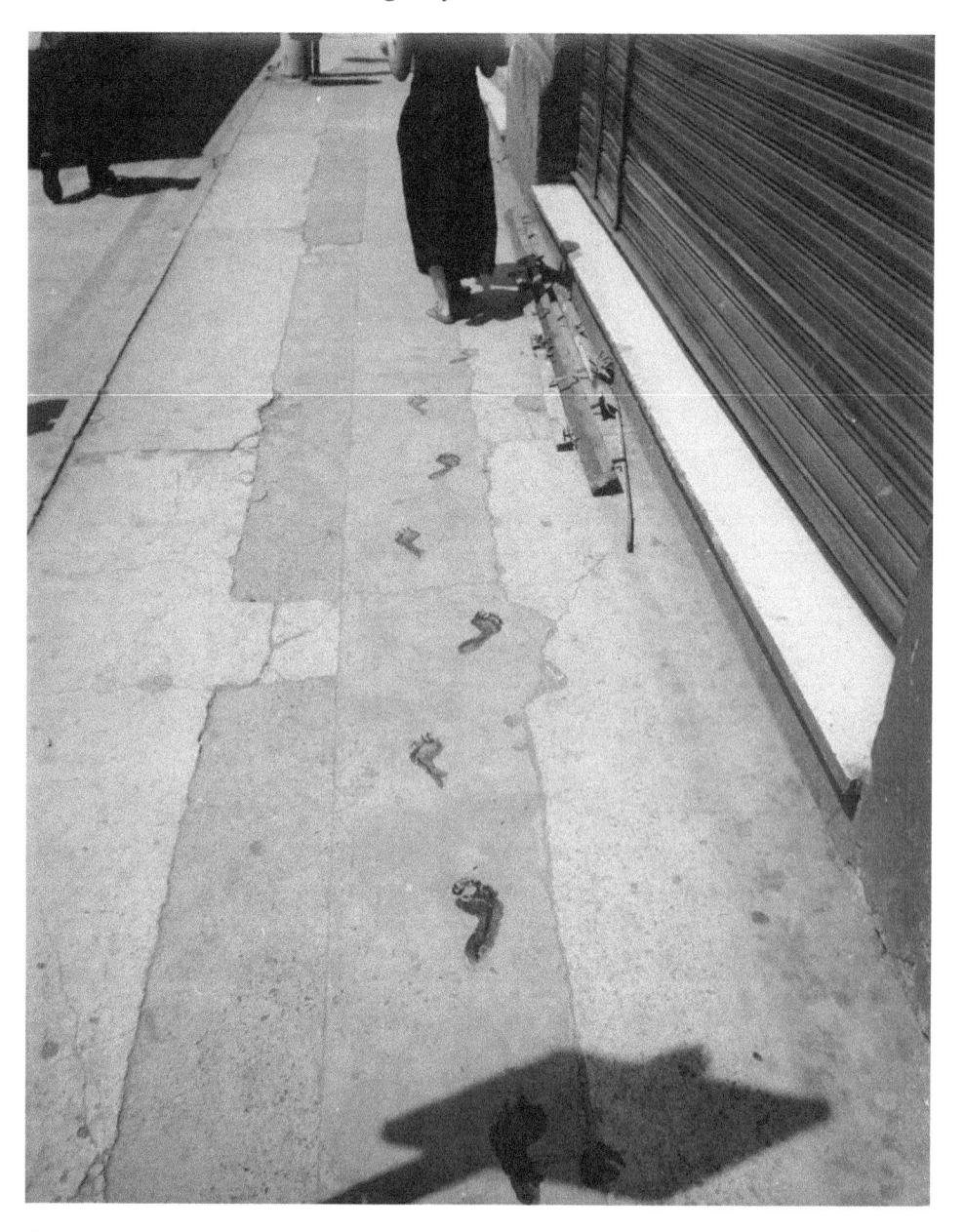

Artist image 7: *¿quién puede borrar las huellas?* Guatemala City 2003. Photo: José Osorio.

Regina José Galindo (she/her) describes this action as,

> [a] long walk from the Constitutional Court to the National Palace of Guatemala, leaving a trail of footsteps made with human blood. In memory of the victims of armed conflict in Guatemala and in rejection of the presidential candidacy of the military, genocidal and former coup supporter Efraín Ríos Montt.[7]

Embodied Writing

It was an important work in my career and it is important because it speaks of a precise moment in Guatemala. [It was a response to] the stress and annoyance over Ríos Montt's announcement to be a presidential candidate

I remember that the floor in some parts was very hot and the blood cooled my feet […] As I walked it was a moment of much reflection, everything was very clear and precise.

Contextual Discourse

Where do 'we' begin and end through the consideration of fundierung is especially interesting in this work by Galindo because it is unquestionably more than a duet; through the external street setting, there is a becoming through an unparalleled level of interaction. This interaction is both active and passive, and also gives rise to intersubjective traces evidenced through the bloody footprints she left behind as she walked. From the *Palacio Nacional de la Cultura to the Corte de Constitucionalidad*, the action extended encounters with presence/s through the busy thoroughfares of Guatemala City. Carrying a basin filled with human blood, which she would intermittently dip her feet into, her footprints became more than just those of herself but of a multiplicity of other's Self/s, each representing a loss of life. Each, only temporary in presence, an impression that would quickly weather away and perhaps be forgotten once more. Here, everything from the glimpses of passers-by on foot to those in buses and cars, through to intense gazes of the *Corte de*

Constitucionalidad security and the unseen viewers that surrounded the area brought a multiplicity of perspectives upon each moment: originator and originated were infinite. Beyond the moment between José and marking the souls lost to conflict, encounters were happening that we are not even aware of; participation existed beyond our awareness, extending the perception of where Self/s began and ended.

Series Notes

Galindo's footsteps created a tangible sense of becoming through phenomenological disorientation (Ahmed 2006: 162–23). Referencing Sartre's *Nausea*, Ahmed makes a comparison between his notion of becoming oblique – the idea of becoming lost in a world of queer objects losing a sense of placement of Being within that set of referents – and her notion of queer phenomenological disorientation, 'A becoming that is at once interior and exterior, as that which is given, or as that which gives what is given its new angle' (1965: 162). Ahmed, writing in reference to objects, stimulates the possibility of how corporeal bodies in a space together, captured in the absence/s – as well as the spectatorship – of Galindo's performance action, manifest to hold presence in-between them. Their presence disorientates the space; the familiarity of the street site is instantly changed through the queer activation of Galindo's performance actions for all who would normally encounter that environment. Significantly, as they bear witness to Galindo's performance presence, their relationship to this street site necessarily reorients in relation to this encounter. No longer can the loss of life be ignored, but appropriately by using blood – which will ultimately disappear from the streets it stains – they can still be forgotten.

Recalling the event in more detail, Galindo spoke about how the process leading to the moment of the action had a sense of surreal calm. It began with her leaving

the office on my lunch break. I drove downtown and parked in a parking lot. I walked to the Congress with a lunch box in hand. When I arrived a couple of friends were waiting for me. I gave a friend my shoes. Barefoot I went to a corner of the congress and prepared the container with the

two litres of human blood. There was a line of policemen guarding the facade of the Congress, none of them said anything to me. They all saw me. Some looked at me strange.

Here José's presence disorientates the normativity of the space; the familiar is instantly changed and queered for everyone who would normally encounter that environment. The incongruity of her presence – even her journey to the location while on a lunch break from work – creates a catalyst for the action to unfold – a shift in how perception can be challenged in this moment. She continues, 'I took the container, wet my feet in the blood and started walking. When taking the first steps I got nervous. … I knew I was going to walk to the National Palace but I hadn't made a specific plan of which streets I was going to take. So, I walked by intuition and inertia knowing … People looked at me while walking through streets, avenues, the market, and the park. When I arrived at the National Palace, its facade was also protected by a line of policemen. They didn't say anything to me, they just looked at me.' Disorientating the space, Galindo's shared presence/s, represented through her actions and witnessed by all around her, defiantly alter the signifiers of hegemony and oppression she is responding to. Yet this does not dictate a new beginning or end of a shared perception of presence/s, be that of Galindo or of the death of countless others, but rather each shift a shared perception of this multiplicity for all to consider.

Normativity is pervasive, and of this reality even Galindo notes how this provocation sat within her workday as she met her friend in a nearby park and washed what remained of the blood in a fountain before putting her shoes back on. She recalled, 'I walked back to the parking lot, got in my car and drove fast back to my office because I was late from lunch and they would scold me.' However, the provocative act to disrupt the status quo – even while finding a way to survive within oppressive systems of control – allowed the artist to offer all who encountered the work a new possibility of becoming. Galindo's queering of a thoroughfare, the disorientation of encounter and the disruption of daily life indeed demonstrates how a multiplicity of experiences feed into each moment of the performance. The actions symbolically speak to the personal histories of the lives lost, which Galindo embodied and shared through her actions, and resultantly altered through each encounter upon the streets of Guatemala City those who bore witness to her work

> and its fading remains. Each moment shifted the multiplicity of Self/s that were exposed through this and continue to live on, beyond the live act in the form of memories, experiences, images and now the words you find here. This performance evidences the immediacy of our perception, which is constantly in flux, and extends across a broad spectrum of time.

Health and Dis/Ability

Tobin Siebers's 'Disability aesthetics' considers how an audience rejects or accepts the body of an artist. In discussion of the human body he notes that it is 'both the subject and object of aesthetic production' (2006: 63). Normative ideals are raised positions of aspiration, endowed with vitality; however, he acknowledges that

> all bodies are not created equal when it comes to ethic repose. Taste and disgust are volatile reactions that reveal the ease or disease with which one body might incorporate another. The senses revolt against some bodies, while other bodies please them. These responses represent the corporeal substrata on which aesthetic effects are based.
>
> (2006: 63)

The Dis/Abled body stimulates both taste and disgust. It is fetishised, symbolic of the queer and sublimely celebrates or revolts. The Dis/Abled performance artist's body in action offers a vicarious enactment of these positions, as one experiences a part of their Self/s through the spectating of another. Merleau-Ponty speaks at the start of *Phenomenology of Perception*, in his opening chapter entitled, 'The body as object and mechanistic physiology' (2002: 84–102) focusing upon the experiential accounts of Dis/Ability for phantom-limb and anosognosia sufferers to broaden our understanding of perception. Here the experience of patients who perceive the presence of a limb that has been amputated or who are perceptibly blind to the presence of one that is paralysed aligns the experiential account away from the hegemony of normativity. We expand our potential to understand that the experience of perception is not merely visual, subverting a dominant empiricism over rationality and introducing a reciprocity.

Merleau-Ponty affirms that we are all capable through our Dis/Abilities to encounter the world differently from one another:

For us the perceptual synthesis is a temporal synthesis, and subjectivity, at the level of perception is nothing but temporality, and this is what enables us to leave [open] to the subject of perception his [her or xis] opacity and historicity.

(2002: 278)

A personal history affects perception as much as temporal and perceptual synthesis, while equally, or at least no less, the temporality of the moment may alter, change, dissolve or even evolve as we engage with the action before us. Here Merleau-Ponty begins to elucidate that subjectivity can affect what one person may visually perceive and interpret based on any temporal moment versus another's perception of that same event.

Exercise 7

Exploring ability through difference can be a tricky task to navigate in an exercise. Before proceeding, be mindful of implementing practices of care for yourself and others.

For this task, you may already be working through or with a Dis/Ability. If that is the case, you could choose to either explore that ability or continue with another as indicatively suggested below:

Considering sensorial deprivation is a simple place to open a conversation around shifting perspectives of embodied experience.

Choose a sense to safely restrain, one which will allow you to remain present through your experience. Note how this changes the way your other senses encounter the world. The duration can be from fifteen minutes to an entire day depending on the resources available.

Be very careful and patient when working in this way. We suggest to always have another person present as a guide to ensure you remain safe at all times, but also to enhance the exercise at the end of the process. An outside eye aware of their own embodied experience is very useful.

At the end of the session, capture a response to the experience in any manner that feels most appropriate – that is, song, drawing, writing, monologue, dance or painting.

When discussing each exploration, the guide should be an active part of that conversation to bring an expansion on the perception of the situation that unfolded. Note revelations, enhancements, new abilities and differences from each other's experience through the world they discovered.

Adaptation: We recommend visiting weareunlimited.org.uk for useful tips and guidance. If you are completely new to this sort of dialogue, be honest with yourself first. Take a moment to write down what you may like to openly share with others (or indeed yourself) and what strategies you'd feel may support you. If you don't have strategies, don't be afraid to state that absence. Then, if working within a safe environment, try to have a conversation about individual needs with other people where and when it feels appropriate to do so. Another recommended website to develop an access document for the future is accessdocsforartists.com.

Illness, disease, and injury can offer temporary insight into a Dis/Abled experience towards the world. Illness and disease could be in part a longer-term disability but may not necessarily be exclusive. In Havi Carel's *Phenomenology of Illness* philosophy is applied to neglected studies of embodied experience through illness. The immediacy of 'life events' through illness are often ignored as difficult to endure, but in fact are part of the universality of a lived experience for all human bodies (2016: 1–13). We all get ill, we all will age, we all will die. Health and normativity of the body are seen as positive experiences and everything else we are 'told' by society to ignore or get over. Dis/Abilities are unfortunately treated in a way which often leads to mistreatment and othering of disability, with the most extreme instances in history being aligned to eugenics or genocide.

We will all experience illness and its othering oppression from either internalised or externalised forces. Carel notes that

> [i]llness is a breathtakingly intense experience. It unsettles, and sometimes shatters, the most fundamental values and beliefs we hold. It is physically and emotionally draining. It can be physically and psychologically debilitating. Illness requires serious effort and continuous work to adapt practically to its limitations and to adjust psychologically to the pain, restricted horizons, and frustration it brings.
>
> (2016: 3–4)

Within these difficult periods is a universalising experience, as Carel states: 'It forces the ill person and those around her to confront mortality at its most direct and bare manifestation' (2016: 3–4).

Carel's writing is not utilised to imply that disability, illness or disease are in a direct correlation to one another but that this application of phenomenology

can usefully expand how we encounter the experiences of the ill or traditionally perceived 'disabled' or 'normal' body. The Dis/Abled body offers a unique perspective, different from what is considered historically normative for the human experience. Caral writes that this can be 'potentially rewarding' (2016: 3–4), challenging commonly held beliefs and ways of normatively experiencing the world around us. Similarly, the word 'Dis/Ability' is applied to capture the power behind this unique perspective and continues this book's use of the forward slash to note a fluidity between states. In this instance the disabled and the able are combined and separated, highlighting that this difference is not a weakness but more often a rare chance to encounter an experience in another manner.

Katherine Araniello

Artist image 8: *The Katherine Araniello Show.* The Yard 2017. Photo: Taken at Buzzcut 2017 by Julia Bauer.

Katherine Araniello (she/her) wrote in her 2017 Buzzcut programme notes,

> The Araniello Show is a rare, sick, congenital performance, featuring guest artists [...] Araniello pays homage to inspiration porn, sympathy and the sufferings and misfortunes of others in a breath taking and heart rending exploration of jelly and ice cream. The unleashing of Araniello's dulcet tones crooning 'A Miracle of Life' is intoxicating and audience participation is contagious. A fatal outbreak of disease and sickness is plentiful for everyone to experience and share. This 'avant-garde dystopian nightmare' will inspire you to embrace pity-porn in all its festering glory.[8]

Embodied Writing

Throughout the work I maintain a deadpan persona so that I never smile or try to manipulate the audience's responses. This emotional state of being is a persona that I use in performative [modes]. The neutrality of being, not trying to become anything more or anything less.

[…] I completely immerse myself into an incredibly negative representation of a disabled person. I try to ooze complete separation from the drawing of the cock which is being [made during the Araniello Show] by one of the other performers who holds my hand around the thick marker. I separate my consciousness from what is happening all around me, including the audience and the physical action of the penis being drawn on crumpled paper that is distorted.

Contextual Discourse

With fevered and typical irreverence, Araniello wrote of herself that she was '[s]ick and twisted. She is also "A Miracle of Life"' (2017). A subversive artist, Araniello used her performance practice to highlight the subjective objectification of herself as a human 'confined to a wheelchair' by those around her, undermining the desire to bring forth unnecessary pity for her position and instead empowering difference through a celebration of taboo. She would call into question the distinction between misplaced support (most famously through use of a 'pity party') and the denigration as othered. Her work was uplifting, ironic and often funny. Shaun Gallager and Dan Zahavi wrote that '[t]he body is considered a constitutive or transcendental principal precisely because it is involved in the very possibility of experience' (2008: 135). *The Araniello Show* (2017) challenged the audience's naïve projection upon the possibility of her experience. Here the fundierung between the originator and originated would evolve through the experience of her performances; utilising archetypes that resonate with fragility or vulnerability, Araniello would lure audiences towards self-sabotage of their own preconceptions of disability. Astutely aware of this intersection, Araniello subverted expectations of who she was and what it was to experience the world through her position. Echoing Merleau-Ponty's own 'criticism of [a] rationalist view of knowledge as conceptual and innate' (Carel

2016: 27) and extending it towards the empirical, Araniello arguably and rightfully prioritised her own *lived-bodily* experience to re-educate how audiences should consider Dis/Ability.

Series Notes

Before her untimely death in 2018, Araniello described her practice as experiencing

> [f]irst-hand a unique perspective on the way in which society disconnects with disability, while seemingly attempting to 'get it right'. I use these ongoing representations and societal attitudes to make work that distorts and alters common notions of disability, for example, portraying disabled people as heroic, medical specimens or 'Super-Crips'. This perpetuates an authority that undermines disabled people's autonomy. This agenda creates a dichotomy between the disabled and non-disabled body, where to be disabled is to be 'other'. I am interested in the awkwardness this otherness elicits in the mundane and the everyday.
>
> (Araniello 2017)

Everyday objectification of Araniello was material for her practice. Saying of the process that when 'removing one's usually high motivation and extremely alert consciousness into a nothingness [you discover] something very exhilarating'. This subversion was often uncomfortable to witness, forcing audiences to challenge their prejudices or unconscious bias through her work. A key moment within *The Araniello Show* (2017) staged at *The Yard* saw her assistant, played by the artist Daniel Oliver, move her inert presence to draw a crude representation of cock and balls on a piece of paper that crumbles under the duress of the act. It is a moment of awkwardness as audiences are forced to question if this is allowed despite being fully aware that they have paid to watch the artwork of Araniello who, like any other auteur, is completely in control of the design and implementation of her performance.

The awkwardness of the action undermines passive spectatorship and resonates with Caral's words that 'the body is not merely a thing among things' (2016: 209). Agency to action questions our presumptions, our

very spectatorship. But why should it? Araniello has the authority to question why we feel she should not have agency over this situation at all. It is hers to enact, not our own. Recalling this, Araniello said, 'Removing oneself away from a role model or an informer [… I'm] not trying to get it right because ultimately what is right and what is wrong should not be a focus.' Her practice questions authenticity, enabling cognitive renewal to facilitate a reappraisal of the appropriateness to pity and the right to own agency for the Dis/Abled body. As Merleau-Ponty ascribes upon the body, it is 'our general medium for having a world' (1962: 146). Through Araniello's being-towards-the-world, the fundierung through multiple spectators collide and perceptions evolve. Araniello exposes these position/s and plays with our expectation.

The natural process secondary to experiencing the lived body is experiencing the body as an object amongst objects.

(Carel 2016: 218)

Kamil Guenatri

Artist image 9: *10-14*. Tempting Failure 2016. Photo: Julia Bauer.

Kamil Guenatri (he/him) prefers not to detail his work in programme notes, but in an interview with *Incident Magazine* directly after showing *10-14* he said,

> In my works, space is a recurrent notion, and I think that it's more or less unavoidable as soon as you're confronting an audience: it happens within a space. It's even more apparent in my case, because my work is often installation based. The body becomes an installation, the installation is built with the body itself. The sculptural body. My face is no longer a face, it becomes a surface in the space, that undergoes a series of modifications. When I try to imagine a performance in a specific location, the space is the starting point of the performance.[9]

Embodied Writing

It is for me very difficult to perceive intellectually the transformations that can cause the performances in me and it is for that reason that I often consider them as cycles and not as a unique moment.

... Attached by the rope to the ham, the public enters.

Bonnie [Bonella Holloway], the assistant, surrounds my face with blue wool

My body is almost totally motionless; I use it as an object of manipulations and transformations that the assistants establish on me. There is no distinction between materials and the body.

On the ground, I have [a] cold back. I had not really tested the weight of ham on my chest [...]

... Performance remains for me a very present memory of the end of this cycle.

Contextual Discourse

The materiality of a body in stasis forces an audience towards an objectifying lens. A lens that finds sculptural form in the figure that is beautiful, fragile and at times brutal. When viewing the body of Guenatri, or indeed any other human form, it is virtually impossible to account for their givenness without any immediate bias. Body-based performance artists are acutely aware of this, which is why the body as material is provocative, not in its (typically presented) nudity, but rather as a locus to un/conscious bias (i.e. a priori).

Givenness is a term used to describe, in a simple fashion, the manner in which things appear to a being/subject prior to their interpretation. The problem lies, however, in that a consciousness must be involved in this process, which is a fallible conduit. Givenness therefore attempts to address this by describing the way in which an entity appears insofar as it may be certain beyond doubt that the appearance has not been distorted by our experience of it. This is innately problematic as it creates a perceptual paradox, because while we may be certain of the nature of something, our certainty is still driven by our personal

perception. For example, consider the apple: a fruit that looks like an apple therefore we call it an apple. Even if we say it is apple-shaped or, with more precision, a small edible organic object made of sweet flesh with a skin of green or red, which grows on a tree and can be made into preserves, pie filling, drinks, both alcoholic and non-alcoholic. We will still eventually ascribe our own a priori knowledge/experience to the perception and in doing so our appreciation of the aesthetic bleeds through into our definition.

The only means to address this is that when documenting an experience, we must attempt to be aware of the givenness of the experience. Therefore, when capturing a phenomenological account, a methodology must be employed that attempts to account for an artwork's givenness by describing the factual actions of the event without inflection or commentary (Bacon 2016).

Perception is a vital element of the phenomenological process that is utilised in order to break down and discover the essential thingness of a thing (Heidegger 1927). Here we are aware of the paradox of differentiating between how something exists versus how something is perceived. The perceptual process can never adequately equate to the givenness of the object/thing/Being but rather is an attempt to apply an eidetic reduction to perceive its basic elements/nature.

The most we can hope to achieve is to be consciously aware of our own fallible mediating influence on this process through the following three stages:

1. how something exists versus how it can be perceived;
2. to account for the internal experience versus external experience;
3. to consider how others may perceive any of the above differently.

To fully account for our own affect is impossible, but to be aware of the potential philosophical 'problem' is useful as it opens new enquiries.

Contextual Discourse
The objectified body of the Dis/Abled performance artist may choose to challenge preconceptions by utilising the potentially distorted perception it creates through our cognitive shared experience. Guenatri's performance score for *10-14* (2016) engaged with the objectified body as material. Occupying his motorised wheelchair attached by a rope to a leg of ham suspended from the ceiling, Guenatri manoeuvred rapidly around the space

causing the tension of the rope to slacken and lengthen thus raising and lowering the ham. This was then repeated with his face bound and blinded with blue wool by his assistant. She removed him from the chair and gently took off his clothes. Placing his body on the cold polished concrete floor, the assistant returned to the wheelchair to reposition the tension between it and the ham, lowering the heavy weight of the meat onto his tiny (apparently frail) body. Polaroid photos were taken of him, which, along with his clothes, she stapled to the ham and raised back into the air before carrying him from the space. The audience were left, and silently took their time to encounter meat as a sculptural body suspended above them.

The action in the space witnessed an insertion in/between the forms of body as meat and meat as body. Guenatri's complex relationship between his form as object, while also subject, resonates with Heidegger writing on the artefact produced by traditional art practices: 'The work makes public something other than itself; it manifests something other; it is an allegory' (2009: 145). The Heideggerian artistic artefact had risen above its inanimate thingness to become complete with an essence of the artist in pursuit of a question, statement, symbol or allegory – even perhaps a truth. This could also be ascribed to Guenatri's own body in performance. Materiality is intersubjectively linked to the artist through the body becoming object. Heidegger highlights the provenance for this origin through the creation of artwork, which we can also evidence through Guenatri's performance that subverts a givenness; appropriating the objectification of his own body as a material (now within his control), he leads the audience's shared experience towards a posteriori (i.e. as witnesses, sharing a new understanding of his bodily experience). Heidegger's origin of the artwork, relocated to describe the body of the performance artist as now also becoming artwork, resonates through his original words:

> The artist is the origin of the work. The work is the origin of the artist. Neither is without the other [...] As necessarily as the artist is the origin of the work in a different way, then the work is the origin of the artist, so it is equally certain that, in a still different way, art is the origin of both artist and work.
>
> (2009b: 143)

Though Guenatri is not ill, his medically Dis/Abled difference highlights what Carel notes as an

objectification [that] takes place under the dual experience we have of our bodies. The body is experienced as both a lived, pre-reflective body (my first-person experience of and through it) and as an objectified, observed, spatial object (the third-person experience of it).

(2016: 218)

This places Guenatri's perspective at the intersection between, 'a physical object and the seat of consciousness' (2016: 218).

Series Notes
Writing on his practice, Guenatri notes:

> Through performance, I confront my almost inactive and dependent body (as a body without organs) within an action-based media. With the help of my day carers, who are also my artistic assistants – [they are the] best witnesses of my daily life – this paradox becomes an excuse to evoke the thin border between: impossibility and hope, immobility and movement, constraint and freedom. In this way the idea of 'impossibility' is exceeded by an affirmation of the 'different' with personal rituals.
>
> (TF 2016)

Time, immobility and the materiality of the body are at the forefront of his actions. They are distinct measures of time, or as Carel states when referencing her paper, 'because illness can affect many body parts and functions, it can delineate different aspects of embodiment by serving as a limit case' (2016: 210–11). In this way, Guenatri's Dis/Ability allows him to reposition the fundierung within the embodiment of his own experiential framework to expose new perspectives.

Guenatri's immobility without assistance or mechanised aids means he experiences the linearity of time differently. Time, within the context of Carel's theories on the phenomenology of illness, is witnessed as a demonstrably malleable experience. For those outside of 'normativity', time can become material in flux for the Dis/Abled body. Time therefore becomes as much a material within Guenatri's practice as his corporeal

form. Both are experienced through the fragility of his immobility. Reflecting in a subsequent interview upon this performance, Guenatri said, 'It is difficult to perceive intellectually the transformations that can cause the performances in me [...] I often consider them as cycles and not as a unique moment.' Guenatri's actions stem from his daily life, where he states, 'I prefer, in my experience, to pay attention to the alterations[... to] see how this affects my Being and new intents.' He re-examines his material existence within those moments, through performance artwork.

2

The Rapture and Rupture of the Lived Body

Artist-philosopher George Bataille's erotic work of fiction, *Story of the Eye* involved the willing removal of an eyeball to be placed within a vagina and then anus of another person. The following is an excerpt from that text:

> He removed a pair of fine scissors from his wallet, knelt down, then nimbly inserted the fingers of his left hand into the socket and drew out the eye, while his right hand snipped the obstinate ligaments [...] Simone [...] had no qualms, and instantly amused herself by fondling the depth of her thighs and inserting this apparently fluid object [... before] slipping the eye into the profound crevice of her arse.
>
> <div align="right">(Bataille 1977: 94)</div>

Indeed, when speaking philosophically about the nature of the eye in *Visions of Excess*, Bataille referenced it as a 'cannibal delicacy' (1985: 17), exposing the horror and virtuous symbolism held in its removal or consumption. He reflected upon fellow surrealist Luis Buñuel's short film *Un Chien Andalou* (1929) in which the eye of a lover, through montage with the passing of a razor-thin cloud over a moon, appears to be sliced open, stating,

> It seems impossible[...] to judge the eye using any word other than seductive[...] But extreme seductiveness is probably at the boundary of horror. [... It is], on our part the object of such anxiety that we will never bite into it. The eye is even ranked higher in horror, since it is, among other things, the eye of conscience.
>
> <div align="right">(1985: 17)</div>

These graphic texts enable us to lean closer to an enquiry where rapture is evocative of a felt response from within our bodies. Here we discover the beauty within

the horror, rather than merely an image; there is becoming through the experiential rupture of the body. To illustrate this further, echoes of J. G. Ballard resonate as a writer of fictional extremis. Ballard could capture the hideousness of rupture and hold it in the arms of rapture, especially when we think of the orgiastic collision of flesh into metal in *Crash* (1973) or the semen-covered landscapes of delusion in *The Unlimited Dream Company* (1979).

Bataille is often found as an influence running throughout the performance art practice of Ron Athey. When writing on him, Adrian Heathfield invokes the connection succinctly, noting how the felt action of Athey resonates with obsession with anatomy and the sacrificial principals of Bataille (Johnson 2013: 210–11). A surrealist, short novelist, and philosopher, the rapturous artistic philosophy of Bataille usefully transports us closer to the ecstasy of the impossibly erotic. He highlights the thin line between life and death, noting that

> only a shameless, indecent saintliness can lead to sufficiently happy loss of self. 'Joy before death' means that life can be glorified from root to summit. It robs of meaning everything that is an intellectual or moral beyond substance, God, immutable order or salvation.
>
> (2013: 237)

Often less specific to phenomenological Self/s than this example implies, his poetic logic takes readers to a place where one would feel at home in appreciating the carnal seduction of such illustrative and evocative writing. When Bataille shared a series of 'free writing' texts that were designed to be contemplative and ecstatic on the mysticism of joy before death, one was significant enough in establishing the themes of this chapter, which we reproduce in full here:

> I focus on the point before me and I imagine this point as a geometric locus of all existence and all unity, of all separation and all dread, of all unsatisfied desire and all possible death.
>
> I adhere to this point and a profound love of what I find there burns me, until I refuse to be alive for any reason other than what is there, for this point which, being both the life and death of the loved one, has the blast of a cataract.
>
> And at the same time it is necessary to strip away all external representations from what is there, until it is nothing but a pure violence, an interiority, a pure inner fall into the limitless abyss; this point endlessly absorbing from the cataract all its inner nothingness, in other words, all that has disappeared, is 'past' and in the same movement endlessly prostituting a sudden apparition to the love that vainly wants to grasp that which will cease to be.

> The impossibility of satisfaction in love is a guide towards the fulfilling leap at the same time that is the nullification of all possible illusion.
>
> (1985: 238)

This writing resonates with the phenomenological concerns we have considered through the lived body; the experiential encounter, shared and reciprocal perception, risk, and how this combines through flesh in a manifestation of Self/s is palpable and present in the practices of performance artists. Those who test the containment of their corporeal bodies and puncture the normality of societal convention through such extreme encounters are invoked in the imagery of Bataille's words. In consideration of the intercorporeal space that such works exist in, we shall examine the effect that reciprocally exists between artists/audiences who may encounter rupture or rapture.

While the previous chapter discussed identity, it is essential that this chapter challenges Cartesian notions of the artist, particularly when focusing upon body art. Phenomenology is uniquely placed to support this, notably through Merleau-Ponty's conception of being-toward-the-world, though it does share a complicated hereditary in its evolution from being-in-the-world (Heidegger). This chapter unpacks that relationship, recalling the importance of a reciprocal symbiosis highlighted between artist and spectator in the first chapter, continuing to embrace how body art may violently and viscerally queer a position of normative containment.

Cartesianism originates through the philosophy of Rene Descartes, who foregrounded rationalism in his ideas, concluding that knowledge can be derived through reason. Cartesians asserted that the mind was separate from the corporeal experiences of the body. Even suggesting that bodily sensation was thought to be unreliable as the only certainty was through the innate thought of a metaphysical mind.

The Cartesian Self originated through Descartes's famous words '*Cogito ergo sum*', 'I think, therefore I am.' This implied that an individual's mind may conclude, separate from the body and the outside world, that one can only be certain that they exist because rational thought proves existence. However, Cartesians also held religion in high esteem and believed that a God's omnipotence meant they could never really be certain of anything. This irrational thought resulted in a tenuous hierarchy throughout Cartesianism. Such hegemonies of importance would then also be attributed to value in the expression or mastery of fine art.

Merleau-Ponty's philosophical proposal for the lived body is regarded as a third way (Chapter 1), encompassing an evolution of thought from Heidegger and earlier notions through Merleau-Ponty. Echoing the title of the chapter, the thematic of this section curates a selection of art practices that witness artists transgressing their corporeal integrity for a variety of reasons that will be categorised herein indicatively – though without exclusivity and acknowledging an intersectionality – between states such as ecstatic rapture or queered rupture. This chapter also notes the significance of risk and investment that becomes vital in the perception of Self/s, which will be explored more thoroughly in Chapter 4.

Acknowledging the potential effect of intersubjectivity and intercorporeality in the perception of presence (highlighted in Chapter 1, expanded in Chapter 3), we now extend further the position of perspective to unpack the reciprocal exchange through embodied spectatorship. Considering accounts for the embodied position of spectating in reciprocity with the artist's Being within the artwork.

Exercise 8

Experience a visceral piece of performance art. Ideally encounter it without prior knowledge of the actions and if at all possible, view it live.

Take a moment here to consider your anticipation of viewing a transgressive performance.

Now, whether encountering transgressive art for the first time or the hundredth, it is important, where possible, to stay mindfully present, to attempt to neither run from the encounter nor remain complacent towards it. Through my lifetime, I have been guilty of both responses and should that happen to you it is also nothing to be ashamed of but rather an enquiry to embrace when you are ready to do so. Whenever that may happen, gift yourself the time to try to understand why it occurred.

Wherever your response/s take you, your perspective of the encounter holds a unique validity.

Who you are in each moment is just as important as it is for the artist. This experience could shift through anticipation, encounter, and reflection. Try to make notes of each shift.

Each temporal state mutates over time; this doesn't invalidate the experiential – even when potentially inaccurate – but should be considered as an evolution. Who you are, who the artist is shifts, perhaps in direct response to each of these fluid moments or due to external influence/s, but whatever that

may mean for you personally, try to consider not only who any given individual may be in a binary sense but rather who are 'we'?

Adaptation: Perception, especially when used as a term throughout phenomenology, should not be considered as prioritising sight over other means of experience. Your encounter with an artwork should utilise the way you would usually prefer to experience the work. A 'viewing' in this sense, should be thought of as the opening of an opportunity, rather than to merely look upon something.

As the categorisation of artists under these two distinct sub-headings is not an exclusive frame for their practices, rupture nor rapture should be considered as exclusive descriptors for these practitioners. We have chosen, however, to utilise these frames as a means to engage the transgressive nature of their work when considering the lived body of each performance artist.

To explicate the notions of rupture and rapture further we will continue to use the practice of Athey. Though influential, he is not alone in utilising a methodology that intervenes in a corporeal Being. Others such as Hermann Nitsch, Regina Jose Galindo, Mike Parr, Franko B., ORLAN, Bob Flanagan, and He Yunchang are among many other notable artists of equal significance, yet Athey is perhaps the most widely studied and written about in regard to similar actions of this nature. Quoted in an essay by Catherine Gund, the director of the documentary *Hallelujah! Ron Athey: A Story of Deliverance*, Athey says:

> Part of this frenzy I'm in with AIDS is, 'Oh my God, I'm going to die in a few years, and I have to leave my mark.' What's my mark? How did Ron Athey change the world? How did Ron Athey shake things up and subvert things? What did I leave behind? Was I just some stupid fag who died of AIDS? Or was I just this damaged boy who was never a minister who rebelled and lashed out at his self, so, between drugs and promiscuous sex, he contracted a disease and died.
>
> (2013: 55)

These words captured the passionate desperation that echoes throughout Athey's practice; a man dissecting not only in his physical corporeality but also his intercorporeal and intersubjective Being. Rapture is an eschatological ecstatic state imbued through notions of the 'end of times' in Christian belief systems. It is held with particular embellishment and feverance for evangelical Protestantism beliefs such as the Pentecostal church, a system within which Athey was brought up to be a child minister. Athey's words above refer to his personal religious

history. This has continued to influence Athey's artwork from the glossolalia of *Gifts of the Spirit: Automatic Writing* (2010) through to the de/construction of iconic Renaissance imagery such as St. Sebastian, which Johnson highlighted in his introduction to *Pleading in the Blood: The Art and Performances of Ron Athey* stating as follows,

> [H]is channelling of Sebastian's tortured bliss has become a signature of Athey's work, and he has repeatedly affected the infectious passivity of the 'gay saint.' [...] Sebastian's spiritual resilience made him a patron saint for those threatened by illness or assault, and his statues are markers of plague in Italian cities.
>
> (2013: 36)

A figure persecuted and eroticised, pierced throughout their body with long spines or arrows, Athey has recreated the image at various points throughout his legacy, capturing the homo-erotic nature enacted through an image of suffering. Johnson noted, 'Renaissance painters such as Guido Reni, Andrea Mantegna, and Sandro Botticelli aestheticized Sebastian's saintly suffering, and sexualised his body, trans-forming Christly transcendence into a decoy for sexual longing and converting his persecution' (2013: 36). This is a body ruptured and held in saintly rapture.

In utilising the word 'rapture', we must acknowledge these Christian-infused origins. However, when applying this across the practice of other artists, we extend the word towards being indicative of the ecstatic or euphoric, where the limita-tions of bodily experience exist beyond a corporeal shell. Equal consideration of the need to intervene in the body, that is, to rupture the flesh, needs to be acknow-ledged through each artist's rationale. Indicatively, this is often framed within and beyond the erotic, the masochistic, the transcendent, and the interrupted or inter-rogated to comment or respond to artistic dialogues of life, death, disease, stasis, ontology, societal, cultural, and the phenomenological.

Such subtle shifts in the way we approach documenting our experience phenom-enologically enrich the potential possibilities of each encounter. This moves our perspective to be considered through being-toward-the-world, when asking what the phenomenological experience is. Questioning the intangible personal experi-ence of an artwork, we consider fundierung as a reciprocal conduit that may mani-fest through the flesh of the encounter. This opens studies regarding the problem for any phenomenological account: the paradox created through the inconsistent nature and presence of Dasein (see Chapter 1 on givenness). Taking account of the innate difference between each person, we utilise the concept of fundierung as offering phenomenology the opportunity for these individual perspectives to form a part of the complete experience. Similar to gestalt, consideration will be

placed upon the individual elements as well as the whole, but with a focus upon how these are perceived, rather than accepting that they just manifest.

When attempting to record embodied experience, we must be aware of the potential critique to this approach. A common argument would suggest that any enquiry focused upon examining the experience of the perception of presence could be considered Empiricist. Then in countenance to this, another critique may see it as giving rise to experience as being no more than a tool for the ideas of a Rationalist Cartesian subject, which most phenomenologists strive to reconsider. Finally, perhaps attempting to move away from this and bringing balance to the two previous viewpoints, a further argument of misrepresentation through Psychologism may evolve. Within these, there is a certainty of truth, especially when each is considered independent of the other; however, each may be useful for exploring a more inclusive view towards the value of experience.

Merleau-Ponty highlights some of the problems for utilising experience within phenomenology when citing George Berkley in his *Phenomenology of Perception,* writing that essentially, we are unable to conceive anything, without it being perceived or perceptible (2002: 373). Merleau-Ponty's acknowledgement of what is essentially an empirical foundation is not a full endorsement of that philosophy's singular perspective, nor does he concur fully with its verification principal; a process that would seek to enforce the empirical perspective of perception, where the merit or validity of any given thing can be based solely upon observation. Merleau-Ponty elucidates upon this, again by conducting a dialogue around the possibility of a rational countenance through the analogy of a desert as initially used by Berkley, suggesting that 'even an unexplored desert has at least one person to observe it, namely myself when I think of it, that is, when I perceive it in purely mental experience' (2002: 373). However, this should also not be misconstrued as an endorsement of rational thought (intellectualism) but rather an acknowledgement that the perception of an experience does not have to rely solely upon what may be observed to manifest in the world before a subject. As with much of Merleau-Ponty's writing, there is a sense of evolution on previous theories established by others rather than an all-out rejection; this evolution is imbued with a sense of reciprocity, which coincidentally resonates with the reciprocity alive within his philosophical examination of perception. His phenomenology isn't a rejection of science, a posterori empiricism, a priori classicism, rationalism or even to some extent the possibility of imagination or faith (in as much as it guides the mind's perspective), but rather Merleau-Ponty relies on what he terms as fundierung (a foundation or originator).

> Thus, every truth of fact is a truth of reason, and vice versa. The relation of reason to fact, or eternity to time, like that of reflection to the unreflective, of thought to

language or of thought to perception is this two-way relationship that phenomenology has called fundierung.

<div align="right">(2002: 458)</div>

Fundierung (Chapter 1) accepts that other trains of thought affect the effect of perception for any given thing. It acknowledges where empirical or indeed rational thought may affectively reduce or restrict the experiential perception, but also allows the process to remain reciprocally open to other ways in which to perceive. Therefore, in the same way that we have explored Merleau-Ponty's *being-towards-the-world* as an evolution of Heidegger's centralisation of Dasein to *being-in-the-world*, so too Merleau-Ponty needed to evolve the rationalist use of the central Cartesian subject. Therefore, to contextualise accounts from artists performing before an audience in this chapter, additional dialogues from our own position as spectators where possible will acknowledge a fundierung of different perspectives.

Rational thought holds that the conception of ideas is innate within the mind and that experience is essentially a means by which to bring or activate these ideas into use by the individual subject. Merleau-Ponty's fundierung suggests we may retain the need for rational ideas and the mind, but not at the expense of everything else. Immanuel Kant, as an empiricist, was also vital to progressing this notion. Kant's theories (1790) highlighted how rational and empirical thoughts could manifestly co-exist; however, Merleau-Ponty, while in agreement with Kant, needed the argument to go further in order to counter not only Cartesianism but also Kant's reliance on aesthetics and a priori, stating that Kant's conclusion

> was that I am a consciousness which embraces and constitutes the world [...] this reflective action caused him to overlook the phenomenon of the body and that of the thing. The fact is that if we want to describe it, we must say that my experience breaks forth into things and transcends itself in them, because it always comes into being with the framework of a certain setting in relation to the world which is the definition of my body.

<div align="right">(2002: 353)</div>

This not only leads us towards an acknowledgement of the reciprocity between both philosophies' application of experience, but vitally for the artist-philosopher it opens the subject towards a lived body and away from a centralised Being such as the Cartesian subject or even to some extent the problematics for Dasein (see postface). Indeed, it goes far enough to allow us to prioritise the importance of both an intersubjectivity and an intercorporeality through a phenomenological flesh. So, while this chapter may explore the qualitative accounts from experiences

as a performance artist or audience member, it does not do this to affirm the Cartesian certainty of the artist, but rather to consider the perception of Being before spectators as intrinsically linked to the experience through the reciprocity of a fundierung.

Rapture

Presence/s are entwined within our shared embodied and disembodied multiplicity of Self/s. They are and aren't *yet-to-be* but are found reciprocally through fundierung. For audiences, this process may have begun months before the performance is witnessed, for others they may be on the precipice of investment. This unfolds in the immediacy of a shared investment of risk, where encounters and re-encounters relate to both the live act and the evolving memories of it.

Immediacy is not explicitly mentioned by Bataille but we find resonance in his writing, particularly in consideration of the catalyst (Figure 1) risk creates for the artist and a shared loci when he said, 'I focus on the point before me and I imagine this point as a geometric locus of all existence and all unity, of all separation and all dread, of all unsatisfied desire and all possible death' (1985: 238). Bataille's language visually illustrates the artist in rapture and in a state of 'becoming', fluxing between harmony or conflict internally and externally. The artists in this subsection explore the ecstasy of such explosions through actions that intervene in their own corporeal bodies to enable this.

Merleau-Ponty noticed how our perception of an object is intrinsically linked to it, which is similar to how we connect with other lived bodies. Our shared experience/interaction brings forth our own unique view of the other, taking them beyond an essential Self, as Merleau-Ponty wrote,

> In perception, we do think the object and we do not think ourselves thinking it, we are given over to the object and we merge into this body which is better informed than we are about the world, and about the motives we have and the means at our disposal for synthesising it.
>
> (2002: 277)

Understanding experiential encounters in this way allows one to recognise how the intertwining between the visible and the invisible Self/s expands, alters and mutates the perception of each individual presence. Rapture can, therefore, transfer beyond a single point of origin to multiply through an audience to such an extent that the notion of an origin is superseded by euphoric amalgam. This is true of the sermon-induced hysteria of evangelism and trance states in nightclubs: the

communal experiences of heightened emotion in audiences to performance. Rapture enhances the sense of the universal – an experiential encounter that transcends flesh so that we become a part of each other.

Can we ever fully perceive the world in which we exist? Writing in *Sense Experience*, Merleau-Ponty responds to this conceit, highlighting how studies have noted that (empirically perceived) colour may manifest as differing (arguably rational) physical reactions in individual test subjects (2002: 244–45). He noted that these variables in sensation are not reliant on thought, quality or implicitness affected by, or changed through, the stimuli, but rather 'it is a power which is born into, and simultaneously with, a certain existential environment, or is synchronised with it' (2002: 245).

Exercise 9

Recognising rapture or rupture within your own Being can be a hard thing to explore in a workshop setting. Perhaps in your private life you have experienced grief, injury, euphoria, maybe even mania, but to induce these unnecessarily is ethically questionable and arguably reductive.

This exercise will help you unpack some of your past experiences from your life or even the absence of them to create a performance score:

1. Think of a moment in your life when you were overcome by shock, grief, fear, euphoria, happiness or uncontrollable laughter. Using that moment as an initial stimulus, we will now perform a series of automatic writing tasks to produce your score.
2. Remember, if you cannot think of a moment then pick the closest memory you can align to it.
3. When you write automatically you need to keep your pen writing on the page non-stop for the allotted time. You don't have to write in full sentences, it could just be random words. It is important not to hesitate or self-edit. If your mind goes blank just keep writing the word 'and' until the words return to the page.
4. Using your chosen memory as a launching point, write for three minutes. Then read back to yourself what you produced. Circle three striking words, images, sentences or phrases. Ask a partner or colleague to choose one of the three for you. Then use this as the stimuli for the next

sequence of writing, which should last two minutes. Repeat the process once more so that the final sequence is one minute.

5. From the three pieces of writing, put a star next to the selected stimuli from the first two pieces of writing and a star next to your personal favourite from the final piece. These three stimuli in sequence will become your performance score.

6. Keeping in mind how the score stemmed from a memory that could align – directly or indirectly – to rapture or rupture, use this sequence as a score to exploratively embody through performative action.

Adaptation: The surrealists used automatism to explore the unconscious mind. Notably, André Masson reapplied automatic writing to the form of drawing, which we will use in our adaptation suggestion here:

Try the same process detailed in the steps above (if necessary, blindfold yourself) and take a pencil to a large piece of paper to capture your responses. Embody your feelings into the flow, speed and angle of the pencil, never let the pencil stop moving and we would encourage you to triple the length of time you would normally elect to write when adapting this exercise for drawing.

As previously noted (Chapter 1), we each experience the worlds we exist in differently, each Dis/Abled body may even encounter them uniquely. As we have discovered, a person may continue to perceive an absent limb post-amputation, or in the rarest examples, synaesthesia may result in hearing or even tasting colours. A world (for every individual) is as valid as it is real to them in any given moment. The differences, or perhaps 'normative' flaws, in how each perceives it, potentially heighten the possibility for rapture rather than detract from the process of perception and experience. Bataille's poetic logic ascribes that

> it is necessary to strip away all external representations from what is there, until it is nothing but a pure violence, an interiority, a pure inner fall into the limitless abyss; this point endlessly absorbing from the cataract all its inner nothingness, in other words, all that has disappeared, is 'past' and in the same movement endlessly prostituting a sudden apparition to the love that vainly wants to grasp that which will cease to be.
>
> (1985: 238)

Here, the immediate is intertwined through self-obliteration, opening a becoming through the apparition of renewal. It infers a reciprocal or perhaps cyclical experience, developing our commentary into the next subsection on rupture, with implications for materials/states/presences created by the artist's Being. Shared states of obliteration and becoming retire the notion of an essential self and open a critique upon the devaluing or revaluing of their origin (the artist) where through transgression of normativity we may consider where to position the commodification of their artistic acts of Self/s.

Rocio Boliver

Artist image 10: *Beauty by Design.* The Attenborough Centre 2017. Photo taken at Live Art Development Agency (2015) by Alex Eisenberg from Between Menopause and Old Age, Alternative Beauty.

Rocio Boliver's (she/her) programme notes state,

> I devote myself to transgress limits. I dig into human behaviour. I'm a human voracious hunter, consumer and provocateur. I show the horrors of hidden lies. I practice a constant situationism, disrupting daily routine. I take on sex topics because the world still shivers to them. Sex is good bait for my hunt. I break the conventional woman scheme so this performance [of] *Beauty by Design* aims to demystify 'the horror of old age', inventing my own deranged aesthetic and moral solutions for the 'problem of age'. I hope my mockery of this absurd contemporary reality exposes a broken society based on looks and how 'old age' became synonymous with insult.[1]

Embodied Writing

I am [still attempting] to write about this revealing stage of performance. There are usually three steps in my experience: tremendous crying, uncontainable laughing and then something similar to [an] autism of being. That lasts for a different time, depending on what I have transgressed [through] myself. After that time, arrives an overwhelming lucidity where I feel a gnostic totality.

I felt very calm when I saw the people enter to the space […] I felt perfectly each piercing, from one pain to another and so on, I was feeling like I was drugged in a state of euphoria. One very emotional moment was when I shouted to the audience if they thought if I knew what I was doing there. One part of me was amazed how I was going from tears to hysterical laughter so quick. I felt invincible. All my body was vibrating. I knew that I could easily endure […] I ended, feeling a light-heartedness and child-like energy.

Contextual Discourse

Boliver challenges what it is to be feminine, beautiful and normative. Her actions interrupt the aestheticized body, often piercing her skin, letting blood or even stretching her facial features in a mockery of cosmetic surgery. She performs explicit sexual acts and penetrates her Being with an intentional lack of finesse. *Beauty by Design* (2017) was trash-art – a mess that challenged normative preconceptions of what is 'artistic' and who can make such things. Often echoing the mid-career actions of Paul McCarthy; Boliver utilises the form to exhume and destroy the patriarchal narratives noted by Imogen Ashby, who wrote as follows:

Women's bodies were seen to be innately different from men's and, [Jill] Dolan (2012) observed, the 'female body stripped to its essential femaleness communicated a universal meaning recognisable by all women' (62). Women used their body in performance as an alternative to the symbolic order of a man-made language ([Marvin] Carlson

1996) which many feminists claimed provided no opening for the representation of women within it.

(2000: 24)

Thereby, through Boliver, we witness a figure that is incorrectly considered to be without purpose, beyond becoming, no longer virgin, mother or enchantress, who is now relegated to the role of a wise elder or even a haggard crone. Boliver challenges these archetypes through orgiastic displays of rapture and acts of enquiry into herself – a shared Being – manifested through the presence of those who witness Boliver's body before them.

Series Notes

Boliver, a former teenage model turned Mexican news anchor, now in her 'third-age' most recently entered the realm of extreme performance art – a definitive act of rebellion to reclaim her body. In an interview she said of her practice that she attempts to

> demystify the horror of old age in an ironical way, inventing my own deranged aesthetic and moral solutions for the 'problem of age'. I hope my mockery of this absurd contemporary reality exposes a broken society based on looks and how old age became synonymous with insult.
>
> (Hemispheric Institute 2014)

Boliver is aware of the perceptions of the ageing woman; the archetype of the hag is a patriarchal domination of the ageing female body she seeks to destroy. She subverts, explodes and reinvents herself entirely through direct action upon her body in front of the gaze of an audience, with unrelenting anarchic joy.

When witnessing Boliver perform first-hand, one experiences a chaos surrounding her filled with both joy and tension. All of which can at first feel impenetrable, though it is the potential sense of judgement this creates that Boliver's methodology uses to expose the very hegemony she seeks to subvert. In further discussion of *Beauty by Design*, she reflected upon how those present transcended through the performance with her

as 'people went from rictus to joy'. This metaphorical ejaculation highlights a sense of the shared orgasmic experience she created together with an audience, echoing the rapture the lived body can share. Even though no two beings are alike, this difference enhances the intersubjectivity of the moment, undoubtedly afflicting and affecting the way they perceive presence and indeed any experience. Her words capture an emphatic release. Heartfelt, she continued to speak with me about the value of pain that would create a 'crescendo' within her, but most intriguing is her experiential account of the post-performance. After holding the space for all present, creating an explicit sense of risk through our perception of her, she felt the weight of this release revealing the emotive weight this encapsulates for her, but it is her last words that move her towards Gnosticism that are most profound. The etymology of this is found throughout orthodox Christianity; an esoteric notion that evolves away from the 'evil' sin of materiality in a journey through knowledge towards the divine and Gnosis. Like rapture this is not an exclusive religious reference but an indication that evolves Being beyond its restricted corporeality and towards the potential for intercorporeal states.

Louis Fleischauer

Artist image 11: *Primordial Kaos Invocation III.* Tempting Failure 2016. Photo: Julia Bauer.

Louis Fleischauer (he/him) creates a series of actions in response to his 'Flesh Art Manifesto' of which the following is an excerpt.

> Flesh Art is naked, raw and under your skin. Flesh Art is the animal inside you that screams for survival, it is your body that longs to be explored, it is your mind hungry for change. Flesh Art is pure, without dogma, ideologies or 'illusion of morality'. Flesh Art is the seductiveness of an open wound, a symphony of desires. Flesh Art is the invocation of primal energy as an answer to a sterilized, consumer friendly reality shaped by a mass media to breed one homogenized people [...]
>
> Flesh Art does not believe in censorship, the Artist dos not compromise. Flesh Art does not define itself by the amount of people that like it, but by the energy it invokes. The artist uses its body to its fullest extend. When the artist bleeds, it is not about pain, but catharsis and transcendence. When the artist opens its flesh it is not about shock but evolution. Why is it socially acceptable to destroy

our body by feeding it poison, but decorating this temple with scars is not? We are all made of flesh and blood, thus we celebrate our body by exploring it.[2]

Embodied Writing

The performance [Pure Kaos against Total Control] took place at an artist compound (Demeure du Chaos, near Lyon). It was some sort of a bunker; when we entered it was more crowded than we anticipa ted, so the placement we mapped out was no longer valid. Since most of my work is improvised, responding to the environment I encount er, this was not a big problem. We went on stage, I did a speech, then we measured the brainwaves of two of our performers while they were getting pierced. We connected two people with a metal coil joined to flesh-hooks in their backs. This coil (an industrial length of spring) was [electronically] amplified and the audience were invited to drum on them. This spiralled the energy through the room and now I was ready to suspend. We took a measurement of my brainwaves and processed them into [a sonic] drone. A bucket of cow's blood was poured over a naked performer, and she crawled through the audience, distributing the smell of the blood [...] The suspension ended and I took needles out of my head so that blood was running down my face, blinding me for a moment. [...] Then the ritual went outside where we suspended two other performers (that were previously conjoined by the spring) from an industrial crane. During this I chanted into a megaphone and danced [...] The police were waiting outside.

Contextual Discourse

When Francis Bacon created his triptych for *Three Studies for Figures at the Base of the Crucifixion* (1944), the spectator was confronted with the beautifully bestial and monstrous. Though Bacon would later relate them to vengeful furies in classical Greek mythology, transgression con- fronts us in the witnessing of these three imposing images. Each figure is caught in twisted, distorted, and agonising poses, displacing the saints

that had been found – notably in Renaissance paintings – at the foot of Christ on the cross. Abstractions of pain, through the immediacy of each figure affects our apprehension of the visceral from within our spectatorship. Performance art is perfectly placed to take this further; subverting the safe distance a painting holds and bringing the act to the immediacy of the live encounter. Amelia Jones asserts in this regard that 'self-wounding performances, albeit often known through documentation, can, through activating a relation of pain in and through the body of the artist/performer collapse the "painter" or "agent" (the person who represents the suffering) with the unfortunate sufferer' (2009: 49). Pain induces empathy as we all have the potential to experience some form of pain, though how that manifests through the body may vary. Jones highlights this, and we would argue that a clear correlation to rapture is obvious. Christianity is built around symbolic imagery of suffering in the journey towards the divine. As Jones writes,' [w]hen allowed expression in the public arena, the wounds in confrontational yet aestheticized s/m [performance] works [...] tend to provoke perceptions that, on the part of each individual spectator, trigger painful memories and thus difficult feelings' (2009: 52). To what extent this is true is debatable depending on our relationship to sadomasochism (s/m) or indeed our desire to access trance and euphoria through acts of suffering, such as in the Modern Primitive (Juno and Vale 1989) actions of Louis Fleischauer. However, as Jones continues, she underlines how for the recessive spectator (see Chapter 4) such encounters connect us directly to the act in front of us, the artist, and arguably for some spectators, this may lead to their own empathic connection to transcendence or rapture.

> If accepted rather than disavowed, these feelings in turn have the potential to inspire in us a visceral empathy, the effects and meaning of which depend on the context in which we experience the wound and our porousness to its effects (our memories and projections, which relate to the extent of our own wounding and thus our capacity to bond with the wounded body sympathetically or empathetically).
> (Jones 2009: 52)

Series Notes

Fleischauer refers to his practice as 'Flesh Art' (Fleischauer 2018) and the actions as invocations. He creates improvised actions around flesh hook suspensions and sonic art production that are typically ritualistic for the participants. His manifesto on this movement makes consistent reference to rawness, nature, and a return to the physical – a primal energy – lost within the recessive nature of the normative body. Of particular interest is the following statement Fleischauer makes:

> Nothing separates us further from our selves than the neurotic need for Order and Control. We fear the unknown, the unpredictable, anything that is even closely related to the primal forces of chaos. We hide away in a system entirely built upon Order, we sacrificed our sense of wonder, we lost our magic, we have no more creative food for our minds.
>
> (2018)

His rituals of breaking the skin and hanging bodies by piercing the flesh attempt to empower a return to what he believes many have lost the ability to experience.

In a subsequent conversation he recalled how '[t]he exhaustion of my body holds an afterglow that comes with completing the exorcism'. Continuing, he expressed how the process of a Modern Primitive (Juno and Vale 1989) ritual sharpens his experience of the world, his connection to the audience and how his body is material, 'I look at things weeks or months later from a different perspective. I have a comfortable melancholia. My instincts feel sharper.' As Francesca Alfano Miglietti highlights through reference to Elaine Scarry (1987),

> Physical pain can cancel out psychological pain because it annuls all of the psychological contents, whether they be painful, pleasurable or neutral. Our acceptance of its capacity to put an end to madness is one of the ways in which we, consciously or unconsciously, recognise its power of putting an end to all aspects of the self and the world.
>
> (2003: 35)

This is the transcendence towards rapture. The universal euphoria felt in the audience of Fleischauer's 'exorcism' that destroys a central Cartesian subject and opens the lived body to be encountered through

use of the materials he lists as '[s]ound, human skin, pain, euphoria, energy, audience and my body', a flesh implicated in both the phenomenological and the corporeal.

Every latrine is a drawing room, every drawing room a latrine. The distinction between
sublime and vulgar no longer make sense. We are hidden beneath our opposite.

(Lea Vergine, *Body Art and Performance*, 2000: 16)

Weeks and Whitford

Artist image 12: *Insult to Injury*. Tempting Failure 2018. Photo: Holly Revell.

Rebecca Weeks (she/her) and Ian Whitford (he/him) say in their programme notes that

[a]s ever the work is highly personal, revelatory and reflects an ongoing lived narrative focused on the recent experience of physical and mental illness and resultant estrangement which has led to a consideration of how we use sex and substances to cope with heartache, and the work of reconciliation.[3]

Embodied Writing

Whitford: I started by sitting on the bed smoking cigarettes with my legs apart, elbow on my knee holding my head in my hand in the same way my grandfather used to. (He was dying of lung disease and I helped him with various chores when I was a child.) I had an anchor chained to my ankle. I drank from a bottle of wine with a glass ship inside that was slowly revealed the more I drank from it. I took a large hourglass from a suitcase under the bed and smashed one end of it with a hammer so the sand could run free, I let it run over my face and body. I walked up to audience members and let the sand pour into their hands.

 Weeks: I circled with a bowl of milk and drank wine spilling it down myself into the milk and leaving spillages in my wake. I left this action at intervals to summon my [sissy] slave (Julie) who would crawl to me with money in her mouth. I would pass this over my shoulder and scatter it on the bed. I then engaged in BDSM activities, foot worship, human ashtray, spitting chewed food and wine into my slave's mouth. I then returned to circling with the bowl. This alternation continued for some time. Then I bound Julie to the bed and sat on a dildo gag and masturbated till orgasm [...] I left this action to take the horns to Ian and bandage them to his elbows [...] Then I knelt and summoned Julie to worship my feet while Ian blew the egg into my mouth. I took the wooden figure Ian made and wrote on the wall with it.

 Whitford: I prodded my face and body, inspected my various cavities with a torch and implements from the suitcase. I ate fortune cookies and if I liked a fortune, I pinned it to my chest with an acupuncture pin. I circled the bed dragging the anchor behind me like Jacob Marley in pursuit of Rebecca. I spat pearls at Rebecca and her slave from my side of the bed. I tied a brick to a boat rope and cut open the crotch

of my trousers and tied the other end around my genitals and dragged this around the bed along with the anchor. I crawled under the bed and gripped Rebecca's legs. I carved a small goddess figure and gave it to Rebecca who burned the end and wrote 'Faith' on her side of the wall with it. She gave it back to me and I wrote 'Hope' on my side. I put pins through my fingers and tied puppets to them using them like T-bars from a boat – an old broken male puppet, a veteran of many performances, and a new gypsy girl puppet on the other hand. I sat on an old leather sofa and watched Rebecca and the audience with my arms outstretched with the puppets on each hand. I pinned butterflies to my chest from a glass case I smashed, I fought Rebecca on the bed trying to make her submit and be still. I shredded all my medical appointments and reports with a hand cranked paper shredder and got the audience to help, specifically an old friend that had helped me when I was in the depths of despair with my illness. I buried myself on the bed in the shr edding. I played the harmonica. I emerged and Rebecca bandaged bull horns to my elbows. I blew an egg into her mouth. I turned out the light and we lay on the bed together. The light went out.

Contextual Discourse

Illness opens up an alternative experience (Chapter 1) to a phenomenological world through the Dis/Abled body and alters the world experience also experienced by the caregiver as well. Following a hiatus from performance, Rebecca Weeks and Ian Whitford continued their ongoing autobiographical series by responding to a recent period of intense illness for Whitford. *Insult to Injury* (2018) was the culmination of trauma; it was the expulsion of the abject; it was a celebration of survival. In advance of the performance, they described this as a ritualised reaction to a

> period of illness, mourning, estrangement and survival that has pushed them to their limits. Asserting life and love with its many difficulties, kinks and complications over grief, disability, addiction, and fear, this complex durational work reflects an ongoing process of disintegration,

renewal and transformation. The work is a rite or a prayer because, at points, performance is all we have.

(TF 2018)

Invoking the notion of Befindlichkeit, this artwork accessed their felt experience of the extended period of illness. It captured a moment in time, a crossroads of the couple's lived experience that could manifest cathartically while held in a space that acted as an abstraction of their private lives – an intimate and private setting that would symbolically reference their lives, centred around an elegant bed.

Befindlichkeit comes from the Heideggerian proposition that feeling or affectivity alters truth. Bruce Baugh notes that it is unusual to consider the philosophical effect of feeling as it is typically seen as too problematic for empirical truth, stating that it takes 'the mind not out into the world, but into itself, making feeling "inner" and "subjective" ' (1989: 124). Befindlichkeit, however, allows the phenomenologist to access subjectivity, but as Michael Wheeler clarifies in the *Stanford Encyclopaedia of Philosophy* (SEP), if we interpret this as 'state-of-mind' it would be an inaccurate application and a 'misleading translation of Befindlichkeit' (2018). As a countenance, Befindlichkeit was proposed by Heidegger (1962) because mood must be considered significant in its affect upon alētheia. The *SEP* makes the analogy that '[w]e talk of being in a mood rather than a mood being us'. However, mood was not external to Dasein but rather part of being-in-the-world. As Johnston notes, it allowed the 'worldhood of the world [to be] revealed; it discloses the structures of human involvement in the world' (2017: 121). Merleau-Ponty would later adopt this beyond Heidegger, furthering the former philosopher's apparent reticence to engage fully with subjectivity and moving being-through-the-world towards the lived body.

Contextual Discourse
The Befindlichkeit in *Insult to Injury* has its locus in the bed. Placed at the centre of the room, it captured – in the same way it would outside

of a performance space – life, sex, illness, peace, despair, sleep and, on this occasion, a grief for death. It became filthy with the detritus of life, recalling Sara Ahmed's (2006) notion of disorientation, we bore witness to Weeks and Whitford sense of loss and sense of finding themselves once more. Held by the stability of the bed through this journey, we watched them ritualistically unpack their *posteriori*: a shared experience of the illness of life. Engaging the queerness of such a state, echoing Havi Carel's (2016) notation upon the absence of normativity that illness can embody, the Dis/Abled bodily experience of Weeks and Whitford affected the Befindlichkeit revealed through *Insult to Injury*.

Series Notes
The intensely biographical nature of this piece filled their actions, navigating a relationship that saw their struggles through love as a couple, navigating illness, and possible death alongside the realities of life and sex work. It was beautiful and painful. It was rapture through a phenomenological flesh, to be held in the space together. Through an intense life-altering illness, we found the Dis/Abled body confronted with its own mortality as '[d]eath is the point at which Dasein can take up the possibilities of life in relation to the fact that choices will one day have an end' (Johnson 2017: 124). In conversation, almost a year after the performance, Weeks and Whitford shared how they saw their bodies as prosthetic or shell-like. They spoke of becoming divining rods, transmitting to others. They gave over the trauma of their real lives, and through sharing this risk, we invested in the experience entirely. We discovered a sense of becoming through queerness that the space held; the durational work transformed the performance venue occupied by the couple for eight hours into a private boudoir, complete with four-poster bed and a museum of curiosity. Lea Vergine's writing resonates here as the 'distinction between sublime and vulgar no longer make sense' (2006: 16), when the world becomes so complete that we are allowed to share a space that would normally be behind closed doors. Ecstasy and self-care were complicit with struggle and resolution for the mortality of not only Ian Whitford but also Rebecca Weeks through her care for him. A shared notion of death is an entirely unknown and uniquely

personal perspective for each Befindlichkeit. Indeed, Heidegger said of this undiscoverable phenomenon, that '[n]o one can take the Other's dying away from [them]' (1962: 240), and he called this being-towards-death. However, through being-towards-death, 'instead of seeing death as a thing, Heidegger sees it as a possibility to essential life. As a phenomenon in life, that can take up a relation to our own death as something is certain and something that is most our own' (Johnson 2017: 121), which were witnessed in the encounters between all three participants, the room imbued with a sense of erotic grief.

The air felt thick,

sweet,

and filled with the scent of

sweat,

cum

and sex.

Rupture

Rupture of the corporeal form in performance art is beautiful; a brave exposure of Being, it is also a process of removing any barrier of concealment; it extends the potential perception of alētheia (Chapter 1).

Alētheia as an affirmation of beauty is rather too simple a definition for its use within phenomenology. But through Heidegger's appropriation of the etymological Greek origins, meaning truth or quite literally and *unconcealed-ness,* the word implies a process rather than a fixed definition (Henriksson and Saevi 2009). Alētheia occurs across a period of time; it extends immediacy. We find a commonality in Heidegger's use of the word with that of appearance, or perhaps in this book's language, a dis/appearance, whereby we may imply through this a space, where things 'appear to us in a bright glade, but simultaneously they withdraw themselves' (Henriksson and Saevi 2009: 38), where phenomenologically a momentary light may shine.

Heidegger states, when writing about appearance, 'Beauty is one way in which truth occurs as unconcealedness' (2001: 54). Through momentary actions alētheia appears to us, explicating,

[b]eauty does not occur alongside and apart from this truth. When truth sets itself into the work, it appears. Appearance – as this being of truth in the work and as work – is beauty. Thus, the beautiful belongs to the event of truth, truth's taking of its place.

(2001: 79)

From this, one cannot imply that all artwork will find the same level of beauty or truth, but we may argue that rupture directly affects perception. The rupture of the corporeal form is a rupture of a shared flesh, which extends beyond the artist's body and affects the passive audience who project a shared fundierung through one another. To penetrate, to intervene, or to defiantly rupture a corporeality, are transgressive experiences; each forces a recessive spectatorship of the viewing to a place of visceral and, most importantly, active engagement. As Jones states,

[t]he difference between performative woundings that become simply spectacular and those that retain the sharp edge of political agency is never inherent. It lies in their capacity to provoke empathic identification in specific viewers – and thus is in large part contingent on viewers' own sets of references and potential to open themselves to the act of wounding.

(2009: 56)

The action and the artist must find harmony within this, but equally important is the reciprocal relationship between all present. From the experience of an artwork in anticipation through to its performance and the aftermath, there is a reciprocal projection of each person and a unique insertion, an entwining of Self/s through the immediacy of the performance art encounter.

As the practice of Athey straddles rapture and rupture, it is perhaps useful to invoke him once more to illustrate the empathic response to wounds as well as notions of a transcendent beauty – an alēthcia 'unconcealed' – through the performance artist's body as artwork. Reflecting upon Athey's practice, Etchells writes:

Athey uses performance to stage a [...] compelling double insistence [...] related to the body. Each work in different ways invokes both the materiality of the body and its link to the immaterial – the body as brute flesh on the one hand, and the body as living container of consciousness and transcendence on the other.

(2013: 227–30)

Rupture compels perception towards binaries of attraction and repulsion, neither negates alētheia – the grotesque may always be witnessed as beautiful – but rupture forces reaction; it is the most obvious catalyst of risk. Etchells continues, noting,

Athey's work exists in the fraught twin spaces of the theatrical/factual, the imaginary/ actual, the bodily/fantastical, such that these troubled, if not collapsed binaries braid constantly around each other; we are never in one space but rather, always between two. The actual always and at all levels is remade as imaginary.

(2013: 227–30)

The construction of the performance artwork unfolds through actions that dissect the theatrical construct with the truth of an actual corporeal body becoming ruptured. The transgression of normativity is not to shock but affect the 'felt-response' within the other. How one viewer may love the experience and another may despise the action before them does not negate the value of such artwork as these variations demonstrate the reciprocation between all lived bodies affecting the fundierung of Self/s. Our shared investments and responses are infinite. The implications of these are both problematic and wonderful as we signpost the potential for the ruptured body of the performance artist *becoming* artwork.

Hellen Burrough

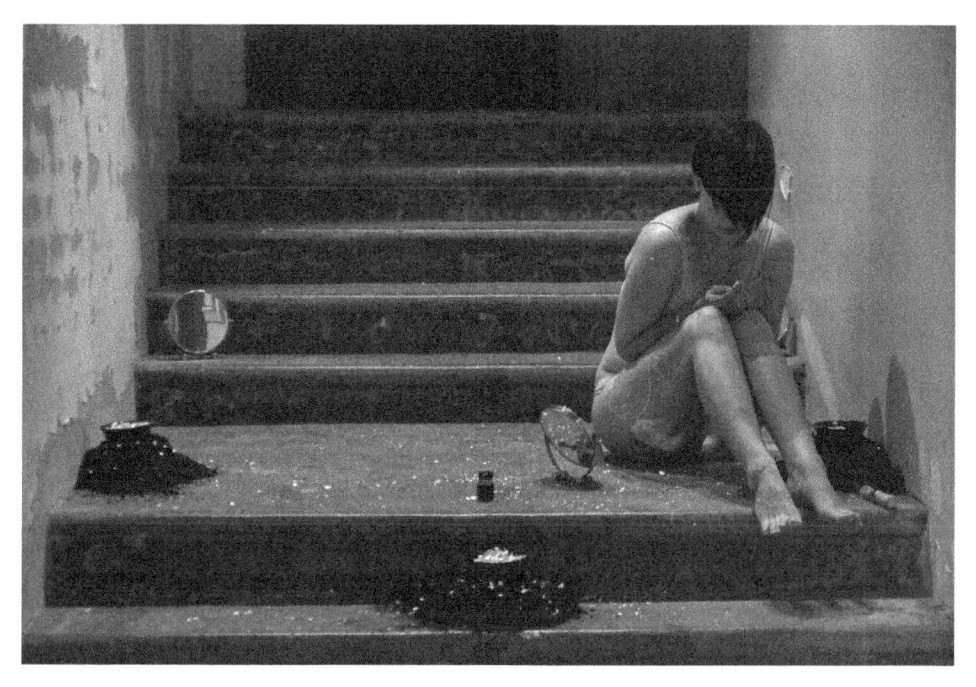

Artist image 13: *Kintsukuroi: Golden Seams.* Emergency 2016. Photo: Gary Cook.

Hellen Burrough (she/her) describes the work in her programme notes as, '[o]ver 3 hours I gild each one of my scars with gold leaf. A ritual of memory and repair'. She continues by defining the practice of Kintsukuroi as 'the Japanese art of repairing broken pottery with lacquer dusted or mixed with powdered gold, silver, or platinum. As a philosophy it treats breakage and repair as part of the history of an object, rather than something to disguise'.[4]

Embodied Writing

I'm not trying to 'repair' myself from this 'damage'. I'm not trying to repair anything through this process. I'm honouring the value of these scars and how I feel these actions, these ruptures in my life and in my body that have caused them, are valuable.

Contextual Discourse

Burrough's body is a document of the intensity of her life and artistic practice to date. Sculptural, there is a significant beauty in the scars left from each incision and piercing it has endured. Her work is powerful, extreme, and precisely designed. It will often involve placing her body in extremis where she may encounter significant pain, endurance, or blood loss through binding, piercing, body modification, or suspension. Her practice focuses upon 'the transgressive feminine body and examines ideas of romance, intimacy, pain and healing' (Burrough 2018). In her discursive paper entitled, 'The mutant woman: The use and abuse of the female body in performance art', Imogen Ashby discusses the importance of practices indicative of Burrough's, to realign the perception of risk for women in performance, stating

> the particular ways in which women have put their bodies 'at risk' or have sought to 'open up' their bodies, have remained undocumented. In part, this is because women artists have always used their bodies in performance but not in the same extreme ways men did. Ono, Pane and Abramović have worked with risk, if in a different and distinctly more feminist way than their male counterparts. This is perhaps because the issue of pain and bodily injury has very different connotations for men and women but also because of the difference in the way the male and female body is perceived.
>
> (2001: 41)

Burrough's *Kintsukuroi: Golden Seams* (2016) honoured her personal histories. Literally meaning 'golden repair', Kintsukuroi is the Japanese practice of repairing broken pottery with a lacquer that is combined typically with a fine dust of gold to restore the object to a state

where its value has increased despite its flaw. It treats this act of repair in a way that would honour the break rather than hide it in order to capture the history of action that saw the break occur. Inspired by this, Burrough created a durational action as a 'ritual of memory and repair' (Burrough 2016) to gild each of her scars on her body with gold leaf.

The materiality of the body becomes phenomenologically pertinent to the dialogue Burrough enacts with the body. Skin is a liminal barrier that is both temporary – literally regenerating every six weeks – and fixed through the points of intervention, held in scars. Merleau-Ponty notes, 'The person who perceives is not spread out before [her]self as a consciousness must be; [s]he has historical density' (1945: 277). Such density is what becomes apparent through the ritual of *Kintsukuroi: Golden Seams*. When discussing her own healed wounds, Burrough said,

> I am not a person who feels bad about any of the scarring that I have [...] some of them are accidents, some [...] are bad things, some good [...] some of them are performance things. It's just where my body has been and where it is presently.

Kintsukuroi: Golden Seams takes place in a durational space where time was foregrounded for the act, where the temporal becomes a focal point. Burrough held a body in flux, writ with histories; her use of Kintsukuroi not a process of emotional mapping, more one of working with the mutable form that scars may hold, echoing Merleau-Ponty's writing that 'we are given over to the object and we merge with into this body which is better informed than we are about the world, and about the motives we have and the means at our disposal for synthesising it' (1945: 277). Indeed, Burrough became aware of this synthesis of herself and the mutable form of her scars through the process of the action. She noted how this became a use of 'a different stage of wounding' as she traced the pathways of previous ruptures.

Series Notes
The incision into the body highlights its potential as object but the body is intrinsically subjective, the possibility for a flux between the two

merges when we consider scars. They help us to consider the intersub-
jective nature of Being: from without within, we manifest our percep-
tion of Burrough together as she gently gilds these shifting personal ley
lines across her body. Processing the corporeal presence's materiality,
Burrough's awareness grew that her 'scars were not static'. Affected by
age, hydration, time, or exposure, they mutate. Reflecting upon this in
a later conversation she said, 'Some of them don't shift at all. And some
of them are in constant flux. And that's something that really appealed
to me about scarification as a body modification. That it's part of your
body, your body is creating this', it is a collaboration of being with time.
She continued,

It's not like a tattoo which is applied externally and relatively controlled.
A scar, once you make that cut, your body does what it wants, and con-
tinues to do what it wants over time. [...] that is what makes this piece
interesting for me, [it is acknowledging] my body operating without my
control.

As Johnstone states, invoking Heidegger's *Being and Time*,
'[t]emporality must not merely be thought of as an appendage to the
present moment' (2017: 41). Immediacy traverses the present moment.
Burrough's scars illustrate both the present and the past as she highlights
her previously ruptured presence before an audience. Each encounter
within the moment is immediate; both beyond and pre-action of the
cutting there is an intertwining of presence across time. Kira O'Reilly's
Succour (2001), which saw the artist demarcate her body into equal
sections before inflicting a single cut in each, was noted as bringing
'into focus a visual and visceral vocabulary that invokes notions of
trauma (a wound) and stigma (a mark) towards a "spoiling" and
opening of the body to explore an alterity or otherness' (NRLA 2001).
Kintsukuroi: Golden Seams revisits this language anew, reinvigorating
Gianna Bouchard's writing by offering 'ways to think through [female]
flesh [upon] the politics and ethics of consent and proprietary rights in
the body' (1999: 95–96).

I was my anus.

<div align="right">(Arianna Ferrari on CLOACA 2018)</div>

Arianna Ferrari

Artist image 14: *CLOACA*. Tempting Failure 2018. Photo: Julia Bauer.

Arianna Ferrari's (she/her) programme notes state,

> After ingesting a quantity of laxatives and diuretics the performer inserts a catheter in their bladder and a tunnel plug in their anus. The performer loses control of their sphincters. A number of contact microphones are attached to the performer's belly, detecting the sounds of their intestines.[5]

Embodied Writing
I take one and a half suppositories of laxative, I wait 30 minutes for it to work. I enter the space where I previously placed a bottle of water, a

catheter, anal lube, and a tunnel anal plug. I disrobe quickly. I sit down in a corner of the room. Proceed to lube the catheter with the water then I insert the catheter. Urine starts spilling from the catheter. Now the area on the floor where I am sat is wet. I attach two contact microphones on my belly. I lube my anus and the plug with the anal lube. I insert the plug in my anus. I lay down. My legs slightly spread. I focus on my bre athing. 1234 inhale, 1234 exhale. I start to hear a booming sound, the echo of my empty stomach maybe. Once in a while I hear belly noises, like a faraway eruption of a volcano. I keep breathing, slowly and regul arly. The noise of my 'inside' keeps on booming. One of my feet, the left, starts to slide on my piss. I don't fight it, I let it slide and my leg gently and slowly falls on the floor.

Contextual Discourse

Ferrari's *CLOACA* (2018) takes us towards her embodied experience through a disembodied state. 'I was my anus', she said in an inter-view as she released conscious control of her self-determined functions. Through the induction of drugs and physical intervention, we become observers (along with her) to the operation of her lived bodily experi-ence of her renal and digestive systems: an embodied disembodiment. This release acted as a symbolic defiance of heteronormative contain-ment and control – a transgression against patriarchal dominance that speaks for the urgency for self-determination over the female form. With reference to Luce Irigaray (1985), Counsell and Wolf highlight the importance for female bodies such as Ferrari to queer normativity with forthright interventions such as witnessed in *CLOACA*, noting,

> Irigaray has consistently focused on the way women are excluded from both the cultural and the socio-economic systems of patriarchal society. [...] Represented only in relation to man, women are thus denied any means of self-representation. [...] [drawing] from Marxist economics to critique [these] anthropological theories [...] founded on the exchange of women [...] the rules of exogamy and endogamy effectively determine what relationships can be formed.
>
> (2001: 59)

Ferrari's own actions became the focus of outrage in the right-wing media, as tabloids revelled in the salacious headlines *CLOACA* could create while Conservative counsellors and extremist bloggers sought to 'other' her right to create queer actions and condemn her artistry (Bacon 2018a). Writing in *The Stage*, I noticed that '[i]mplicit in the commentaries was the idea that such radical acts could never be called art' (Bacon 2018b). The notion that a woman could be empowered through acts that were a release from control were controversial. The queered body of Ferrari challenged the notion of women as 'tokens within a male symbolic or economic system' (Counsell and Wolf 2001: 59), disrupting the identities imposed upon them as no more than a 'function of their value to men' (2001: 59).

Series Notes

Interviewing Ferrari, she was asked to recall her sensorial memory for the action, to which she noted:

Calmness and relaxation: I am serene. I hear a noise that may not be coming from me. I am disturbed. I start to feel very cold. I get very worried. I am losing the contact with my body I am returning to my head. I want to shit. I want this to be over. I want to push the shit outside my body. But no, that's not the point of my practice. I am thinking now. It's already over.

To be in the moment but not in control of her conscious thought was the intention of this work. To be free. This exploration – an expression of freedom – was momentary, yet its impact for many who never even encountered the action first-hand extended the immediacy beyond the live action. It marked the beginning of Ferrari's continuing enquiry into how 'leaky bodies' can challenge fascistic systems of control (see Chapter 4 and postface). 'The project of [Heidegger's] *Being and Time* [was] not meant to be exhaustive in its description of all human experience [...] Temporality [was] the key to [...] rethinking [...] the meaning of Being' (Johnstone 2017: 45). Heideggerian being-in-the-world suggests Ferrari locates Dasein in relationship to the critiques and objections

of others as a set of referents to distinguish between one another or in this case 'reactions'. Ferrari's *CLOACA*, however, relocates immediacy through Merleau-Ponty's being-towards-the-world as her experiential account guides us through her opening to a sense of visceral presence in the moment, returning us to the intention of the work to be present within felt lived experience of the body.

Exercise 10

There are many excellent ways to practice mediation. A body scan can be the simplest, but lots of guides will suggest different ways of doing this. Asking your mind and body to 'be present' is a skill that we must learn to develop. Whenever you attempt to mediate, try to insert a moment that embraces your mind wandering either due to physical or psychological frustration/distractions. Note each by sitting within the experience of them in your mind's eye and then returning to becoming/remaining present in the mediation at hand. This simple task will enhance your focus and expand your perceptual awareness of the world around you. Try to apply it to the following exercise:

1. In your group you should split into pairs.
2. Decide who is A and who is B.
3. Remove watches and phones or any devices that indicate time.
4. You will be going for a silent walk and B's will lead the way.
5. A's will follow their partner, maintaining a ten-second gap between them.
6. You should walk for 20 minutes and return to your studio within what you perceive to be that time frame.
7. As you journey through the world you encounter, try to remain present in the experience of everything you sensorially witness. Note these things by naming them with a single word in your head.
8. When you return to the space, locate yourself opposite your partner. As each new partner enters, try to divide the space in interesting ways when placing yourselves in situ to each other.
9. As soon as you are in situ, start to recite the things you noted. Keep looping until everyone is present and finish the loop only when complete for the last time. Keep the words in order as best you can and only

speak the notes out loud as they occurred in real time. For example, if you saw a squirrel and then a dog 60 seconds later, only say dog 60 seconds after saying squirrel.

10. A unique soundscape will be created the more you overlap. Be aware of not only your partner's experiences in correlation to your own, but also other people's journey and this new soundscape that you are embodying.

11. Once complete, take at least 30 minutes to debrief and explore the multilayers of experience you noted as you attempted to remain present.

Adaptation: It is important to practice forgiveness; remember to be kind to yourself! If you get distracted and are unable to follow the guidelines at the start of this exercise, embrace the failure. We often incorrectly consider failure as a negative. Instead try to use it as a provocation to explore further.

Furthermore, if you are in a situation where you are unable to go outside, take the journey through the memory of a previous experience. Or, if you do not have a partner to practice with, simply follow the same exercise – without following anyone – and allow yourself to walk mindfully (without a plan, but remaining present to the entire experience).

Ernst Fischer

Artist image 15: *tjb, post-performance image of xis own hand following PASSION/Flower.*

Ernst Fischer (he/him) has collaborated with a number of other artists, including Nicola Hunter, jamie lewis hadley, and tjb, to perform *PASSION/Flower* . My own programme notes say the following of our two iterations of this work,

> Inspired by a ritual known as Matam, which takes place in the Shiite ceremony of Ashura, *PASSION/Flower* transcends its origins, becoming an action that opens the body to a trance state of rhythm & ritual practice, that the artists intentionally interrupt.[6]

Emboided Writing

I attached small pins stuck through plaster strips to the three middle fingers of my right hand (two pins per plaster/finger). I entered the venue (a large 'greenhouse' constructed from discarded wooden window frames) through its main door, carrying an old suitcase, which some years previously had been painted white. I wore brown, loose-fitting trousers with elasticated waist, a light brown shirt with large buttons and two side pockets, and a pair of black, scuffed army boots. Once I reached the front of the performance area, I lowered the suitcase, laying it flat on the ground, and – squatting down facing the audience – extracted from it a plastic bottle of water and a portable CD player – if I remember correctly, the CD player, which was provided by the festival's produc tion team, was mainly red. I then took off the shirt, baring my chest, flipped the suitcase upright, and sat on the side [on top of the] handle. After turning on the CD player (the soundtrack consisted of two Early Music tracks by Byrd and Palaestrina), I closed my eyes and proceeded to rhythmically beat the left side of my chest with my open right hand, which was covered by the left one. The action was periodically interr upted by turning the CD player off or on, shifting between tracks, or adjusting the volume, by taking sips of water, or by moments of stillne ss. The rhythm of the beating changed in an unplanned fashion. After approximately five minutes, tjb also carrying a suitcase and wearing a similar outfit, entered the space, positioned xemself behind and to the side of me, and performed their own version of the described actions. Approximately fifteen minutes later, I stopped hitting my chest, rose, slipped back into my shirt, returned the water bottle and CD player to the suitcase, lifted it, and left the venue the same way I had entered it. tjb joined me about five minutes later outside the venue, while I was smoking a cigarette.

I have and had no emotional engagement in these actions. I simply 'observe' my body and the atmosphere surrounding the performance, listen to the sounds of my collaborator(s), and/or think of my next step: should I change my rhythm, skip to the other music track, or simply sit still? I feel the air currents on the skin of my torso, and after a while become aware that my arms are growing tired. I focus on hitting the same small area of the chest, trying to create a circular wound, and attempt to gauge how much blood the wound produces. The pain of the pins piercing the skin is minimal: a tingling and soft burning.

Contextual Discourse

PASSION/Flower (2006–15) furthers our opportunity to consider the entwining of Korper and Leib (Chapter 1) through performance artists in collaboration. Queering the Matam ritual, the action focuses on the aesthetic and intentionally disrupts the ritual's transcendence. The de/constructive nature of the action, interrupting its own crescendo, affects the potential for presence to be lost into a transcendental state. In contrast to the Modern Primitive (Juno and Vale 1989) styled 'invocation' performances of Fleischauer, Fischer has produced a work to question ritual as transcendent experience, that, as with Ferrari, offers an objective and subjective enquiry but takes it further by actively controlling the experience. He said of this process,

> Distance is a good term, because I feel like a performer and an observer at the same time. I'm aware of my body, the slight pain, the rhythm. Clearly, I'm not a Muslim, I don't have a religious or spiritual relationship to the action, unlike the people in Iran or Iraq who do it and I've also chosen to play Christian Church music to accompany the action.

Fischer's intent is to produce what he describes as a 'kind of hopeless action', a state that cannot transcend itself; it is grounded, but in doing so it creates a uniquely objectifiable enquiry. The harmony of two Leib-like essences are grounded by their Korper bodies – interrupted. The action of each lived body is locked into a ritual without culmination. Both bodies bleed, which we are taught implies suffering, yet neither Being seems to be in pain, nor do they seem to be rising above; they are merely present, stopping and starting, pausing to drink water, to listen, and to change their accompanying soundtracks. Fischer reflected on this in a conversation recalling,

> [A]fter the second or third performance of it, some acquaintance of mine had seen the performance and had said they liked that it disrupted or interrupted itself. [...] The action itself is interrupted by drinking water and stopping and starting the music track, so it became a kind of integral part of the performance. [...] I want to absolutely resist some spiritual, emotional state [...] it's only when I talk about it, I acknowledge a link to religious fanaticism, and that if anything

I want it to be a critique of it, and not for the performers to reach that point of transcendence.

Merleau-Ponty would ascribe this as experiencing 'a participation in the world, and "being-in-truth" is indistinguishable from being-in-the-world' (1945: 459), which as an encounter that is entangled through the subjectivity of the lived body leads an audience towards a shared experience of being-towards-the-world. A world open to be experienced through the flesh of the encounter, intersubjectively and intracorporeally.

Series Notes

Fischer has performed many variations of the action with numerous collaborators over the years, the most notable of which were with Nicola Hunter and tjb who both staged the work with Fischer separately on repeated occasions. The following is our own account from the first performance we did together in Berlin in 2014 at *Das Theater der Zukunft* for the *Month of Performance Art*:

tjb: The score of the action saw Ernst Fischer entering the space before me. I waited outside of the building and could hear the soft choral music emanating from inside. This was accompanied by the sound of slapping of skin. Navigating through those who stood close to the entrance, I joined Ernst. Took the CD player and water from the suitcase and removed my shirt. Both of us were dressed in a similar manner, the brown/beige clothing of transient peoples circa early twentieth century. The score of the action meant that there would be a period in which we overlapped. Slapping the pins repeatedly into the same position on the chest, we were to create a bleeding rose effect on the left side of the chest, in line with the heart. When doing so, I closed my eyes, only to open to reset, sip water, stop/start, or turn the accompanying music on or off. At times our syncopated rhythmic slapping between us would synchronise and we would separately try again to disrupt that harmony.

After fifteen minutes, Ernst left the space. Not looking towards him, I observed this through a shift in the presence the space held. Continuing alone, it was easier to potentially slip into another state, but the pattern of self-interruption helped to stop this. I returned my belongings to the

large old-fashioned suitcase that had provided a chair to my action. Put my clothes back on and left.

I recall the action being a mix of emotions, my attempts to navigate this and remain distanced were at times difficult. Ernst had been a mentor to my early performance career, and this was the first time we had both finally performed together outside of some group-curated festivals. It held a sense of tension and anticipation that perhaps would normally be absent from my practice at this stage in my career. The pattern of disruption was therefore useful, especially when alone at the end and during the moments of syncopated slapping between us, to stay focused and present on our own presence/s. At these times, had the score not been present, I could have started to find a transcendence towards a different state. Trance has never been something I have wanted to engage with through my practice, in much the same way that I reject catharsis or the notion of shock. The pain of the action was minimal, it was reminiscent of being tattooed, a constant soft burning of the flesh.

The most intense image was in cleaning up afterwards, to look at the hand that had been slapping. This was covered in blood and the detritus of soft flesh; it was quite beautiful and on both occasions of performing *PASSION/flower* has been the most startling image for me post-performance and interestingly one that the audience never sees as part of the live piece.

Exercise 11

In this task you will explore how being present in the experience of your body in action manifests as artwork.

Sitting opposite your partner, take a ball of jute twine, hold one hand up each – ideally the opposite hand to your partner – then try to work together to pass the twine between each other to bind the hands together. The hands should be about 30 cm apart and the twine should remain taut at all times. Be slow and consistent in your actions. Maintain focus in the present, note the texture of the string on your skin, the tension of the binds you are creating, and the energy you transfer to one another as you complete this task.

If it goes wrong, that is ok as this was a basic exercise to explore how we connect. You may notice that the material does not behave how you want it to – it might break, become knotted, and so on – if that happens try to let your focus be present in that moment. Try to avoid it derailing the action and navigate the unexpected. Any potential point of failure enhances the work when you attempt to respond appropriately with an open focus.

Keeping what you have learnt from your previous experience, the main task will require a 50 m (minimum) reel of jute twine:

Sitting opposite your partner, keep your focus present in your body and on each other. Maintain your posture and the intention of your actions throughout. You should be about 1 m apart from each other, so that outstretched arms could reach the other person's hand comfortably.

Keep eye contact with each other so that your energies connect. Whoever starts should place the beginning thread in their mouth as an anchor. Now you should bind your heads together (maintaining this distance) and again keeping the twine taut throughout.

As the twine unwinds, be aware of texture, and as your ears become enveloped, notice the changes in sound. When the reel ends, an outside observer should take an image of the bodies connected.

You can end the piece by either lifting the twine off and placing it on the floor or by attempting to reverse the action and wind the string up.

At the end of the action, share your reflections/experiences with each other before viewing images or asking the outside observer for their experience of you both working together.

Adaptation: Once you have been able to complete the task without encountering failure, see if you can intentionally disrupt or intervene into the action with pauses, breaking eye contact or even conversation. It is important to only attempt this after following the original exercise successfully. What is the effect of these interventions in breaking the trance of the action?

3

The Intersubjectivity and Intercorporeality of Noise and Sonic Arts

This chapter reflects upon the fundierung of a lived body experienced through sonic art. It considers where the subject may begin and end. For example, the live sound emanating from the presence of a performance artist manipulated through an electronic amplification system enables the noise created to be loud enough to permeate the bodies of all present due to the extreme frequencies utilised. This 'altering' experience will affect the relationship between corporeal presence/s in a phenomenological flesh. This enquiry holds an awareness of gestalt and accepts that we are not exploring the singular at the cost of the whole, acknowledging the need to eidetically consider the intersubjectivity and potential intercorporeality created through sonic arts as part of the experience of a 'complete' lived bodily experience.

Vito Acconci commented upon the perceived presence of the artist as something that permeates through the flesh of the space, noting,

> [Y]ou can't say a body is in a space or exists in a space – it haunts space (that's a Merleau-Ponty phrase I just came across recently, but it clicked). A body is here, but while [s]he's here, [s]he's also there. [S]He's in a lot of places at once, making signs and leaving marks because of the way feelers go out from the body to things around him [her].
>
> (Nemser 1971: 20)

A multiplicity of Self/s is perceived through presence/s experienced through each other, in the same way as when a sonic artist produces sound and it resonates through us. The artist is present, their live input or analogue manipulation of material or object is a second presence, and the digital output through the sound waves of amplifiers a third. This manifestation occurs as an intercorporeality and

also highlights an intersubjectivity, as Being affects the environment through the signs and marks Acconci highlighted. Though he wrote about the physical act, the principle of affect is the same: the encounter of sonic vibration with body, space, eardrums, walls, and floor, 'touches' us and to varying degrees it makes its mark through our shared flesh. Intersubjectivity is essentially very similar in nature to intercorporeality, in as much as its effects and affects may crossover with one another. Where intercorporeality relies on the presence of the Being, the material relies on the manifestation of the corporeal; intersubjectivity transcends these 'realities', expanding how presence/s are perceived. To explicate this with consideration for sonic arts, we will share examples in this chapter of performance soundscapes where an artist's presence and our perception of them entwine through sound and action.

Performance artists featured in this chapter are categorised into two sections. We start with those that use live sound but then consider how this may be phenomenologically reconsidered in practices where the sound is recorded or exists after the manufacture of the sound through installation or document/recording. A consideration will be made here upon liveness leading to artefact – sound as a thing now detached from the performer's body, extending the potential experience of the performance artist as artwork. The subdivision of the chapter considers pieces that produce sonic art through the body or its actions and works that produce sound through collaboration or third-party manipulation. All of the artworks lend themselves to an intercorporeal analysis, but within the context of this second section, we will also discuss their intersubjectivity.

The manifestation of a Being through the conduit of noise, as experienced in the sonic arts, offers us an opportunity to further reconsider the construct of perceived presence/s. Salomé Voegelin introduces an application for noise analysis through phenomenology, highlighting how extreme sound draws together the symbolic with the experiential, suggesting as follows:

> The semiotic and the phenomenological meet each other in the obscurity of this noisy voice [...] they feel each other's weight and outline, and shape the desire to practice a signifying that meets occasionally and lights a sparkle in what are misunderstandings turned understandings for the expediency of nominally illuminated visual communication.
>
> (2010: 75)

Taking perception beyond sight, here Voegelin reminds us how through sound we may reconsider the experiential significance of the body of the artist. Noise opens the experiential process and Merleau-Ponty offers us a way into this with the analogy of a cube to illustrate the experience of perception. By looking at dice,

he acknowledges that it is perceived as much through what can be visually seen as what cannot. Rational (intellectual) and empirical thought converge in the perception of the experience of a cube, creating it as absolute. Here, the physical and the intellectual entwine in the locus of the very existence of a thing, an

> [a]nalytical reflection puts forward, instead of the absolute existence of the object, the thought of an absolute object, and, through trying to dominate the object and think of it from no point of view, it destroys the object's internal structure.
>
> (2002: 237)

Similarly, the body of the artist may be openly conceived. To explicate this further, the perception of the subject or object we are experiencing needs to be expanded to include its physical position in relation to us. Therefore, the line between empirical and rational thought converges to create the experience of the thing in question as Merleau-Ponty states, '[t]he thing, and the world, are given to me along with the parts of my body, not by any "natural geometry" but in living connection comparable, or rather identical, with that existing between parts of my body itself' (2002: 237). Within the analogy of experiencing the dice, Merleau-Ponty explains how perception must go beyond the sides that we can visibly see, perhaps two, maybe three, to equate towards those remaining that we are left to rationally perceive (2002: 236–37), opening language towards the experiences of cause and phenomenological affect for the recessive and visceral body (Chapter 4). This defines how the experience of the subject or object before an individual is created through our connection to it, which is as much through the visual encounter as it is through a projected understanding, or even the sonic experience of it. This is how fundierung evolves from the point where appearance intertwines itself through our experience of it.

Exercise 12
Perhaps the most abstract task is a challenge; we call it the noise of silence.
Your challenge is to remain silent for 24 hours.
The intention is not to go through your normal daily routine by miming awkward encounters as you navigate the world. Instead, before taking this task on we ask you to reflect on this: have you ever been present at a performance that has been very quiet and the sounds of the outside world permeate the space? Be they emergency services, the chatter of people, the rumble of an underground train, bird song, or perhaps just very intense

rain, thunder, or wind. Suddenly, in those moments you find yourself spilt over two worlds – one present in the show you are encountering and the other acutely aware of another ephemeral space.

We would like you to experience that intentionally for a day – this could be in multiple locations, but when travelling between them, continue to remain silent. Each location should be a quiet place close by but removed from another world. For example, you may be able to open your windows of your front room on a hot summer's day, you could sit in a studio of a university, or perhaps find a church or similar quiet space outside of services in the centre of a town.

This challenge asks you to give yourself the gift of a day. Do nothing other than this. Make only mental notes and wait until the next day to capture your phenomenological experience. After this, reflect on the idea of noise as silence. Were there times when the noise became very loud, almost static like? Did you become aware of minutia? How did another world become part of this experience? Did you encounter disembodiment at any time and if so, how did it manifest?

Adaptation: If you are hearing impaired this task may be very close to an everyday reality. But when was the last time you gave yourself the gift of time to remain very present in the moment? If you are hearing impaired and decide to take on this challenge, allow yourself the opportunity to note how your body experiences frequencies. Even when you detect an absence this could be useful to reflect upon, as may be the touch, vibration, and static effects of sound on or through the body.

Voegelin highlights that noise, as the most challenging of the sonic arts, offers instability – a fixed position with varied perspectives – a catalyst of risk: 'Noise cannot speak, but knows there is a fragile relationship between its experience and the system of communication and longs to practice that relationship. It taps into the dense ephemerality of subjective objectivity' (2010: 75). A need to move away from Merleau-Ponty's analogous dice is therefore required as we consider something less fixed and utilise the performance artists' body to address this. The sonic arts and noise offer us the chance to challenge the corporeal and extend the possible reach of presence/s through shared flesh. The phenomenological experience of the sonic arts acknowledges that the perception of the unseen can be based on our intersubjective position, and the intercorporeal experience is affected by the environment and the presence of all in the encounter with the soundscape.

In a western cultural context, an artwork is innately aligned with the potential to become a commodity; it is therefore important to note the potential for objectification in our perception of the artist/action as artwork. From investment in artwork as financial security through to the proliferation of music as industry and the pursuit of monetary success, examples of the commercialisation and commodification of art are prolific. It is, however, the responsibility of the transgressive artist to actively challenge this. Transgressive practices wrestle, commune, or reject the commodification proposition, challenging perceptions and disorientating (Ahmed 2006) their associated hegemonies. The apparent unconventional or discordant scores of sonic arts assist in this reclamation, as the corporeal body of the artist as artwork moves away from sterile normativity, queering conformity through its sound and actions.

By acknowledging the potential commodification of the lived body (Berardi 2009: 109) as part of an evolving dialogue focused upon the performance artist as artwork, we must be aware that this creates a tension for the commercialisation of traditionally non-commercial forms. Aligning the body to the notion of 'artwork' implies meaning and intent but predictably 'value', which must be recontextualised in order to be appropriately applied to transgressive practices. In Amelia Jones's (2003) survey of the historical use of the artists' body, she chronicles the socio-cultural cause and effect of its reading and developmental use. Herein she made an important (though perhaps brief) reference to Heidegger (1977) and Merleau-Ponty (1968). Both serve her analytical critique upon the evolution of how a body-politic is vitally important to the form today. These notations by Jones signposted Heidegger's ontological view of the lived experience for Being as capturing a 'world picture' (Jones 2003: 21) and later Merleau-Ponty's opening of Being through an 'excavation of the flesh of the world' and 'as the locus of an inscription of truth' (2003: 26). However, it is beyond the dialogues of gender, social, and queer histories (Chapter 1) she concluded with perhaps her most useful and arguably most ontologically universal phenomenological insight:

> Like Walter Benjamin, in his signature 1936 essay 'The Work of Art in the Age of Mechanical Reproduction' argues, reproduction evacuates the authors 'presence' […] reveal[ing] 'entirely new structural formations of the subject.' [… therefore] the more we are simultaneously collapsed into the representation [we are] alienated from it.
>
> (Jones 2003: 41–42)

The significance of this Merleau-Ponty-esque intertwining of presence/s through a multiplicity of reproductions results in the original Cartesian authority becoming sublimated, conjoined, or consumed by the other: the spectator, the consumer, or the enacting presence of another participant. Sound in the twenty-first century is arguably one of the most accessible and commercially reproduced forms of artistic

practice. It is universally considered to be evocative of memory; it can stimulate recollections from our lives and enhance the immediacy of an experience in the initial encounter, irrevocably linking the two through a temporal timeline. Yet its mass reproduction places its unique 'value' in jeopardy. The transgressive sonic art of noise challenges this and repositions alētheia. When considering the accounts of sonic arts in this chapter, the experiential reflections highlight the value of the performance artist becoming witnessed as artwork. This is recorded through our shared notation upon an intercorporeal conduit (i.e. a reciprocal exchange) between Self/s of artist and audience. This subverts the tensions of commercialising any non-commercial forms of performance art and noise in our appropriation of the origin of the artwork (Heidegger 1927), as the value alētheia holds is not exclusive to the artist. Instead alētheia, as we shall demonstrate over Chapters 3 and 4, is shared in the fundierung of perceived experience beyond any Cartesian authority thus allowing our reappraisal of assigning value.

When operating through the commercial art territories of sound, the performance artist as artwork must continue to subvert the homogenisation of their own Being. The transgressive performance artist therefore co-opts commodification of their own subjective (knowingly objectified) identity. Normative commodification is queered, and commentary that questions and creates wider reflections must be embraced. Continuing upon this, Jones references Vivian Sobchack (1998) on Heidegger and Benjamin, noting the dialectic affect that an intercorporeality holds in our experience of the artwork, '[r]eturning to Heidegger's terms, we begin to experience ourselves, as part of a 'world picture', where all is increasingly unreal or simulacra'. As Sobchack puts it in her extension of Heidegger's formulation,

> To say we've lost touch with our bodies these days is not to say we've lost sight of them. Indeed, there seems to be an inverse relation between our seeing bodies and feeling them: the more aware we are of ourselves as the 'cultural artefacts', 'symbolic fragments' and 'made things' that are images, the less we seem to sense the intentional complexity of the corporeal existence that substantiates them.
>
> (1998)

This is crucial for the fundierung of the lived body experienced through sound. When one presence may entwine with another, it affects it, creating a quagmire of self-objectification, self-consumption, and commodification. Therefore, where does the experience through a fundierung begin and end? Jones's conclusion highlights that Benjamin's writing upon a 'subject' confirms it is not a static simulacrum but reciprocally open to 'otherness' (ibid), as Self/s similarly are in flux through the immediacy of experiential encounter. When the sonic artist distorts the sounds of a body to produce an intimidating wave of noise, or the performance artist

pierces their own flesh, both break a world driven by normative accountability of an image that is easily consumable, a world that celebrates ideals and aspires for success, rejects failure, and queers manifestations of gender, race, or geopolitics. The transgressive act exposes the structure of a commercialised system, pushing recessive spectating towards visceral reaction: they share a truth. The risk of this is vital to the catalytic expansion of Self/s when considering implications for intersubjectivity and intercorporeality for fundierung through noise.

Sound through the Body

Performance art's potential to encapsulate intersubjectivity extends through sound for noise and sonic artist alike. Sound offers a means to demonstrate the splitting of Self/s away from our sense of sight. This challenges Fortenberry and Morrill in *The Body of Art* (2015: 266) who eloquently suggest that an outer limit of the corporeal Being is the skin on a prosaic level and that on a philosophical level the limit of the body is its own finite mortality. Instead, sonic art leads a corporeal presence towards an aural landscape. As Merleau-Ponty proposes, 'it is the invisible of this world, that which inhabits this world, sustains it, and renders it visible' (1968: 151). In this context the use of the 'visible' should be interpreted in the metaphorical sense – that to be visible is to be perceptible rather than simply seen. So, sound in this way makes us aware of our own 'interior possibility' (1968: 151) – something that Merleau-Ponty refers to awakening our 'Being of this being' (1968: 151). Experiencing live artistic practices that manifest sound, the presence of the body is witnessed in the making of noise or an aural soundscape as the processing of frequencies demonstrates an intersubjective becoming. This altered and removed soundscape is not simply a live microphone, but it has become something new beyond its origin. For example, when distorted with reverb and overlays, noise can at first feel like impenetrable chaos but with patience and gestalt-like attention, we notice its beauty as each channel traces a staccato path, layered samples, or wondrous loops. The cacophonic belays artistic intricacies that may at first be imperceptible.

Presence/s begin to not only manifest within the physical landscape but are further extended in a manipulated electronic landscape – connected and simultaneously separated, the potential fundierung of Self/s is exponential. These interrelated elements bring together the subjective and objective in the experience of the artist and artwork to form what John Dewy 'distinguishes between the art product (the vehicle of the artistic experience) and the work of art (the vehicle as it is actually experienced)' (2005: 162). Richard Eldridge highlights that Dewy

> argues that product and work are essentially interrelated [and] perhaps the importance of the product-of-activity-as-experienced is what Heidegger had in mind in

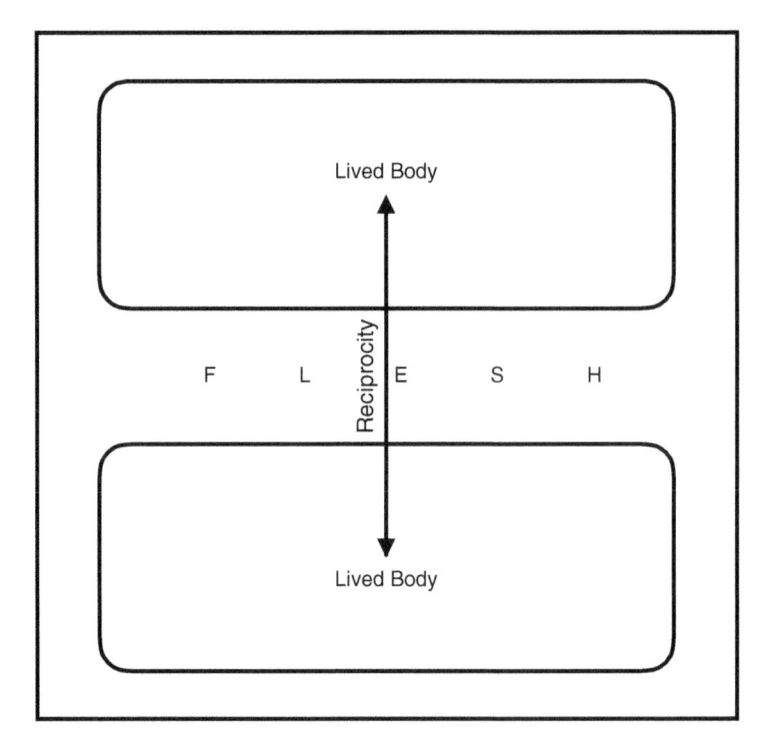

FIGURE 5: A line drawing where a large square contains two rectangles parallel to one another. The two rectangles are connected by a vertical line with arrows at both end to represent a conduit between both positions.

> speaking of 'the work-being of the work' and of how 'the happening of truth is at work' in it.
>
> (2014: 9)

Through the immediacy of the sonic experience – not only through the lived body of the artist, but also the lived body of each person perceiving the action – we reciprocally create the vehicle as it is actually experienced.

Returning to the structure of the diagram that demonstrated the effect of reciprocity through flesh upon gestalt (Figure 3), we reuse it by replacing the positions of gestalt with the lived body (Figure 5). This illustrates Merleau-Ponty's words:

> There is a 'reciprocal insertion and intertwining' of the seeing body in the visible body: we are both subject and object simultaneously and our 'flesh' merges with the flesh that is the world. There is no limit or boundary between the body and the world since the world is flesh.
>
> (1968: 138)

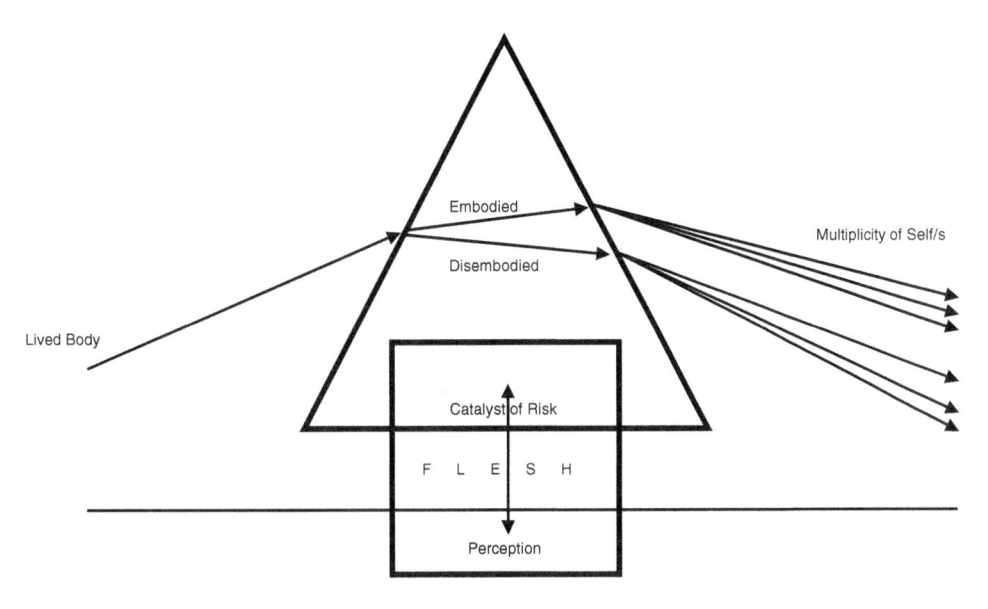

FIGURE 6: A line drawing where a single line passes through a prism. It is split into two and exits the prism as multiple lines that represent a refraction of the whole. Below this is a horizontal line to represent a position of perception outside of the prism, which is now connected by a square that intersects the horizontal line and the bottom of the prism. Within the square is a vertical line with arrows at both end to represent a conduit between both positions.

Sound art demonstrates the unseen reciprocal conduit of perception as soundwaves traverse a space, permeating the flesh, passing through bodies, walls, through analogue and digital instrumentation, literally touching the eardrums, organs, bones, and minds of all present. These soundscapes can be engaged as part of the whole experience or separately through audio recording alone, allowing a gestalt consideration of a perceived Self/s across either. However, it is in the encounter with the live action that we witness the intersubjective nature of both the origin of a sound and its separate existence outside of the body.

Incorporating this reciprocal exchange between lived bodies represented now as a square in Figure 6 between the two positions of artist and audience, we highlight the investment in a transgressive risk (see Figure 1). A point at which Self/s for either presence/s do not exist solely within the shell of the body, but through investment in the action, a prosaic corporal realm of Being manifests through flesh. As Merleau-Ponty stated,

> if we want to describe it, we must say that my experience breaks forth into things and transcends itself in them, because it always comes into being within the

framework of a certain setting in relation to the world which is the definition of my body.

<div align="right">(1945: 353)</div>

The intersubjective body of the artist is opened again in the risk of the action and our intercorporeal investment becomes a means of shared exposure, as presence/s of those through each encounter are linked in the immediacy of the sonic experience.

Sarah Glass

Artist image 16: *DSM III – No Demoniacs!* Tempting Failure 2016. Photo: Julia Bauer.

Sarah Glass (she/her) mentions in her programme notes that:

> since 1980 the concept of hysteria as a medical condition has been obliterated by the contemporary mental health industry, and dismissed as a historical diagnosis conferred upon sexually frustrated females. Yet, hysteria is a powerful emotional state. Gendered madness and the heavily symbolic sound of the female scream tap into primal emotions and socially constructed responses, as well as providing personal catharsis for the individual experiencing a hysterical episode.[1]

This performance captured and distorted the scream of Glass.

Embodied Writing

I allowed myself to recall the mental state that I have historically felt at times of emotional distress and placed myself back there. I felt a form of pent-up rage and upset – the feeling of wanting to cry, but not allowing myself to – of attempting to rationalise myself out of an emotional state by appealing to ego. The same 'fuck you' feeling of not allowing others to win. Psychologically, I held that state during the duration of the perform ance, but not at the expense of the practical nature of the task of creating a live soundscape. Prior to performing I had made the decision not to totally immerse myself within this feeling – to refrain from becoming truly hysterical, as I had some concerns about the emotional aftermath of this.

As I looked at the audience en masse, I felt a strong wave of misanth ropy, and a strong sense of self-empowerment. Performing the first few screams, my focus was slightly broken by a sense of concern relating to both the volume of the screams and the potential technical limitations of the loop pedals. Throughout the performance, I made eye contact with each individual member of the audience. I allowed my body to move as it wanted in a flowing, swaying motion as I stood behind the table and operated the sampler/mixer/Dictaphones as per my cues. When the time came to start the first scream loop, I arranged the skirts of my dress and stepped purposefully through the audience to the first amp, where I looped my initial scream. I returned to my starting point and triggered another sample. I then stepped through a different portion of the audience in order to loop my second scream through the second amp. I repeated these actions until the time came to use the third micropho ne on the stand beside the table bearing my equipment. I screamed the repeated phrase 'No Demoniacs' until my breathing and throat struggled to expel this from my mouth, maintaining eye contact and also changing my stance to kneeling/crouching on all fours.

When performing the end vocal I came close to becoming subsumed with the emotional impact, and then pulled that back into a rational mindset in order to finish in a performative manner. At the end of the piece, I shut off the audio from the mixer and then the two amps sequentially, then left the room.

Contextual Discourse

GRIMALKIN555 is the performance persona of Sarah Glass. To endure Glass's ear-piercing vocals through *DSM III – No Demoniacs!* (2016) is a discovery of her presence/s vibrating through every part of your own Being. Her mouth was the locus in which all of the hysteria would emanate as Jane Blocker suggests, '[t]he moist hole at the centre of our faces [...] filled to chocking with meaning. [...] a locus of fear and repulsion, the site of betrayal where the body threatens to distort beauty with hateful physicality' (2004: 19). The voice of Glass spills through this orifice and surrounds the space through manipulated sonics so 'the mouth can stand metonymically for the art of performance – the living, breathing, speaking body. Moreover, like performance it is the site of deep ambivalence, because it is there that we make meaning out of flesh' (2004: 19). Blocker correlates this with how often the origins of performance art demonstrated the painful relation between aesthetics and feminine appropriation indicatively highlighted within the early works of noted artists such as Yves Klein and Hermann Nitsch (2004: 19). Today through queering normativity to challenge patriarchal dominance, this has shifted by a certain degree within most performance art practices but will often still manifest in the wider world. There, the fem-body is still victimised, mediatised, commoditised, and maligned as Irigaray states,

> uprooted from their 'nature' they no longer relate to each other except in terms of what they represent in men's desire, and according to the 'forms' that this imposes upon them [...] For them, transformation of the natural into the social does not take place, except to the extent that they function as components of private property, or as commodities.
> (1985: 188–89)

As a locus to expel the abject, Glass links this repression metonymically through the mouth to the patriarchal concept of the hysterical female, noting that

> [s]ince 1980 the concept of hysteria as a medical condition has been obliterated by the contemporary mental health industry and dismissed as a historical diagnosis conferred upon sexually frustrated females. Yet, hysteria is a powerful emotional state. Gendered madness and the heavily symbolic sound of the female scream tap into primal emotions

and socially constructed responses, as well as providing personal catharsis for the individual experiencing a hysterical episode.

(TF 2016)

As André Lepecki (2010: 30–31) writes in relation to the dancer or choreographer's form, it brings a unique perspective on the construction of a Being's image, drawing corporeal relationships between a seeing body and a felt body, which one could argue is evident in the vocalised performance of Glass through a phenomenological flesh – a flesh that perhaps exists beyond the immediacy of the initial moment of her original performative act and imbues her presence/s through an open-ended timeline, as Self/s continue to manifest in the memory of her action and their sonic resonance.

Series Notes

Ahead of this performance, Glass had cited Adele Olivia Gladwell's *Catamania – the Dissonance of Female Pleasure and Dissent* as an integral influence upon the work, evoking the following words:

> She is forced to scream. She screams abuse. The minute she screams she hates herself for the sound she makes. She sounds just like the person he wants her to sound like. She is a stranger to her own discursive or expressive sounds. Her sounds either have no meaning or they are the sounds he says 'hysterics' make. She hates her own voice. (1995: 12)

Experiencing the work first-hand, I recall being rapt with awe, our body pounded with the vibrations of her screams. She strode forcefully through the audience. Some people had to leave. It was audibly painful to experience. There was no way I would have left. Feeling her anguish with every breath. Feeling her command to fight to stay upright. She stood before a projection of a montage of women screaming from 1970s and 1980s horror exploitation feature films with her face shrouded in black lace.

As she left the venue, her vocalised screams continued to ring within our ears in the silent space she left behind. Experientially this tinnitus created an intersubjectivity as her presence/s were literally echoing within our own bodies.

Paul Clarke (2013) invokes this concept in reference to Rebecca Schneider (2011) who 'argues that, rather than disappearing, a constellation of performance residues remains present, held in a network of relations, between bodies and objects, embodied and remembered collectively' (Clarke 2013: 15). Likewise, we held the collective encounter with Glass's felt experience, whose abject pain lived on in our eardrums despite her absence.

Joke Lanz

Artist image 17: *Love Bite/s Love.* Tempting Failure 2014. Photo: Roser Diaz.

Joke Lanz (he/him) was commissioned in 2014 to return to his body as a solo artist. His programme notes highlighted his approach to the action as 'creating a unique blend of physical sound poetry and epileptic noise bursts, using contact microphones, loops, tapes etc. The result is an extreme form of musique concrète that juxtaposes spasmodic gibbering with a battery of disorienting electronics.'[2]

Embodied Writing

My heartbeat was rising high. I tried to concentrate and go deep into my inner image of the planned performance.

I remember careless childhood times, a mother that sings a song for me and puts me at ease. I remember the pain of relationships, heartsickness, arguments, separation, a father that bows out from one moment to another. I remember the joy of sexuality, the taste of skin, the forbidden fruit, the lust for perversion. I remember the recurring moments, the perpetual mistakes and doubts. I remember loneliness and aspiration.

All these moments are carried inside my mind, my heart, and my muscles. Occasionally they appear in daily life and in personal moments as part of a bigger process.

Contextual Discourse

Joke Lanz's *Love Bite/s Love* (2014) tests the corporeal limits of form, moving through action-based experimentation towards the intersubjective. Encountering his own body, Lanz explored the permeability of his own presence, splitting his Self/s orally and aurally. *Love Bite/s Love* unintentionally responds to Merleau-Ponty's own question, '[I]s my body a thing, is it an idea?' (1968: 152), as the figure of Lanz tests the corporeal shell of the body, amplified through the flesh of the space. Evocative of Acconci's performance *Trademarks* (1970), Lanz attempts to discover a punctum in the body's own image. Punctum is a term applied here to the lived body rather than loci, as it offers a means to signpost the evolution of our conversation of the artist as artwork.

Punctum arises from Roland Barthes's word for 'a "detail" i.e. a partial object' (1981: 43). Punctum was originally used when considering the photographic image, but interestingly Jacques Derrida argued that it was 'the referent which, through [one's] own image [...] its "presence," forever escapes [...] having already receded into the past' (1988: 264–47).

Contextual Discourse

As Lanz expresses in interview, the result of his actions in *Love Bite/s Love* becomes 'part of a family, a family of intuitional moments, emotions, feelings and memories'. The mouth biting into the flesh attempts to find/imbue each punctum with a history, as George Bataille expressed, 'terror and atrocious suffering transform the mouth into an organ of rending screams' (1995: 62). This is a notion that was echoed in the performance of Glass and considers the body in action as creating an artwork-like image' evoking Tim Etchells writing on Athey, where un/familiar accounts of personal histories became activated through the artist embodied and disembodied 'thick with futures and pasts' (2013: 227). Lanz's punctum to his own image is discovered in each bite, as his bruises eradicate an essential self and intervene in opening his own Being to a perceptual encounter. Each burst of sound creates another punctum through the flesh of the space. Each opens a visible and invisible impression made through both the physical and sonic encounter.

With body beaten, bitten, and sore; a bruise rising on the forehead from being repeatedly smashed into a microphone, the work transgressively offers the body to be dissected through our gaze. Impressions are left through the space, beyond references to Acconci's bites into his skin/image, and towards a becoming through sound for a felt body. Amelia Jones discusses how the wound 'makes the body read for others and thus opens up complex circuits of intersubjective desire that have the potential to transform the way we inhabit the world' (2009: 45). Here the artist's body in extremis becomes a material/presence. An intersubjectivity is opened as Lanz's personal enquiry into his body dissects the singular Being into an objectified artefact of fetishized flesh: a thing of enquiry, of fixation, that often features in Lanz's work, most notably in the publication, 'Stunt Rock #2: Foot Noise' (2015).

Series Notes

In our own experience of this performance, we recalled how Lanz appeared as a fragile being, emanating warmth to the audience located in a cold industrial space. Bare-chested, he had nothing more than two microphones, looping pedals, and reverb. He would whistle, scream, and suck at his own arm and toes. There was a growing pain in his presence: an angst and a love. Much like his fellow alumni of the *Schimpfluch-Gruppe*, Dave Phillips and Rudolf Eb.er, the solo sound action of Lanz is stripped back in design yet extremely complex in its impact. We experienced through *Love Bite/s Love* an emergence of patterns that test the liminality of a corporeal flesh in conflict with the solitary emotions of what felt akin to un/requited love. Voegelin (2010: 175) notes how sensation and perception merge, as she references Henri Bergson who wrote, '[t]here is hardly any perception which may not, by the increase of the action of its object upon our body, become an affection, and, more particularly, pain' (1991: 53). Here the effect of the actions that witness Lanz beating himself with a microphone, biting and bruising the punctum of his own bodily image affect how we encounter the resonant sounds he created. We feel his pain. Voegelin continues to expand upon this by identifying that '[s]ound produces this simultaneity' (2010: 175), where the action of the work directly affects the body, suggesting that '[t]here is no distance between the heard and listener. I can perceive a distance but that distance is heard in the location of my listening. The distance is heard: it is the separation as perceived phenomenon' (2010: 175). Therefore, clearly identifying how Lanz and the audience entwine presence/s and the separation of sound from his body, now experienced within us, affects how we become together through a shared felt experience.

The following is our abstract sensorial response, which attempts to capture how the heard experience, as a separately perceived phenomenon actually felt when instantaneously captured through a rhythm within our body:

Big toe Big toe Suck Kiss
Suck flesh Skin
Arm Chest Beat Loop Beat face Loop
Whistle. Smile. Beat face.
Suck. Kiss. Loop. Big toe. Suck. Beat. Whistle. Loop. Loop. Beat face.
Suck. Big toe. Suck flesh. Kiss. Body. Beat. Loop. Beat. Toe. Suck. Big.

Kiss. Whistle. Loop. Beat. Flesh. Suck. Kiss. Loop. Big toe. Suck. Beat. Whistle. Loop. Loop. Beat face. Suck. Big toe. Suck flesh. Big toe. Suck flesh. Kiss. Body. Beat. Loop. Beat. Toe. Suck. Big. Kiss. Whistle. Suck. Big. Kiss. Whistle. Loop. Beat. Flesh. FLESH. Scream!

A man begins with himself and takes solace in his own cycle of repetition. A religion to his own flesh. An existence of love. An existential love. To be loved. Loving. Love in absence. In solitary. With. Without. He is kissed by two others. They touch and leave him instantly. A brush stroke with the outside world. With the purgatory of relationships, we all must endure. A lesson to suffer. Are we better off alone?

Mother Disorder

Artist image 18: *Crystalline*. Tempting Failure 2018. Photo: Julia Bauer.

Mett Bowman (they/them) is the person behind *Mother Disorder*. They state in their programme notes the following intentions:

> As a response to societal pressures to be functional when neurodiverse [...] In an environment where the value of a person is entwined with productivity and permitted mindsets are homogenised to fit within a capitalist framework, therapy can be a sanctuary; a release from life-altering attributes and an opportunity to become a part of a world that was previously inaccessible [...] Relief from the pains of mental disorder [are] paramount but who decides the benchmark of recovery?[3]

Embodied Writing

I start to rearrange the crystals. From there I am focussed on the sounds, feeling out rhythmic connections, pondering transiently and with haste melodies that can be inserted. Very soon I lose track of what has occurred before and remain on my toes emotionally, both highly conscious yet unconscious. Desperately attempting to generate audio and maintain performative gestures but further dissociating and losing myself within the performance. I forcefully decide to reach out into reality by engaging an audience member, but they exist behind a fog, almost unreal and impossible to perceive. But arriving back on stage I feel their eyes on me and it's exactly what I'm looking for. I hesitate as I prepare to collide my arm with the quartz and remember prior times where I had accidentally drawn blood when peeling the skin. As I hit, it all recedes and I feel like a puppet to the sound.

I become the character, vulnerable, afraid, unknowing bar the inevitable knowledge of my difference to the audience. I must remove the skin; it feels sickeningly good to remove it and I shout and scream as if I'm trying to exhume my very essence. I feel entirely alive and my insides are shaking, I feel like I have made all inhabitants of the room conspirators to my own validating self-destruction. It's suddenly over and I'm aware of what could be future sprouting bruises, I'm so happy ...

Contextual Discourse

Mother Disorder is the performance project of genderfluid musician Mett Bowman who utilises crystals as avatars (an abstraction that could be linked to Uri McMillian (2015) to encapsulate their personal experiences with mental health). However, rather than focusing on the notion of the avatar itself, it is useful here to return to Ahmed to question the queered orientation of experience through the object. Crystals imbued with an intersubjective dialogue through the psychogenesis of *Mother Disorder* allow consideration for how

> disorientation is an ordinary feeling or even a feeling that comes and goes as we move around during the day [...] Say, for example, that you are concentrating. You focus. What is before you becomes the world. The edges of that world disappear as you zoom in. The object – say the paper, and the thoughts that gather around the paper by gathering as lines on the paper – becomes what is given by losing its contours.
>
> (2006: 157)

The focal point raised by Ahmed is found in *Crystalline* (2018) through the crystals in communion with the artist. The edges of both become blurred as Bowman experiences the audience behind a fog, the intangible presence/s of the genderfluid artist merged with the crystalline entities. Ahmed describes how one may move through these worlds as they become disrupted, or projected into and through, as experienced in *Crystalline*, but the useful language herein is the connection to the 'thing' itself. The material significance of the crystals for *Mother Disorder* are described by Bowman as 'something solid, something static'. Their stability provides an intersubjective vessel to hold the psychogenesis of the artist.

The crystals are a fractured object, consisting of many sides and take presence/s beyond a corporeality. Bowman described their materiality as

> act[ing] as vessel to my body, the body itself being material yet subject to constant change. I often do not feel material so physical material seems to ground me in reality, like an anchor to my perception of the world around me.

Mother Disorder maps their psychogenesis through the language of sound and object, oscillating in the in/betweens of the intersubjective

and the intracorporeal, echoing the fractured language of their experiences with mental health.

Series Notes

Crystalline was described by the artist as a response to the pressures of normativity, experiencing therapy for mental health conditions and questioning what Bowman defined as 'adaptive and maladaptive trait definitions'. They presented a body connected to amplification through contact microphones on throat, hands, and kazoo. Some of the contact points were under a sparkling latex flesh, which, during the performance, they tore from their body.

Surrounded by crystals, *Mother Disorder* would move into the audience and interact with the space and crystals with increased urgency creating a heady cacophony. Their intersubjectivity created a body that reached out, imbuing its presence/s into the permeable sound of the objects before them, which, to borrow from Voegelin's writing, held fragile connections based on our own observation of the artist's 'lexical semiotico-symbolic relationship,' (2010: 179) with the objects. This embodiment for the action and disembodiment through the sound of the crystals also echoes Ahmed's notations that '[t]he body emerges from a history of doing, which is also a history of not doing, of paths not taken, which also involves the loss, impossible to know' (2006: 159). Bowman's breaking and stripping away of their own latex skin freed them from a corporeal shell and exposed a multiplicity of Self/s. A metaphorical risk, the queered body of the artist was re/born, perhaps newly orientated or in a queered disorientation, that Ahmed would suggest as the locus for the arrival of the body. Through the destruction of an essential self, *Mother Disorder* shared a meditation towards the intersubjective connection that held the flesh of the space/crystals and our perception of the experience towards their intercorporeal presence/s.

Sound through Collaboration

Voegelin considers the ephemeral language that noise and sonic art provide through reference to Merleau-Ponty, highlighting that interweaving is a

> moment of coincidence that is achieved through the effort of exchange and through chance, in the agonistic relationship between listeners [...] The utterances of this exchange play on the ephemeral and transient board of sonic sensibility. They do fill the space of expectation and do not speak according to a symbolic lexicon, but build a timespace phenomenon in the articulations of their practical speech. This is language as sound that makes sense through sensate expression.
>
> (2010: 165)

Performance art, like sonic art, provides a set of sensational referents during the experience of it. These evidentially will typically link us to a body producing sound, but as noted previously, transgressive noise enables us to transcend corporeality as a single complete presence beyond a traditional symbolic lexicon as we witness the production of the sound and simultaneously encounter its soundwaves through our separated bodies in a shared space.

Sound through collaboration could manifest in a variety of ways via accompaniment, partnership, or an enquiry through materiality. Living both through and yet outside of itself, artificially resonate, yet remaining part of the Being/s or Object/s as originator, we encounter here a further way to perceive presence/s. Each allows an exploration of embodiment and disembodiment, the collaboration through an object, material, or body creating an intersubjective soundscape, remaining open to a subjective interpretation and arguably separated through the objectified artefact.

Performance artists who go further in removing elements or separating the body from itself, through their artwork, re/invigorate the potential catalyst of risk and investment in each encounter. To inhabit the experience of each artwork through Being and in becoming artwork allows, in the Heideggerian sense, each artist/artefact (as thing) to transcend its own limited thingness to be imbued with something of a higher value (the ethics of which are highlighted in Chapter 4 and the postface). However, it is useful to recognise that the body artist who creates no secondary artefact other than themselves or their action immediately breaks with Cartesian tradition (Jones 1998: 39). This equally applies to the ephemerality of the noise artist who does not conform to the hegemony of melodic convention. Heidegger (1927) tested and arguably inadvertently reaffirmed the Cartesian tradition with his analogy upon the origin of the artwork, which, in the original context towards artefacts such as traditional painting or sculpture, raised their uniqueness above other things. Perhaps we may speculate that Heidegger's own fascistic politics

(Farias 1989), as highlighted by Tom Rockmore, was 'increasingly clear that [...] his turning to National Socialism, and his anti-Semitism are neither separate, nor separable but rather inseparably linked' (2017: 152) and therefore had some influence upon perceiving a higher value in an object born through the artist, and in particular for Heidegger, this was specifically in reference to the higher value he adorned upon German artists (see postface). The hierarchical structure of this, one could argue, would align with some Cartesian principals, which ironically Heidegger had opposed. However, it is with a certainty that we can affirm that phenomenology should be considered in opposition to Descartes's philosophy and we can reclaim the Heideggerian misappropriation that some art practices were more 'worthy' of being considered art by proposing a separation of the poetic-logic of Heideggerian notions from its political origins. We may therefore queer his writing through our new application of his theories in conjunction with our studies of performance art and sonic art to reconsider the phenomenological importance for the origin of the artwork of the transgressive artist who also subverts an essential self and Cartesianism.

In the sonic arts and noise, we witness breaches of corporeal containment manifesting through sound. This acts as a metaphorical 'wound', which affects our responses as we witness a body risking – arguably queering – the containment of a (normatively complete) frame. Jones, seeking to deconstruct the phenomenological effect that invasive acts have upon the body, questions the argument that 'in a globalised economy of image-saturation that seems to turn everything into a spectacle, the act of wounding apprehended first hand is somehow more authentic and less commodifiable than the photographic or [...] painted wound' (2009: 47). Here the value of a document versus the perception of the act first-hand is raised, echoing the commodification through the commercialisation of sound as product. Jones continues by referring to the photography of Catherine Opie, whose stills of Athey highlighted the effect from the 'affect' of witnessing a physical wound, leading Jones to compare first and second-hand encounters. Jones (2009: 48) cites Luc Boltanski (1993) on *Distant Suffering: Morality, Media and Politics*, who proposes a three-stage response to such acts. Each stage leads a viewer through angered denunciation, tender-hearted sentiment, and culminating in an aesthetic distance, that Boltanski refers to as sublimation, a process that in traditional artistic practices would allow a painter to become a conduit to traverse, and transmit sublimely the act of wounding to an audience through graphic representation. Jones highlights the problems for this aesthetic hierarchy – akin to Cartesianism – between painter and action, before considering how the performance artist collapses these processes and responses into the action of their own body (2009: 49). Focusing on Opie's photography of Athey, Jones notes how such mediating representations enhance the aestheticization of a wounded body:

While the experience of wounding first hand is ontologically distinct from experiencing it through a picture, film or video (after all, there is no fluid erupting from a photography), I argue here that a 'live' wound is not necessarily more affective (or for that matter politically effective) than a representational one. In fact, as Athey's work makes clear because the wound is a mode of signification, it renders the body as always already representational, complicating our attempt to make a firm division between the 'real' and the 'image.' At the same time, the wound affects us if and only if we interpret and experience it as 'real,' that is, on some level as a violation of bodily coherence that we feel could happen to us.

(2009: 50)

This relocates the dialogue away from a discussion on the representation of pain, to highlight the body of the artist as significantly open to a wider range of perceptions, such as the queered disorientation produced by noise. The fundierung between the recessive and visceral bodies (Chapter 4) of audience and artist are constantly in a state of flux through the most extreme frequencies of a sonic soundscape. From Cindy Nemser through to Amelia Jones, the phenomenological investment through risk for the performance artist is identified through how they may 'enact or perform or instantiate the embodiment and intertwining' (Jones 1998: 38), of Self/s and other in the most literal sense. Sound subverts Cartesian principality, as the artwork 'becomes' through the reciprocal insertion and intertwining of all present. Sound permeates flesh in the most obvious manner and is reliant on the reciprocal fundierung of perception in its challenge of Cartesianism. Utilising a multiplicity of body/s or material/s collaborating to produce sound artefacts, we open Being to an intersubjectivity that widens the perception of presence through an intercorporeality.

FK Alexander

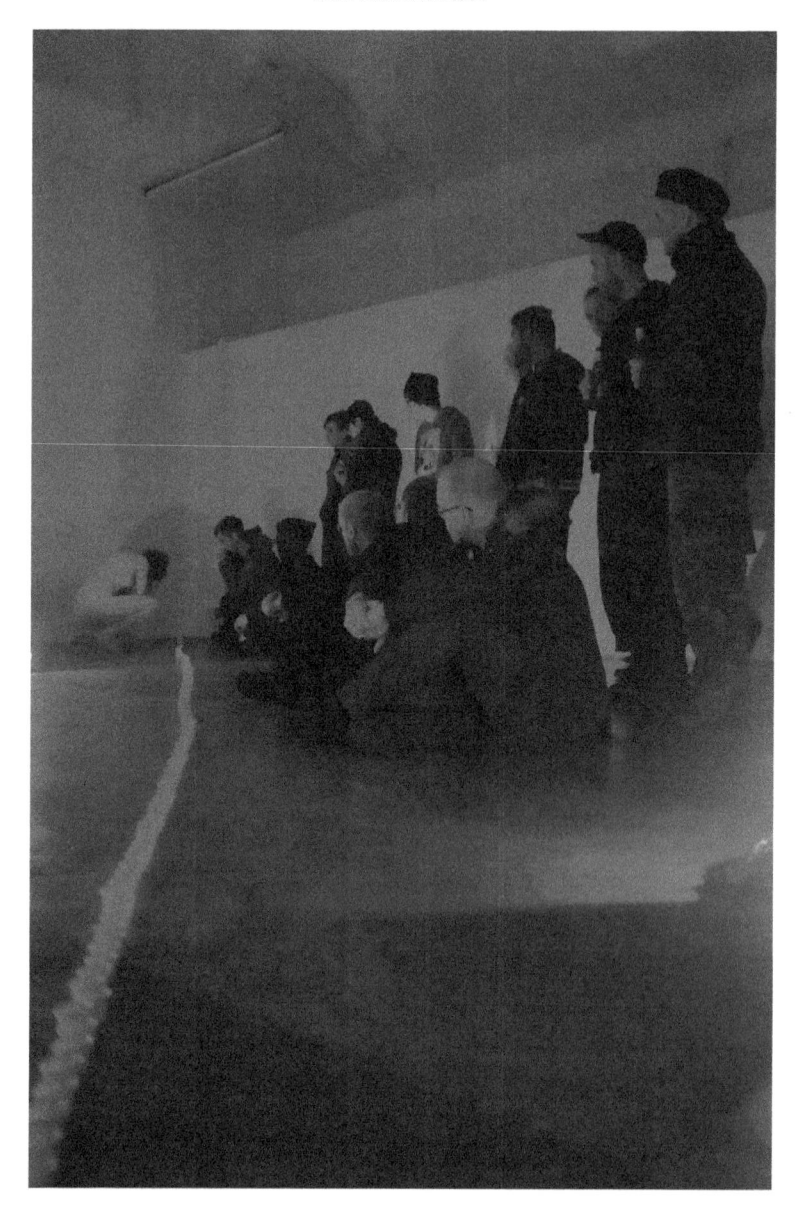

Artist image 19: *CLEAN TIME 276.* Tempting Failure 2014. Photo: Roser Diaz.

FK Alexander (she/her) performed *CLEAN TIME 276* in collaboration with Sarah Glass's *GRIMALKIN555*. Alexander's programme notes indicate that over its four-hour duration it featured, '[l]ive blood-letting and noise [as] 276 paper medical cups are filled one by one with blood, water, and glitter to a repetitive noise soundtrack.'[4]

Embodied Writing

However – I am making an offer;

 OPEN –

 time/space/thoughts/images/noise/cleansing/body/meditation/repe tition/ritual/revulsion/chaos/blood/calmness/connection/disconnect/ wound/glitter/frequencies/volume/nothing …

 time to Sit with Self, to Witness Self as Witness to an other Self

 to observe personal ritual without language – suspension of narrative – when 'you' and 'I' are not here …

 only aktion and time. This is the offer.[5]

Contextual Discourse

Through separation from the body, the intersubjectivity of the corporeality of a Being manifests beyond its origin in FK Alexander's *CLEAN TIME 276* (2014) collaboration with sound artist Sarah Glass. Akin to Mother Disorder's collaboration between body and object, this is extended further through *CLEAN TIME 276*. The psychogenesis being explored here through the artist's environment demonstrates a visualised 'becoming' of simultaneity in the subject and object traces of her physical body deposited across the performance environment. Perhaps a symbolic manifestation of a Being in a state of visual gestalt, Alexander's body was broken into tiny shot glasses – imbued with regurgitated glitter-water, spit, and the blood from an unclosing wound on her arm. The corporeal violation of the bodily containment was held in our subjective reciprocal engagement and bound together through the sound collaboration with Glass. Magnifying this, the artists held the space as open metaphorical

wound through both sound and action. In writing about the notion of this intertwining through the perception of objects and flesh, Merleau-Ponty stated somewhat metaphorically:

> What there is then are not things first identical with themselves to the see, nor is there a seer who is first empty and who afterward, would open himself to them – but something to which we could not be closer than by palpating it with our look, things we could not dream of seeing 'all naked' because the gaze itself envelopes them, clothes them with its own flesh.
>
> (1968: 131)

Here the intersubjectivity – literally for Alexander – bleeds into an intercorporeality of the shared world that the two artists create. Presence/s are held in a catalyst of constant flux as audience, artists, and the entire room literally palpate with the frequencies of noise connecting us all.

The environment as 'wound' furthers the possibilities of our shared perception. It alters the lived body's position as artwork: split down the lines of emotive subjectification and an objectified artefact produced through a fractured space and body. Elements from the body are taken, split, shared, violated, and separated. Questions then arise for Being through the dissected element of the body now held within each artefact: forcing an audience to rhetorically ask, if my body is part of a thing, am I more thing than body, or is it more body than thing? Each specimen cup of blood and spit is an artefact; each is a product instantly connected and disconnected to Alexander, as equally the noise was similarly connected to the voice of Glass in *DSM III – No Demoniacs!* Both products represent a progression from the recessive body towards body as subject and body as object, sharing unlimited reciprocal resonances through the flesh of the space-as-wounded-world that the artists occupy.

Series Notes

Alexander's presence in the space was imposing, equalled only by the intense sonic frequencies that travelled through our body and harmonised

with the environment around us. Collaborators were made of the floor and walls, which shook in resonance with the harsh noise produced by Glass; some spectators took to lying on the ground and bathing in the environment that had been created. There was a strong sense of an open reciprocal intercorporeality through audience as the flesh between us, the space, and the artists connected via Glass's binding noise. Experiencing the work first-hand we reflected on our encounter with the work thus:

The Being of Alexander is the room. Her space divided by a long diagonal line of medicinal-measure paper shot cups. The room is lit by pendant lights, hung or on the floor, nestled in small groups of rocks. Each has a red bulb attached to its line making everything within the white-walled space red, even the wooden floor has hue of danger to it. On one side of the cups stand and sit the audience while on the other, Alexander is watched by with an unflinching stare by Glass who sits wearing a medical mouth mask. Glass is mixing the ominously freeing bass driven noise. The pacing Alexander wears heavy eye makeup, ragged hair and neutral underwear. The tonality of the sonically driven space arcs through the body; a peace within the mania to be discovered by those that accept the harmonics encapsulating them. Alexander cuts at her arm, mixes blood with glitter and water, gargles and spits into each shot cup. She flicks her head to one side as she marches across the space, returning to the end before beginning the cycle once more. She pauses to stare at members of the audience; the environment feels alive.

As Acconci had referenced and coined the term for his own work (Nemser 1971: 20), Alexander likewise, 'haunted' her space; she was present, as much through her relationship to the environment in which she was consumed, as she was in regard to the reception between intertwining and 'becoming'.

The presence of Alexander transcended the limitations of corporeality, becoming as much of the space, existing beyond an essential self. The reciprocal collaboration between her and Glass challenged our potential passivity as audience. We were directly caught in the captivation of risk and an intercorporeal investment to be shared in/between our lived bodies (see Figure 2) together as illustrated in Figure 7.

Speaking in a subsequent interview on her relationship between body and material, Alexander said, 'My body is the vessel that the energy of connection and vulnerability gets around. My body makes contact with [each] other body.' Figure 7 demonstrates this in action, showing how a multiplicity of lived bodies increases the manifest variations of perception. Each affects the other and the more present to encounter the action, the wider variation manifestly affects our shared experience/s.

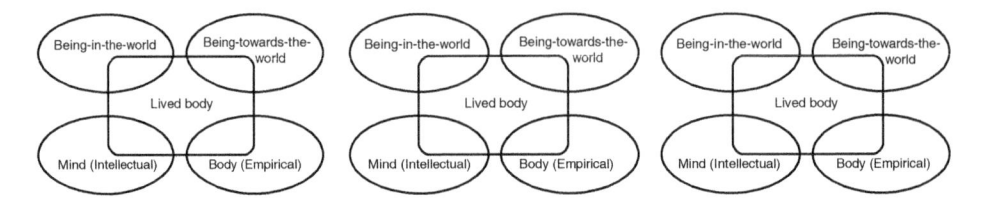

FIGURE 7: A line drawing where a rectangle is located at the centre and at each of the four corners a different oval intersects to represent how each is a constituent part of the whole and can be considered individually or completely. This is reproduced three times and each illustration is positioned next to one another on a horizontal plane to demonstrate multiple positions and the elements that complete them.

The thickness of the body, far from rivalling that of the world, is on the contrary the sole means I have to go unto the heart of things, by making myself a world and by making them flesh.

(Merleau-Ponty 1968: 135)

Clive Henry and Yol

Artist image 20: *Boxed In.* Tempting Failure 2016. Photo: Julia Bauer.

Clive Henry (he/him) and Yol (he/him) have been regularly commissioned by *Tempting Failure* since 2014 to create new works based on chance encounter and provocation to literally tempt failure. They are tasked to arrive in a space and realise a concept without prior collaborative preparation. Their programme notes in 2016 simply read, 'Cardboard noise, caveman Houdini (low rent), contaminated recycling.'[6]

Embodied Writing
Yol: It feels in some ways when I am performing that my beginnin gs and endings are blurred to some extent [...] it might look like I'm pushing something onto space/

Clive Henry: As with previous performances with Yol, there was no path or planning. We had a starting position and an ending, but in between those no plan. I am ok with this, and beyond setting up to see how things would physically work, I give little

object/audience but the experience for me is less delineated/more blurred than that. Objects and texts seem to be in a blurred or movable state. They often come pre-loaded with meaning for the performer and audience and at the same time that meaning changes constantly; it can be altered by space, juxtaposition, mood [...] in some ways it comes back to language. I think of these things as blocks of language that can be played with and in perfo rmance, I'm not sure how much I can separate them from my presence [...] The objects I use are mostly found junk and my selection is instinctive – I will play around to see what range of sounds they make [...] some of them might not get touched and are almost totemic [...] Humour isn't an intentio nal thing, when I am putting together a text, I do like a punch line but I'm not trying to get laughs. On the other hand, everything is so fucked [in our current society] and in such stupid ways that laughing at it does seem a valid reaction. There is definitely some nihilism in there ...

thought to the performance in the weeks running up to it. There is always a degree of fear with this, but also a confidence that my brain/body/skills would carry me through it when needed [...] I wouldn't be pretentious and talk of possession, or channelling but I'm incredibly aware that a switch flicks when a pe rformance begins, and I act very di fferently [...] As far as the physical presence of the world is concerned, I experience (on and off – and it has waned considerably) a general sense of detachment from all things [...] depersonalisation disorder is most likely [...] I spectate on my hands touching things etc., and my body can feel these things, but there's a di slocation [present...] During perfo rmance, I appear to disregard the body's normal wishes, i.e. hurting myself or causing injury. To parap hrase the Kevin Rowland song, 'I'm going to punish my body [...] until I believe in my soul.'

Contextual Discourse
Clive Henry and Yol (CH&Y) is a unique collaboration project born through the festival *Tempting Failure*. It has brought together the two geographically disparate solo sonic artists to perform without preparation beyond their conceptual conversation and remote design. Their collaboration through this project has resulted in work that is frenetic,

often unintentionally humorous, and completely anarchic in the noise it discovers. Their bodies are placed at the centre of the work: conjoined in struggle for *Two Bodies: One Mic* (2014), simultaneously scoring the same work of other artists with two opposing tracks for *Silent Noise Dive* (2015), disconnected in two large cardboard boxes parallel to each other for *Boxed In* (2016), and until they made any form of sound, in total darkness for *Strobed* (2018). As Merleau-Ponty highlights, these bodies are the sole means by which to enter each enquiry, for CH&Y they make of themselves a world, a flesh (1968: 135), which Merleau-Ponty attempts to clarify further by stating that' [t]he body interposed is not itself a thing, an interstitial mater, a connective tissue, but *a sensible for itself*, which means, not that absurdity: colour that sees itself, sur-face that touches itself [...]. The body unites us directly with the things through its own ontogenesis by welding to ones another the two out-lines of which it is made' (1968: 135–36). Relating 'becoming' meta-phorically to ontogeny, here Merleau-Ponty's writing resonates with the 'unknown' collaborations of CH&Y: a becoming that manifests through a world held in their momentary coupling. It is these moments that birth a process of encountering the temporal phenomenological world where interaction, making, and collaboration are exposed through risking the moment of the sonic noise work. However noise, which is arguably the most appropriate method for this, is typically found through action of the individual as Voegelin suggests, 'Merleau-Ponty's phenomenological non-sense that comes out sensation rather rationality and transgresses the collective through individual sense-making as a contingent and recip-rocal trail of the material is intensified in noise which emphasises the solitary fantasy of sonic experience' (2010: 45). CH&Y collaborate as individuals, rather than as makers who have designed a careful interplay, their work therefore offers a unique way to consider the intersubjectivity brought forth through dual intercorporeal encounters. This is illustrated in the rationale for placing the two excerpts from separate interviews with Clive Henry and Yol next to each other rather than combine them or bring a hierarchy of order.

Series Notes

The discoordinate collaboration that noise creates demands our attention, which Voegelin highlights as grasping 'to the exclusion of all other sensorial possibilities' (2010: 47). When witnessing CH&Y perform, there is a genuine sense of unpredictability. Yol speaks of blurring presence and Henry on repositioning his Being in relation to the world, through the moment that they finally meet in performance. This echoes Merleau-Ponty's notation towards entering the enquiry through manifesting a world through their Being.

Each performance creates a new world. These artists are not alone in their ability to do this, but as the live action is an unplanned response to a provocation, the genesis of their worlds are foregrounded in the artwork they create.

Two presence/s come together with a Big Bang explosiveness, an anachronism which appropriately returns our commentary to the sound they also create. Voegelin suggests that noise 'is not a desensitised position, but the position of acute sonic-ness' (2010: 45). CH&Y create noise that is of two techniques in intentional disorder with one another. Both artists are aware of the design to play and therefore find moments of resonance and contrast in the action but return forcefully to positions of opposite polarity. Here the penetration noise can imbue through the flesh of the space and evokes a 'body of the sound [that] has moved so close it is my body: I am the host of noise' (2010: 45). This re/positioning is found through constant readjustments played out through CH&Y – echoed in their separate interviews – pertinent to our reciprocal insertion and intertwining of a shared perception of presence/s – for all encountering the risk of this unique experience.

Exercise 13

How many phenomenological worlds can you name?

1. Pick one world and try to list all of the elements, objects, actions, or things that manifest in or through that world. For example, you may pick a baseball game or a ballet recital as two separate worlds.

2. Excluding anything that may be considered Being. Rewrite this list so that it is in an order that makes logical sense to you, such as one that may indicate hierarchy or perhaps a process of interaction.
3. Now pick a Being that exists in this world. Name them as Dasein and insert them into the centre of the list. This is akin to being-in-the-world.
4. Take a large piece of paper and write out the list as individual words so they make logical clusters. Ensure that the page is covered with clusters. They do not all have to connect but some clusters may resonate with others and if so try to draw lines to highlight this.
5. Now insert the Being from step 3 (this time written on a sticky note), and rather than placing them at the centre of the world, place them at various points on the page. Theoretically discuss how each position would shift your perception of that world. This is akin to being-towards-the-world.

Adaptation: If you do not have the resources, there are a number of free online thought-boards that allow you to position sticky notes on a virtual whiteboard. Whatever version you are using, you can take this exercise a step further by inserting the Being between more than one completed world system you have made to imagine new perspectives for convergence through a flesh. This is akin to starting to visualise the Being as a lived body.

4

The Perception of Self/s

The final chapter draws together the phenomenological philosophical thoughts explored so far, expanding the nuance of how risk can be interpreted in performance art practices across vulnerability, failure, and extremis. Continuing through this chapter, we note the problematics of phenomenology: the impossibility to reduce experience to a single view or an individual perception when we (as Dasein or lived body) are part of a complexity of intersubjective relations with other Beings and things (which are also in constant flux).

Exercise 14

Look up from this book. If you are not alone or surrounded by colleagues then wait to try this until you are sitting in a library, coffee shop, or on a train or bus. Notice someone you do not know and ask yourself, 'Who are they?'

As humans we are continually reading the world around us, attempting to interpret our experience. Consciously and unconsciously we make judgements, we ask questions of ourselves and those around us. We sometimes fantasize, playing out predictions to help us make decisions in navigating the world in which we manifest.

Now imagine that same person is looking back at you – maybe they actually did – and they have been asked, 'Who is that?'

They don't know you, but like you, they have made some assumptions. Projecting on to each other is what we as human beings do. This is the beauty of how we reveal and expose the fluctuations of Self/s that manifest through our perceptual reciprocity.

> *Adaptation: It is important to remember that this exercise does not have to be based simply on sight. When redirecting your attention to another person, implement the primary sense you would usually utilise to become aware of another individual. However, take time to mindfully draw your attention to how you become aware of people through other senses as well. For example, have you ever noticed someone you don't know while travelling on public transport and as you refocus your attention on them you realise they have had their attention directed at you for some time without you even knowing?*

Previous chapters have examined how Self/s manifest through an intertwined fundierung: encouraging perception not to be limited to the visual, the surface, or the superficial. However, the innate paradoxical and yet wondrous problem is attempting to account for our subjectivity within this process. This is particularly important when proposing to reconsider the performance artist as artwork, to reclaim Heidegger's phenomenology through an application in the study of the transgressive or queer actions of the performance artist. This has specific implications for a queered evolution of Heidegger's essay, 'The origin of the work of art' (2009b). It is my intention to demonstrate in this final chapter the necessity to apply queer phenomenology. We have highlighted through previous chapters how Heideggerian thought acts as a bedrock to the evolution of, and our application of, Merleau-Ponty's phenomenology. But we must go further to acknowledge Heidegger's troubling application of his own philosophy – especially when we are using his words to examine queer practice (see postface).

Heidegger's phenomenology originated from a position of exclusivity (Rockmore 1992) born through fascistic agendas (Farias 1989) and heteronormative hegemony (Rockmore 1997). Rockmore (2017) has highlighted Peter Trawny's (2016) speculation that the entire conservative strand of German philosophy, from German Idealism over Nietzsche, to Schmitt, Jünger and Heidegger, is anti-Semitic. There are many examples: [Immanuel] Kant depicts Jews as forming a dishonest merchant class (2006). [Johann Gottlieb] Fichte suggests Jews are a menace to the German nation and should only have civil rights if their heads were cut off (1964). Heidegger's anti-Semitism is both more or less open, more deeply rooted in his philosophical thought, and, since it was linked to Nazism, certainly more dangerous (2016: 156). Therefore, it is highly concerning that Heidegger's

poiesis is foundational to our understanding of phenomenology. To ignore his irresponsible application (see postface) undermines our own use of it today and feels inappropriate to utilise in relation to queer transgressive practices unchallenged.

Heidegger's writing is intrinsically linked to Merleau-Ponty who redeveloped and importantly evolved many of Heidegger's ideas. Therefore, as Merleau-Ponty did, we must also address how our reapplication evolves Heidegger's intended application of 'The origin of the work of Art' (2009b). This requires attention if his essay is to have worth in the twenty-first century in correlation to performance art studies. There is a poetic justice as a queer individual to suggest a new application through a position intrinsically linked to our multiplicity of Self/s (Bacon 2016) – to use this to not only move beyond Cartesian fragility but also subvert the fascistic hierarchies Heidegger imbued into this essay; to be purposely claimed for queer and transgressive performance art. To do this, this chapter will indicate the phenomenological implications for this evolution by utilising Heidegger outside of the traditions of mid-twentieth-century German philosophy to further our studies of performance art, which will be primarily supported through summations from the later writings of Merleau-Ponty (1968).

To regard the body of the performance artist as the artwork we will consider material/presence initially from outside of the physical body to view it aesthetically, before blurring the line where material/presence ends and an artist's Being/body begins. Tehching Hsieh's five *One Year* performances, which took place between 1978 and 1986, help to introduce this. The materials that remained from the body of work for each action were of such an excessive volume that it arguably superseded everything. Each article, each document, each photographic still, note, or film cell held within it an element of Hsieh's presence. This is particularly evident in Hsieh's *Time Clock Piece* (1980–81). Adrian Heathfield says of this amalgamation of bodily experience and material that

> Hsieh's actions are evidently uneconomical, they create[d] a product [film, photo, etc., where the] use value is in doubt. [...] [Were they] the accumulation of the work, or [...] its residue, its waste product? [... It is a] questioning and recondition of the time of the image, through a "conversation" enacted between distinct visual media.
>
> (2009: 33–34)

Imbued phenomenologically with his presence/s, often capturing a life over the course of a year, the materials produced by Hsieh revealed more than just a photo or notation of an act but something intersubjectively substantial.

The materiality in Hsieh's practice blurs the line between material/presence and artist's Being/body, opening the potential resonances between these positions.

Hsieh resists the suggestion that the materials he produces are a part of the action of the work (Heathfield 2009) but they illustrate here a bridge between the body in action as artwork equal to the archivable material/presence. Hsieh's materials extend the objectification and apparent dis/embodiment of an artist and their artwork outside of their body.

Using Paul McCarthy's work from the mid-1970s, we can introduce another point of enquiry. Heathfield's notations on Hsieh's materiality as waste-like could be arguably comparable to McCarthy whose practice originated from a distinctly different artistic imperative. McCarthy at that time produced temporary (non-artefact) intersubjective materials through performance, highlighting a useful symbiosis between the body and associated detritus. McCarthy's mid-career (video/action installation/performances) de/constructed body and presence/s through materials as diverse as paint, ketchup, saliva, mayonnaise, and raw meat among others. Jennie Klein aptly described his work and use of materials in her paper 'Paul McCarthy: Rites of masculinity', in the following way:

> Thanks in part to his use of substances that conjure up abject bodily fluids such as blood, semen, spit and excrement, McCarthy's work has been compared to Hermann Nitsch and the *Viennese Actionists*. While McCarthy's performance work from the seventies does bear a superficial resemblance to [these performances ...] his later work [...] makes it clear that it is less about shoring up the mythological potential of ritual [...] and blood sacrifice and the artist/high priest, than it is about undermining the myth of artistic greatness as it is played out in high and popular culture.
>
> (2001: 15–16)

Works including *Class Fool* (1976) and *Hot Dog* (1974) stand out for their anarchic, queered rejection of a Cartesian subject through their intersubjective use of materials and objects with McCarthy's body. Though vastly different in intention to the use of materials by some of the artists we have featured over the previous chapters including Bowman, Neff, Yol, or Weeks and Whitford, we find relationships through each as similarly imbued with an extension of the artist's Being: a connection through object and body that intertwines material/presence/s. In *Class Fool*, McCarthy threw his body around a classroom in the University of California, slipping in food, hurting his body from falling, and vomiting until he inserted a Barbie figurine in his anus. Similarly, *Hot Dog* pushed audiences to the point of leaving as McCarthy filled his underwear and mouth with raw hotdogs and bandaged them into place. Audiences were reported in a Los Angeles Institute of Contemporary Art (LAICA) journal by Barbara Smith (1979) as wanting to vomit, while *Class Fool* did not end until everyone had ejected themselves

from the space. Such actions offer a radical evolution, unconcealing McCarthy's concerns with aesthetics in the 'otherwise seamless relationship between artistic greatness, artistic creation and phallic potency' (Klein 2001: 15), of Cartesian artistry. They utilise (non-traditional) materials, undermining an assumed high-art value, becoming equally both a product of the action and temporary. A status that a material/presence has shifted through, altering perception; a value, truth, or alētheia that both audience and artist reciprocally 'become' through a shared intercorporeality.

Our final illustrative case study draws both of the previous examples together. Alethea Raban's *s/kin* (2014) utilised actions that exposed her social history through a costume of pustular sacks to unpack her autobiography through material/presence. Recalling the performance first-hand we were struck by the asexual body malformed by stuffed full-length tanned stockings that gave this Being a pustular, cyst-like elephantine neurofibromatosis look. The action saw Raban cut away at herself as the cysts spilt food or metallic paint. A manic tearing unfolded as the figure tore itself apart before attempting to engorge and restore its own body before us. The tight, figuratively transformative costume sacks were filled with contents significant to her past. In this design, she commoditised who she was and through these intersubjective materials attempted to consume her past in the immediacy of the present moment. A temporal throughness and intertwining manifested, separated and held in deformed stasis of the present. Accounting for my sensorial experience of the act I wrote:

A disfigured doll; a pustular reckoning of an aborted creation between Bellmer and the bubonic plague heaves before us. She exists within the stretched nylon cysts: hidden beneath the body stocking and attempting to Be. To be content. To be complete. To be still. To breathe. Reaching into herself she pulls out a blade to tear at the cysts and the contents spill, ooze or seep from her. Each cyst is different, sig nificant to her, and I, and perhaps only a few others, but this abject detritus pours from her. She attempts to sew herself together, with equal measure tearing herself apart. Stuffing, akin to a child's teddy bear's intestines, breaks forth and falling to the floor she wrestles with her own desire to be free, while with equal measure re/consuming herself. Within the mix of vibrant colours, it reminds me of Tetsuo's visceral disembowelling in *Akira*. Her breath becomes ever more intense, a sound-track to the whole scene. The focus of the gaze of all seems to intensify, making it feel like we are crowding in on her, yet no one is moving. We watch the mania rise and fall from within. A mess of material, white stuffing and ooze are blended across the floor. She consumes herself. Calm but frantic in intent to re-envelope. Retain. Restore. Re-engorge. Recollect. Re-consume her Self/s. Her Being. Lost in the mess of who she is. Her breathing calms. Still. She is.

Raban's self-commodification and subsequent consumption of these materials, and indeed her presence/s, enriched the value of the artwork. Through them, similar to Hsieh but more so McCarthy, spectators were allowed access to a unique perception of Self/s through each stage of the de/constructive action, an act that openly acknowledged the significance of a multiplicity through her autobiographical symbolism.

The materiality in the examples from Raban and McCarthy demonstrate the way something may exist (i.e. spilt paint, lentils, ketchup, nail polish, or mayonnaise) between overt and symbolic language. Each interpretation is representative of a personal dialogue between the artist's presence and the material. When discussing materials in Clarke's 'Performing the archive: The future of the past', he notes what permeates a document is that they hold the 'possible pasts and future of events. As it happens, a performance document tends to be made from the performance event as its material' (2013: 18–19). Clarke's application of 'document' is, in the traditional sense, associated to documentation. His language, resonant with the material/presence and body/Being of an artist intersubjectively imbued with a heightened significance: a process that could raise the status of the document above other objects. Nigel Stewart (1998) comments on how we must incorporate such readings into our aesthetic appreciation from the position of a reductive phenomenological analysis noting that it

> demands that we strip the object of 'layer upon layer of culturally derived preconceptions and predispositions [that] obscure a direct view of life ...' (Arturo Fallico 1962:7). [However ...] phenomenology is [...] not just the 'science of appearances' (Vesey and Foulkes 1990: 20); it is the science of essences deduced from appearances.
>
> (1998: 45)

Subjective considerations therefore become part of the process to perceive an alētheia within an artwork.

Raban's sociocultural personal history in *s/kin* (2014) is re/born through a McCarthy-esque detritus. These materials undoubtedly expand our access to the phenomenological experience of the artwork. However, as any materialist abstraction from a Marxist train of thought would infer, traceable through gender, queer, and feminist critiques upon the commodification of identity – evidenced in the writings of Amelia Jones (1998, 2006), Judith Butler (2011), or Luce Irigaray (1985) – we find that the materiality of these documents may potentially act as undermining symbols of objectivism in their own (self-contained) aesthetic status now to be seen as commodities. Phenomenology is often encompassing of other western philosophical thought and is not merely a rejection of such potentially

Foucauldian critiques; arguably it is the ontological bedrock that connects them all by considering the experiential perspective. To avoid dismissing this useful criticism, the context of our study acknowledges the significance and implications herein. To consider how this may actively become part of the experience of perception for performance artist's origin as the artwork, Gina Bouchard, with particular reference to the female body, usefully locates this discussion into the body of the artist. She notes that the

> [s]eemingly innate rights to physical integrity, to agency over one's body [...] have come under serious stress [...] As a cultural practice focused on, 'the exploration, use and examination of the human body' (Heathfield 2004:11), Live Art [should ...] challenge and intervene in these debates.
>
> (2012: 94)

Intersubjective materiality extends the dialogue to object/subject (and disembodiment/embodiment) for the artist's presence, that is, how it exists and how it is perceived beyond the physical body. This is particularly relevant for a critical engagement through phenomenology with gendered, queer, Dis/Abled, and socio-historical cultural readings of the performance artist (Chapter 1). Ontologically, an analysis of materiality's affect through presence/s assists both the provocation for bodily objectification as artefact and the associated dis/embodiment through intercorporeality and intersubjectivity for the artist as artwork.

The artists featured in this chapter either foreground the use of phenomenology in their practice or may be witnessed to expose the perception of their presence to vulnerability, failure, or extremis. In considering the intercorporeal space (see, flesh) that may originate a context to experience the performance artist as artwork, this chapter highlights how the catalyst of a transgressive artwork affects both artwork/artist and audience/spectator to enhance this proposition. Drew Leder's *Absent Body* (1990) locates a parallel to Tim Etchells's concepts on investment (1999) discussed in Chapter 1, noting how the physical effect of a visceral body affects the recessive body of another. Ergo, if we perceive something, we may be invested enough to feel something. Further explication is found through Victor Ladrón de Guevara's acknowledgment that the

> recessive character of the body [...] can emerge at any time (for example, [it] can be made present to one's awareness) by a process which he calls *dys*-appearance. By employing the prefix *dys* (generally used to signal something that does not work properly, for example, *dys*function), Leder indicates the depth that characterises this body only surfaces when the habitual conditions that surround it are disrupted.
>
> (2011: 27–28)

Contextualised originally for the single body, but when utilised in a reciprocal context, the following passage illustrates recessive and visceral bodies not as singular but rather as receptors on either end of a conduit:

> Pain [...] and discomfort are the main ways in which the recessive body becomes ecstatic. When a wound occurs, blood makes itself present. When hungry, one can feel one's own stomach. If a piece of [...] apple gets stuck in one's throat, it would be possible to feel one's own digestive tract. But, when the body is able to achieve a state of homeostasis (balance), the body then recedes, it makes itself absent.
>
> (2011: 27–28)

This empathic response highlights how the vicarious experience of performance is shifted for audiences of performance art from a 'safe' recessive state towards the 'transgressive' catalyst in experiencing a multiplicity of Self/s (see Figures 1 and 6). We can experience empathic and sympathetic responses by producing not only positive encounters but also negative ones. Body art practices are ideally placed to consider the extent of this due to typically transgressive or visceral nature of such works. Many artists use the medium as a means to explore issues of gendered or queer bodies (Chapter 1). As Jones indicates in *Body Art: Performing the Subject*, the body artist 'dissolves the opposition informing the Cartesian conception of self' (1998: 38) and performance art de/constructs the 'artist as heroic but disembodied genius, the transcendent "I" behind the works of art' (1998: 37). This necessitates the imperative to apply the Heideggerian notion of the origin of the work of art away from a position of fascistic exclusivity, queering through a form that transgresses the possibilities of 'fine art' principles and exploring instead how the artwork manifests through a shared ontology between artist and audience together.

Merleau-Ponty relocated Heidegger's being-in-the-world as an outdated position; similarly we now also queer 'The origin of the work of art' (2009b) towards a position of 'disorientation' (Ahmed 2006) as noted in Chapter 1. Merleau-Ponty's being-towards-the-world ontologically allows phenomenology to consider the experience through a lived body –a locus that is perceived in reciprocity with other elements within a specific context. The body of the artist becomes the site of our apprehension of the world through which performative actions are experienced. As Jones notes, this was for Merleau-Ponty relatable to the world through

> a vision that is resolutely embodied and open to the 'flesh of the visible'. The embodied subject is thus a 'being of depths' but also a 'presentation of certain absence' whose flesh both directs her into the world as a seeing subject but also

consigns her to being seen: 'my body is at once a phenomenal body [sentient body and objective body [sensible body]'.

(2006: 140–41)

Perception is at once sentient and objective through the reciprocity between artist and audience who empathically enact an/other through each shared experience. Jones draws us back to the principles of Merleau-Ponty upon insertion, intertwining through flesh, the seeing body, and feeling body. Susan Kozel also refers to this reciprocity, stating that 'there is a reversible relation between the visible and the invisible; there can only be a visible for us because there is the invisible, which is the "lining" of the visible' (2007: 41), while reminding us that 'the invisible is not simply the nonvisible' (2007: 41). It is an acknowledgement that we cannot account for a unique essentialist experience that may be eidetically reduced, for each experience is pluralistic in its very nature. We must instead rely on a fundierung. Every lived body is open to the 'flesh' of the 'visible' (Merleau-Ponty 1968, 2002).

Vulnerability

In the essay *(Dis)Figuring Space*, Stanton B. Garner Jr. (1994) discusses the potential of the artist's body – albeit in theatrical forms – to become a multiplicit tool to communicate risk, saying that it

> becomes a kind of artistic material. In Pierre Chabert's words, the body 'is worked, violated even, much like the raw material of the painter or sculptor, in the service of a systematic exploration of all possible relationships between the body and movement, the body and space, the body and objects, the body and light, and the body and words'.
>
> (1983: 54–55)

Here, the performer becomes an artistic material through investment in risk. This is relevant for the performance artist who shares their body with an audience through performance that often does not dictate a character, but is in a mode of 'becoming' performed as themselves, through working with the raw material of their own presence/s. We discover this material/presence through a position, which, in quoting Chabert, Garner suggests develops a language of intersubjectivity for the artist between body and space, object, light, and so forth, thus confirming that how the lived body is experienced, manifests Self/s beyond the corporeal.

Vulnerability has no singular universal aesthetic a priori. Writing in 'RE-Languaging the body: Phenomenological description and dance image', Nigel Stewart noted, with specific reference to the phenomenological aesthetics of an artwork, that 'subjective feeling does not exist prior to the object of the artwork. Feeling

does not seek a form to express itself through. On the contrary, feeling is produced in and through the contemplation or performance of the artwork' (1998: 42). This suggests that artistically aestheticized states such as risk or vulnerability cannot be fixed into the singular a priori or a posteriori. We cannot suggest a universal phenomenological experience for all audiences but rather a reliance through flesh and the reciprocity of fundierung to open the possibilities for audiences as Stewart notes, '[f]eeling is the gestalt intimated (not imitated) by a work's aesthetic form. Yet aesthetic form will fully exist only when it has been experienced subjectively as it is realised physically' (1998: 42). Therefore, our analysis of these aestheticized states for the artist's body as artwork needs to also evolve towards acknowledging the mutable Dasein at the centre of the performance artwork –an organic, sentient, and often unpredictable force, whose lived experience is shared with an audience, an exposure that allows the spectator to evolve their perception of the artist in a state of 'becoming' artwork. Exposure, as noted in Chapter 1, through the shared aesthetic of vulnerability was highlighted by Tobin Seiber (2006), who suggested it

> tracks the emotions that some bodies feel in the presence of other bodies. This definition of aesthetics, first conceived by Alexander Baumgarten (2013), posits the human body and its affective relation to other bodies as foundational to the appearance of the beautiful – and to such a powerful extent that aesthetics suppresses its underlying corporeality only with difficulty.
>
> (2006: 63)

This intertwined language of body and action through the performance artist and audience reveals a shared alētheia between both. This necessitates a relocation of 'The origin of the work of art' (2009b) away from high-art hegemony and towards pluralistic experiential origin to perceive the artist as artwork.

Exercise 15
For this task you will need a granular (non-edible) material such as gravel, sand, or *unused* cat's litter. Substances such as soil are not suitable as they can clump, and you will require something with less stability. It is important you remain silent throughout the task.

1. Sit on the floor cross-legged.
2. Holding your hands cupped in your lap, your partner will pour the material into the hands. This should be a heaped quantity at the point of potentially spilling.

3. Allow yourself time with the material, keep a relaxed focused gaze upon the heap you are holding. How does it feel against your skin?
4. Project a significant personal value upon the weight you hold in your hands.
5. Now attempt to stand up without dropping any of this material. It is inventible you will spill some of the material but recalling the significance you have ascribed to it, try to remain present with the action of loss you are now encountering. Give value to each grain you lose.
6. Once standing, be still for five minutes with your arms slightly raised in front of you. Maintain your gaze upon the material. Be present in every breath.
7. Now go for a walk to an external space. As you traverse the environment, your focus should remain exclusively between your shared materiality. Extend the significance of the bond between you and the material by focusing on the weight in your hands. A world beyond this immediacy does not exist.
8. Whenever you drop a grain, be present and pause; feel exposed in the loss this is creating.
9. At the end of the journey stand once more for five minutes, recalling the experiences you have just encountered while keeping your focus firmly fixed on what remains in your hands. Try to acknowledge the absence of materiality.
10. Find a suitable place outside to gift your granular material to the ground. Be present in the manner in which this happens and how you depart the space.
11. Notice how the world around you has changed.

Adaptation: An alternative that requires less mobility but a similar focus – not necessitating sight – is to place a single ice cube in the upturned palm of one hand. As suggested in the main exercise, ascribe a value of personal significance to the ice and the water as it melts. Navigate through the rest of the task prompts regarding thought and reflection but remain still. Maintain focus in your mind's eye until the ice has entirely melted.

[I]n one sense the body is the most abiding and inescapable presence in our lives, it is also essentially characterised by absence.

<div align="right">(Leder 1990: 86)</div>

Helena Goldwater

Artist image 21: *embed.* Tempting Failure 2016. Photo: Julia Bauer.

Helena Goldwater (she/her) describes this action in her programme notes as a

> four hour performance [that] sought to nourish the ground with small actions. Nourishing the ground is a labour of love, and small actions take time. They are hard work. It takes the whole body. In this attempt to find fertile land in which to bed down, Goldwater sprinkles, draws, digs and buries. Then departs, leaving behind traces of past moments and an unsettled memory.[1]

Embodied Writing

The main materials I have worked with are of the body (milk, hair, water) but there have also been some digressions into others (ice, earth), but which I still consider of the body. This relationship between the internal and external of the body are distinct, by which I mean that I never use materials of the body by extracting them from the body, for example, it's never my own hair, I never use blood. This separation also relates to the red dress I usually wear. All are materials, much like how sculptors work. I am also a material. I see being a performer as a material. So, I might be moving these materials about, but they are equal in power, telling me what to do. The closer I get to that dynamic the better I think the work is.

Contextual Discourse

Helena Goldwater's merging evokes a *dys-appearance* (Leder 1990), an embodied awakening of the subject and object through her presence as material sculpted through the action. This durational artwork was indicative of her practice, often described as creating work that shifts bodily materials and territory over time, transforming the everyday or repetitive tasks into extraordinary acts and environments to dwell upon. Goldwater explained that this was an enquiry to create 'miniature spectacles, which are concerned with re-positioning, revealing and re-forming the spaces we inhabit' (TF 2016). Ahead of the performance, she described the intended process to be explored in the artwork as the task of

> transforming a vast space with small actions. By covering, enclosing and ordering, these actions I hope to nourish the ground... It takes the whole body [...] bedding down, in the hope of finding a place, to rest one's head awhile, or to journey toward.

This process of journeying to unpack an artist's own psychogenesis through actions, which in this instance evoke nourishment can be clarified by Stewart (1998). He suggests that an artist may be perceived through different frames that evoke material/presence for an audience.

This is indicative of the actions of Goldwater. Stewart also notes the distinction that a phenomenological consideration applies

> if we are dealing with consciousness as it is *presencing* itself as the moving body, we are dealing only with that very instant at which we perceive the object as an image of which we are conscious. Now a cultural materialist would claim that this phenomenological image is always tainted by a lifetime of perceptual habit within a narrow cultural frame. A semiotician would claim that the image (as something which is nothing but itself), is inevitably turned by socialised codification into a sign (something which subtitles for something else) [...] A phenomenologist, however, reflects upon the pre-reflective sensation of the image – the Big Bang of the perceptual explosion.
>
> (1998: 45)

This gestalt demonstrates material/presence existing through the aestheticized variations of perception. This extends across the immediacy of Goldwater's action. Before, through, and after the live event, her Self/s unfold through the material/presence; we witness her journey from an intent to nourish the soil, to ultimately discovering how the soil nourishes and consoles her. Through this action Goldwater's own lived experience is tilled as much as the soil would appear to have been by her. Their materiality evolves through this journey – sculpturing past, present, and future – together.

Series Notes

Prior to this performance, Goldwater had suffered a loss in her family, which meant that the original intention of *embed* now shared an unplanned vulnerability through the enquiry that would unfold through the action. Her body, at first dwarfed by a tonne of earth in a cavernous warehouse space at the former *Hackney Showroom*, placed her against-the-world. The presence of an absence that was impacting her through life and performance became integral to what unfolded over the duration of the artwork. Maaike Bleeker, Jon Foley Sherman, and Eirini Nedelkopoulou highlight in reference to Leder, that 'bodily states of

experiential, present key structures to embodiment' (2015: 15) which were evident through Goldwater's struggle through time, material, and her own corporeal capabilities. When asked to recall her own sensorial experience of this performance, Goldwater said

> The instinct to fall into the earth became apparent. I was in the midst of a bereavement and a very stressful time, which all came into the work. Sadness was an overwhelming emotion [...] throughout. The enormity of the mound implied hard work but the reality was far greater. Moving a tonne of earth was really slow and exhausting. Physically painful at times.

Though the majority of the audience was unaware of her bereavement, the vulnerability she shared in the action was evident. Her exhaustion and perseverance in her attempts to manage, craft, and shape the soil and hair became distinctly resonant with navigating an overexposure of Self/s. Goldwater continued,

> There were times that I felt a complete love for the audience. I wanted to be with them. Later as I was threading the hair into the trough, I felt disdain and pretty unhappy because I didn't like what I was doing. It didn't feel right. Leaving the space, I felt dissatisfaction, but also the sadness, which had remained throughout became overwhelming. Leaving the space also meant I was on my own and this both felt isolating and liberating.

Returning to Bleeker, Sherman, and Nedelkopoulou, Goldwater's actions remind us that '[o]ur bodies are the blind spot in our experiences [...] or the 'I' inside this world as it laid out' (2015: 15). This was echoed in Goldwater's vulnerable state; processing of materiality of her body and the space, *embed* became a sculptural response to the process of grief.

Natalie Ramus

Artist image 22: *16000*. Tempting Failure 2016. Photo: Julia Bauer.

Natalie Ramus (she/her) describes this series of actions in her programme notes as emerging through a 'fascination with the materiality of the body', which led her to 'to question its edges and boundaries'. She continues,

> 16000 is a long-term project in which I will make use of a stack of paper which equates to my body's height. This stack will be used to extend the body into the occupied space; it will explore and document the body through action – the traces of which will be captured and documented creating an archive of time, memory and body.[2]

Embodied Writing

I felt so vulnerable. To really open my body up to the viewer. But as soon as the audience were there it felt like a release. To just be in my body felt so honest. No small talk but an honest offering up of my being. This also seemed the case for myself – I was being honest with my own body through its processes. I felt closer to myself than I ever had in a public space. I felt a release of self-critique – but only while the performance was happening. I felt empowered in my nakedness – a sense of acceptance. Pushing my body and experiencing pain and endurance meant that I held more respect for my body. Instead of seeing it as being limited and faulted, I respected the strength within it. When using my children's teeth [as material/object in the performance] I felt emotional – I missed them [as they dropped to the floor] and I just wanted to be near them. Breaking the stitches in the third performance moved me to tears. I felt I was disconnecting, and I didn't want to. This bond I had built was comforting. I felt like I was disconnecting from the strong connection I had structured within and through my body.

Contextual Discourse

Ramus's performance series *16000* (2016) was staged in a number of variations, which allowed the artist to make a direct enquiry into the materiality of her body through a lens of vulnerable exposure. These performances saw her undertake various interventions into her corporeal shell through sutures, paper, menstrual blood, and children's teeth. The last of this was utilised in the second action, where she clarified the importance of this material,

> Her children's teeth came into existence inside her body and left inside the bodies of her children. As her children lost their teeth they came back into Natalie's possession; with those teeth as material [...] she will consider where the mother's body ends.
>
> (TF 2016)

These emotive words echoed the artist's vulnerable exposure through Self/s and the necessity to unpack her own psychogenesis through this

shared materiality between her body and the bodies of her children. Merleau-Ponty wrote, 'Since the total visible is always behind, or after, or between the aspects we see of it, there is access to it only through an experience which, like it, is wholly outside of itself' (1968: 136). Ramus enquires between the felt and visible. This is resonant with Merleau-Ponty's writing as her presence/s become intertwined through the immediacy of past and present; a temporal thrownness to unpack the gestalt presence/s through her current Being as artwork before an audience.

When Ramus took the teeth of her children and reinserted them into her vagina, she questioned the materiality of past in the present: working with the body as raw material for the artwork's exploration of presence/absence. The body of the performance artist in abject states of vulnerable enquiry such as this acts as a symbolic frontier to transgress. The most basic or normative instincts of containment and control over an essential Self are challenged, as Jones (2009) writes, '[p]enetration [... or] acts of wounding [...] activate the most profound fears that are repressed in normative culture: fears of the ultimate lack of cohesion of the "skin-ego," and thus of the mythical unified self' (2009: 53). The yonic void as 'wound' transgresses a corporeality reliant on the whole. These conceptualised wounds are emblematic in Ramus's explicit use of menstrual blood. For the recessive spectator this societally othered blood, removed from the body without incision is an explicit confrontation with the cycle of life through the immediacy of its *viscerality*.

Series Notes

Ramus's other explorations of the wound in the series of *16000* manifested via sutured piercings and self-penetration. Reflecting on the work in an interview, she noted that it has 'always been there for me, wanting to explore the body as a system of processes. It's almost like [witnessing] the body as machine, doing these things we can no longer deny an awareness of'. In these extremely vulnerable moments of performance art practice, normative states collapse as the completeness of a unified essential self can no longer be sustained. Ramus is acutely aware of this but attempts to reflect how such states survive within normative worlds

of conformity. The hidden viscerality of motherhood suddenly becomes present, confronting a patriarchal hegemony that suggests it should be ignored. Evidenced in Ramus's reflection, she notes:

> Being a mother and having four children so close together, I was a machine for those years: of making a baby, birthing a baby, feeding a baby [...] By the time I stopped breastfeeding one, I'd be giving birth to the next. So, during the early part of my art practice, I always used to keep being a mother and my art practice very separate because I felt people would look at me different knowing I was a mother [... but] I can't deny that I've been through those experiences, I can't pretend. And those processes were so visceral, so it would be ridiculous to exclude them [... But I am] not specifically making work about being a mother, it's about the body and these processes.

In these moments we witness a part of ourselves in another body and again further the multiplicity at play in the immediacy of the moment. This intercorporeality demonstrates 'the capacity to understand another person's actions through the body prior to, and as a condition for, cognition' (Atkins 2010: 48) and highlights how we must account for variation in perceptions but equally how each variation informs, alters, and brings manifestation to the multiplicity.

Helen Spackman

Artist image 23: *Salento.* 2008–09. Still taken from the film Salento by Manuel Vason.

Helen Spackman (she/her) and Manuel Vason (he/him) collaborated to create the video artwork *Salento*. Vason's programme notes describe the process in the following way, 'The two artists spent a week in *Salento*, southern Italy in 2008 and returned to the location a year later in 2009 to work on a video project using site-specific improvisations for the camera and working without a storyboard.'[3]

Embodied Writing
This rock-face is mine, a head heavy as stone. […] The sun had been fierce, and my shoulders were burnt, it was pleasant easing into the red pool, the mud embracing my body, feeling I could sink down forever. Getting up is never easy, take it slow, legs steady, always the head so heavy, looking out to a sea, just sea, space, how can you walk on water with feet made of clay. Washing off in another this time clear pool, mud

running off my body like blood. Did I mention the butterfly or was it a moth, hovering on my cheek, then its dead brother in my wide-open mouth, not swallowed, nor spat out? Hard: hard quarry, dizzy height, relief to run back into the little house, and thousands of tiny spiders, bending their way into another world. Feeling at home, not wanting to return to – nowhere. When I go back there, I slow down.

Being acutely aware of the texture and temperature of the natural elements (earth, stone, air, water, light) on my skin and of how the earth used as body-paint felt like another layer of skin. When in contact with water this felt like a kind of (literally) bloody lotion; for scenes where I didn't get wet, I remember feeling my 'own' skin contract slightly as the mud-paint on my body dried and crumbled, as if my skin itself were chafing. After (not during) some takes, I often felt chilled to the bone, due to the wind and – not surprisingly for the time of year – when entering the sea/ Bauxite Lake. By contrast, entering the muddy rock-pool (opening scene) was like easing into a warm bath and the mud-base into which I partially sank was very soft, a welcoming and accommodating if slightly tickly 'bed'. In such site-responsive perform ance, there is a different sense of time, of being present in the moment and merging with the elements, not thinking cerebrally, just being there and feeling intensely but not in the common sense of emotion, just he ightened sensation to the extent that I often felt fluid and weightless – like good sex!

Contextual Discourse
Salento was a collaboration for the camera between Helen Spackman and the performance photographer Manuel Vason. It was filmed over two separate visits to *Salento*, Italy, in 2008–09 and has been exhib-ited as a video installation from 2010 onwards. It offers an extension of the momentary act, a temporal 'completion' unique to film that, through edits, creates a cohesive timeline despite the passing of time in the real world. *Salento* combines through the single video document two separate interactions between the artists and their landscape. Here our conversation with the performance artist revealed the fallibility of Spackman's memory confused with the product of the final document,

echoing Kozel (2007: 53), on the evolution of a phenomenological record in the mind that enhances, exacts, or alters a memory. *Salento* captures the immediacy of a performance across a multiplicity of perspectives – from two performances between two artists, to multiple edits and through multiple screenings with audiences. Each offers an opportunity to extend Paul Clarke's (2013) proposal for the document holding the past, present, and future, while also demonstrating the performance artist as becoming artwork across multiple points in time. Clarke notes the enhancement that evolving memory through process produces 'the fallibility of memory, creative forgetting, and the relationship between remembering and imagination [...] We're interested in the ways in which performances remain, as well as disappear, not as objects or document, but held in memory' (2013: 6). Spackman's performance was an attempt to expose a vulnerability between body and earth across each interaction with the landscape. In a follow up interview almost ten years after the initial action, she said,

> On reflection, I think what I tried to do in *Salento* was to transgress the sense of an embodied self as a distinct entity towards an embedded and hence indistinct embodiment. Not to think about meaning but to use all my senses, especially touch and kinaesthesia to open up and respond to, to connect and merge with the elements 'found' in a particular site which can become boundless, even if very small in terms of conventional scale. To lose a sense of where the body begins and ends. To move without leaving a trace. To disappear with grace.

Spackman's recollection of her encounter through the materiality of the land and her own body resonates with the manner in which the final artwork was created, as the process expands the immediacy of the work across a long period of time. When asked to define her own impression of material, Spackman said that it was

> [b]oth concrete and 'immaterial' in relation to what is 'found' at the site – elements more than objects, air is generally thought of as immaterial, not to me. The space around us is living, it just requires a delicate touch and I think the earth pushes us up as much as – I hope and trust more than – we weigh it down. Body memory is material, and this is not about conscious recollection nor something simply past; in

linguistic terms we might say it's past-present-future continuous and not necessarily in chronological order, neither active nor passive. For me, the material in *Salento* was about opening up and responding to the 'here-and-now' experienced on site – which is and isn't now past.

This reciprocity between Spackman's felt and seeing body is similar to the notions explored in André Lepecki's 'The body as archive: Will to re-enact and the afterlives of dances' (2010). Here the perception of an action instantaneously sees the body of another acting to respond, recalling the unique perception one may experience in the other, as Lepecki (2010: 32–35) details Julia Tolentino's *Sky Remains the Same* series. One particular iteration from the series that took place in Berlin 2009 saw Tolentino's body act as an archival response to the performance of Ron Athey's *Self-Obliteration*. Watching him with a documented unflinching gaze, raised above an audience from an identical platform, dressed identically, she absorbed his performance, before immediately re-performing it again alongside Athey. This very act saw Tolentino not only 'becoming' but, publicly and immediately without external editorial, sharing the vehicle of her felt experience, something that typically we never would have the opportunity to express in such a way. Here the immediacy of past and present through the distortion of memory was shared in front of a live audience. In *Salento*, however, we encounter the collaboration between Vason, Spackman, and landscape across multiple time periods all blurred into the one artwork. The immediacy of each felt experience combines: the body 'bleeds' into the landscape – visually evoked in the piece where Spackman's red mud-stained skin oozes into the land – there is a blurring between the materiality which extends through the temporal captured in Vason's montage. Viewing allows the spectator to re/encounter the artist as artwork in the moment of becoming over an infinite period of time. When asked how an artwork born across time and with collaborative influence exists within Spackman's own singular Being, she said, 'It has become a metaphor I live by, an impossible and perhaps broken dream that I both grieve yet still believe in.'

Series Notes

Spackman's language navigates through her openness to the worlds across which her body-as-artwork now inhabits, arguably less with an emotively vulnerable state but more towards a dis/embodiment. She notes that it can no longer map where the body originates or extends to. Merleau-Ponty guides us towards considering this notion anew when he said, '[f]or the first time, the seeing that I am is for me really visible; for the first time I appear to myself completely turned inside out under my own eyes' (1968: 143). This risk of exposure speaks to the sensitivity that Spackman requires to be vulnerably open to connect with the world around her, as Merleau-Ponty continues: 'For the first time also, my movements no longer proceed unto the things to be seen, to be touched, or unto my own body occupied in seeing and touching them, but they address themselves to the body in general and for itself' (1968: 143). Spackman works with Vason to place her Being within what at first appears to be a singular world, that, as she notes, requires a delicate touch. Yet, much like the apparent completeness of an essential self, the artwork of *Salento* extends itself across multiple phenomenological world experiences.

Though noting the paradox of re-enactments, Lepecki's conclusions are also appropriate for the construction of Spackman as artwork through *Salento* when he wrote,

> because they seem to return somehow to a past and an origin, [we] need to bypass the arresting force of authorial authority [...This] participates fully in the virtual cloud surrounding the originating work itself – while bypassing an author's wishes as [the] last words over a work's destiny.
>
> (2010: 35)

Lepecki therefore helps to phenomenologically illustrate the expansive fundierung of perception and reciprocation manifesting across a wider period of time for our shared experience of the performance artist as artwork. Spackman presents this reciprocity between the body and land as interchangeable material and an infusion through an intercorporeality between herself and Vason in creating the final image of the body as artwork through our perception as audience.

Failure

To embrace failure is to transgress normativity, however the transgressive act brings an easily identifiable context of risk and investment for the performance artist and their audience.

> 'Transgression,' as Maurice Blanchot (1992) says in *The Step Not Beyond*, 'does not transgress the law; it carries it away with it.' If things are not the same afterward, it is not because the artwork has smashed things to bits but because it has pushed them into new and constantly mobile admixture with those forces that seem to oppose them. This admixture allows us to view transgression both as integral to art and as a force that is not merely *reactive*.
>
> (Mackendrick 2004: 140)

This illustrates the primary context to be considered when looking at the artists in this section, foregrounding the risk of failure and not merely the act of failing. Each artwork offers an investiture in what Mackendrick terms an admixture, linking both the causes of intentionality and change positively together but through 'the experiment' that may fail.

The catalytic effect of risking failure enhances the potential for the re/consideration of the effect of affect, acknowledging the fundierung for both recessive and visceral encounter with performance art. Kozel describes the effect of affect as inhabiting

> bodies and the spaces beyond them. Bodies, objects, architecture, imaginations, memories, even meteorological or atmospheric qualities, make up the affective clouds within which we live. More like particle systems or fields, affect is an ever-fluctuating exchange of forces. It is most commonly reduced to emotion, but philosophical thought contributing to the area of affect theory reveals it is much more subtle and expansive than human emotion.
>
> (2015: 69)

Affect exists between our shared perception of presence/s. Manifesting through the flesh of a shared investment in the risk of an action; it is tempered and agitated by the possible failure of the artist. Paraphrasing Heidegger, Carina Henriksson and Tone Saevi explain that '[a] piece of art is not beautiful because it is enjoyable, admirable or precious, but because of its essential ability to let truth happen, which means to reveal "the isness of what is" ' (2009: 38). The experience of Self/s, which are so intrinsically intertwined through audience and the artist, inform and reciprocally affect this 'isness'; through investment in the risk of failure we take

a chance to discover ourselves through the performance artist's body in action. Merleau-Ponty noted the manifestation of this intercorporeality as follows:

> In the same way, we shall need to reawaken our experience of the world as it appears to us in so far as we are in the world through our body, and in so far as we perceive the world with our body. But by thus remaking contact with the body and the world, we shall also rediscover our self, since, perceiving as we do with our body, the body is a natural self and, as it were, the subject of perception.
>
> (2002: 239)

The risk of failure (see Figure 1) allows our shared encounter to affect not only our perception (see Figure 6) but also how the felt and visible changes through our experience of presence/s (see Figure 7).

Exercise 16

The following exercise should not be attempted if you suffer from any orthopaedic or musculoskeletal (short-term or long-term) injury or illness. Should anything hurt, immediately stop the task and seek medical help. Finally, do not carry out this exercise unsupervised.

1. Remove your socks and shoes and stand with you back flat against a studio wall.
2. Adopt the 'jetliner' stress position: Slide your back down the wall until your bottom is parallel at 90 degrees to your knees. Your knees should be an arm length in front of you. Variations in posture may allow you to attempt this either feet together or feet shoulder width apart.
3. Now raise your arms above your head; palms must face out, arms must remain straight, the back of the hands and the arms must touch the wall.
4. Ask your partner to set an alarm for fifteen minutes.
5. Maintain the position for as long as possible. As soon as you fall down, reset the position and keep going until the alarm rings.

Ask your partner to:

Spot you for errors in position throughout the task.
Do not tell you how much time has elapsed.

Ensure after each fall that you reset as quickly as possible.

You should:

Try to remain present in every moment of the experience.
Try to ensure that your experience of failure and risk of failure does not become insular but is projected outwards to your partner.

At the end of the task, talk about your shared experience and then swap roles.

Adaptation: If you do not feel fifteen minutes is possible for you to attempt, then select a time period that could challenge you but will not harm you. Remember the priority here is to always be kind to yourself and maintain self-care but to have the opportunity to experience the risk of failure. Finally, explore how closing, opening, or fixing your eyes on a focal point, can alter your experience.

To understand the relationship of the body to the universe through the lens of performance, it is necessary to know that to exist is to be part of an experience that can never be fully comprehended.

(Coon 2018: 26)

Chelsea Coon

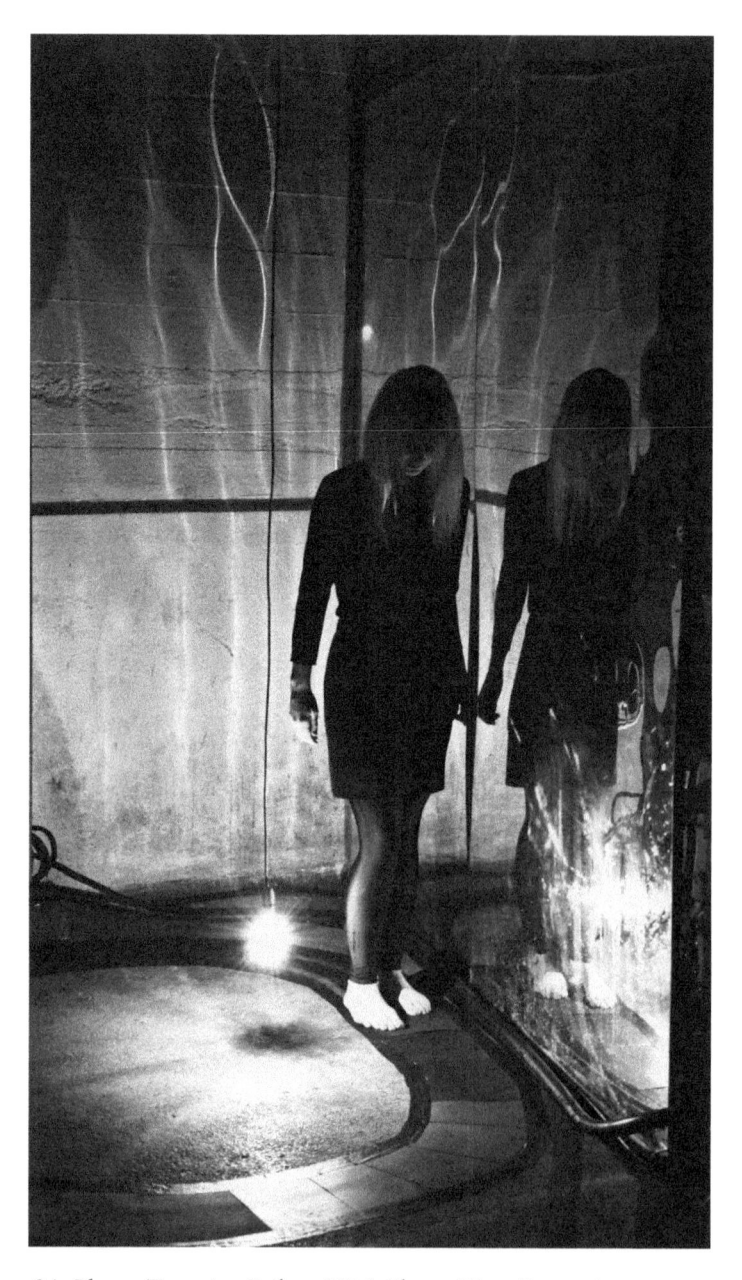

Artist image 24: *Phases.* Tempting Failure 2014. Photo: Yiota Demetriou.

Chelsea Coon (she/her) describes the construct of this six-hour durational action in the following way.

> I installed a circular loop composed of *eighty-grit* sandpaper and affixed it to the floor with heavy-duty black electrical tape. The structure measured approximately two meters in diameter. The eighty-grit grade of sandpaper is categorised for the accelerated removal of materials such as hardwoods and metal. Since I had considered the necessity of this structure to take form as an endurance performance over the full six hour duration, this grade of sandpaper was a necessary component in that it provided a variable that my body would need to work with over the duration.[4]

Embodied Writing

There was this smell from the skin on the sandpaper as the hours went on that I'll never forget. It was strange to see the traces of my body so vividly against the black grit paper. As the hours passed, the work was harder to maintain. Emotionally, physically, sensorially – it was intense. It took every ounce of focus I had to continue on in the calculated manner I had set out with. To keep the skin from breaking until the very end of the piece. That tension was accentuated because there was no way to know when that point was close to being reached. I would only know when I looked down and saw the blood trail congealing with the traces of skin.

Contextual Discourse

Coon's *Phases* (2014) was a durational action that resonated beyond its immediate simplicity. For as near to six hours as was physically sustainable, Coon walked slowly, barefoot, dragging the soles of her feet across a sandpapered surface. The potential for failure for an artist enduring such durational acts is most apparent. The extended time affected the intercorporeality of the environment and our shared experience, as they

transformed both the artist and audience across the immediacy of our shared timelines.

The presence of a Being shifts through the duration of the transformative action. Durational performance practices, where the presence/s of the body blurs through the temporal, echoes Merleau-Ponty who proposed that

> landscapes interweave, their actions and their passions fit together exactly: this is possible as soon as we no longer make belongingness to one same 'consciousness' the primordial definition of sensibility, and as soon as we rather understand it as the return of the visible upon itself, a carnal adherence of the sentient to the sensed and of the sensed to the sentient.
>
> (1968: 142)

This is the intracorporeal landscape that the performance artist must navigate. Coon's felt bodily experience transcended the subject/environment, shared through her actions and witnessed by an audience – beyond sight, through the conceptual, through the physical, the aural, the olfactory, spiritual, philosophical, and emotional; a space shared in the immediacy of the encounter between both her lived bodily experience and our own.

Echoing Atkins's studies upon identity, who defines it as 'the capacity to understand another person's actions through the body prior to, and as a condition for, cognition' (2008: 48), we must be aware of when we extend this towards the phenomenological. The intercorporeal, (see Figure 5) transcends a priori and even a posteriori, locating perception in the fluidity of the immediate: the present encounter with presence/s in the moment, be that in memory, anticipation, or action. Coon described her work before performance as a response to the space, '[b]y walking across the floor which will be lined with sheets of coarse sandpaper. I will drag my feet across the paper slowly and repetitively for the duration of the piece. The image would relate to the proximity between the body and the universe and the interconnections between them would be addressed by the physiological wearing down of my own body seen in the accumulation of dead skin on the coarse paper. The end always looks like a beginning; everything has to come to an end so that it can begin again' (Coon 2014). Her Being and the immediacy of the space became

intertwined. It opened through her enquiry beyond the intercorporeal to also acknowledge the innate intersubjectivity of her flesh traced across the floor.

The flesh between Coon, space, and others created an interwoven sensory landscape, not limited to sight, but open and incorporative of both an intersubjectivity and an intercorporeality. In my second interview with Coon – conducted four years since the original performance – she recalled of her Self/s as follows: '[I]n my memory it is this image of myself both appearing and disappearing.' Here phenomenology allows us through gestalt to consider how for the lived body, we may note being-in-the-world and being-towards-the-world, alongside mind and body as pluralistic elements of the whole experience, because, as Merleau-Ponty posits, 'the self/other as reciprocal: not in the sense of oscillating positionalities but in terms of simultaneous subject/objectification – one is always already both at the same time' (Jones 1998: 40). Therefore, we allow gestalt to lead us towards an oscillating self, moving between positions in a manner that Merleau-Ponty speaks of as always present for Being. This is essentially an active exchange between Self/s and other (see Figure 7).

Series Notes

Coon's recollections capture the materiality of a body divided. They foregrounded a recollection of the failure in her body to continue with the performance. However, in 2016, then only two years after the artwork rather than the four years from the recollections shared so far, her focus was held within the temporal:

At once, I felt the immensity of the weight of time and the fleeting nature of it. The focus was on the present, with an understanding of the beginning and a vague idea of the end. As the soles of my feet wore away on the sandpaper circuit, and the shedding of the skin became more visible, I witnessed the wearing away of my own body and felt the haunting presence of the end. I do not remember feeling the aftermath of the action fully until the performance was over; it was something else entirely while I was making this piece. The idea and the

execution of that idea remained the most important: In the end, we will all disappear.

Though the body as a material is noted, this experiential account by Coon alternatively foregrounded her emotive state in comparison to her words two years later. The passage of time between the second year and the fourth year in Coon's reflections are indicative of how we build our narrative through memory, and what becomes clear is that while the action remains the same in Coon's recollection, her felt experience has been distanced.

Intercorporeality builds upon the reciprocal exchange through flesh to entwine experience for and through the body. When encountered through risk, it not only allows a multiplicity for all present, but as intercorporeality foregrounds experience alongside the body, it is also comparable to the importance of investment that Tim Etchells (1999) highlighted as occurrent in the exchange between audience and artist. With this consideration, I present a sensory account I made as a spectator to the performance of *Phases*:

Questions of moment. Tender footfalls.
Sore and painful. Tender feet.
Tender.
Duplicity of image.
A split dialogue between the Self/s and her reflected image captured in the mirror beside her.
Who is in the moment … Who?
I can see the most resonance here with ideas of Multiplicity at play. Her Being journeys onwards; an endless circle.
She is both subject and object to me.
Lost in the background and alive in the perception of any one who gazes upon her or through her.
Her skins rubs from her feet and onto the floor. A dust trail of her Being; objectified before us. Split from the subject alive. Skin is dead before it breaks free.
She shares her Self/s. She shares her Self. She shares her self.
She shares herself.

In our account, Coon transcends the body, and through a shared investment in the risk of failure, the action enhances a fundierung towards intercorporeality. It is within this context that we can clearly acknowledge there a 'reciprocal insertion and intertwining of one in the other' (Merleau-Ponty 1968: 138). Perception is more than sight in this context, and through this process, we understand the potential for unlimited reciprocity between what Jones notes as

> the relation to the self, the relation to the world, the relation to the other: all [...] constituted through a reversibility of seeing and being seen, perceiving and being perceived, and this entails a reciprocity and contingency for the subject(s) in the world.
>
> (1998: 41)

When Coon encounters the task of the performance action, she transcends the limitation of her singular corporeality through our shared perception. Our investment in the risk of her actions allows us to perceive a multiplicity of Self/s through the experience. A state that, paraphrasing Merleau-Ponty, we may perceive in the following way, as explicated by Jones, 'we are both subject and object simultaneously, and our "flesh" merges with the flesh that is the world. There is no limit or boundary between the body and the world since the world is flesh' (1998: 41). Speaking on this and the relationship between body and materiality around her practice and the later performance of *Diastole* in 2016, Coon said, 'The material of the body is contingent on its interrelationship to the immaterial of what is beyond easy categorization.' The body as the material component of the work is important in that it addresses the astrobiological shared relationship in both immediate and expansive spaces. Time, process, action; an in-between and thrownness leaves this in flux. Coon provides a shared process through body, space, et alia, that runs through her action as much as our reaction/encounter. All of which gives rise to an expanded perception of presence/s, and multiplicity of Self/s through the shared experience of performance artist as artwork.

Selina Bonelli

Artist image 25: *honey-glassed.* Tempting Failure 2016. Photo: Julia Bauer.

Selina Bonelli's (she/her) programme notes unpack that the work explores

> themes of violence, desire and loss [...] The inability to verbalise sensations, the
> silence that ensues, the attempt to express and hold shame, the guilt feeding off
> self blame and the body's enduring loyalty to scarification, all play out into a
> mix of sharp edges and failed dreams.[5]

Embodied Writing

As you go in a certain trajectory, you still feel what you've left behind, in
the space behind you. So, when I am occupying space and flesh and then
if another body enters the space you just left behind then that becomes a
sculptural effect and that's very interesting. It's non-visual, because we're
very ocular-centric [...] I think in images, but it's so much more interes
ting when you take away the visual and you have these intangible, perc
eptive differences within a space that you have to make yourself aware
of. So hence occupying space feels an appropriate way of describing this.

Contextual Discourse

Bonelli is clear in conversation that *honey-glassed* (2016) was not a point
of catharsis, a narrative to be told or an 'offloading of trauma' but rather
a becoming through 'occupying space'. However, the artwork explored
the failure we inflict upon ourselves through haunted memories. Who
is Bonelli in this action and in turn who we are through it? The flesh
of the space is held entirely by Bonelli's openness to risk, which mani-
fests what Merleau-Ponty reminds us is 'the invisible of this world, that
which inhabits this world, sustains it, and renders it visible, its own and
interior possibility, the Being of this being' (1968: 151). A place where
a temporal flux of past histories meets, not only for the artist but also
in reciprocal perception with the lived bodies of all present. Exploring
themes of violence, desire, and loss, she said of the work that its action
occupies 'materials act[ing] as carriers for haunted memories and para-
lysed wakefulness' (TF 2016).

Bonelli splits her presence/s between the materiality of the body and the objects she surrounds herself with. In acknowledging the commodification through these artefacts and the intertwined placement of the artist through the creation of an artwork, we encounter what Jones suggests may be a study upon the narcissi enacted by body artists, highlighting 'the psychic dynamic by which self/artist/artwork is constituted' (1998: 46) with participants and viewers. However, the risk of failure found in Bonelli's vulnerability appropriately subverts the attainment of this Cartesian ideal of an artist as significantly unobtainable, raised beyond other. Bonelli exposed her fragility without compromise – placing a series of honey jars in a row, sawing the buttons from her trousers, tearing into the crotch of the clothing, pulling it free from her body. She then unflinchingly continued by sitting with her legs apart and breaking the glass in her hands, cutting herself accidentally in the process. Her eyes fixed on us, she gathered the shards into her crotch, pouring each jar of honey over the shattered remains before standing – the glass falling stickily to the floor – and leaving. The audience remained in silence, evoking what Jones notes as the exploration of and fixation on the self '[that] inexorably leads to an exploration of and implication in the other: [as] the self turns itself inside out, as it were, projecting its internal structures of identification and desire outward. Thus, narcissi interconnect the internal and external self as well as self and other' (1998:46). We find through this a shared alētheia between our Self/s in the risk of failure experienced not only for Bonelli but also for the audience. A failure Bonelli described as helping her 'develop a sensorial language beyond the failure of the words I cannot find. This became a discursive action and a confronting of myself: a conversation with both myself and the audience'.

Series Notes

Bonelli's phenomenological interpretation of the risk imbued in the space is about holding an enquiry: a shared ontology that goes beyond the viable and indeed leads her towards a macroscopic sense of occupying space via epigenetics. In a subsequent interview she noted that

basically you have genetics and you have epigenetics, and these are within genetics they're looking at certain small pieces that get transcribed in our DNA that have to do with stress, and to do with memory and stressful events and a lot of it came from studies looking at the children of Holocaust survivors that could not have ever gone through what had transpired in the family, yet [they] still felt the affects of the trauma.

This resonates with Havi Carel's notations on the phenomenology of illness applied in our context for the Dis/Abled body.

Occupying space at an epigenetic level to open perception of trauma through the biology of a Being evokes Carel's consideration that the uncanniness within trauma is that 'the body becomes an obstacle and a threat, instead of my home, a familiar place I inhabit. A change to one's body is a change to one's sense of being at home in the world' (2016: 221). Bonelli's actions expand the possibility of perception through this proposition to consider Self/s not only within the seen and unseen but also equally to be experienced at the macro. There, hereditary and its failures, traumas, or genetic triumphs become part of the phenomenological language as we share our experiences through the artist and audience in becoming artwork.

215

Heather Sincavage

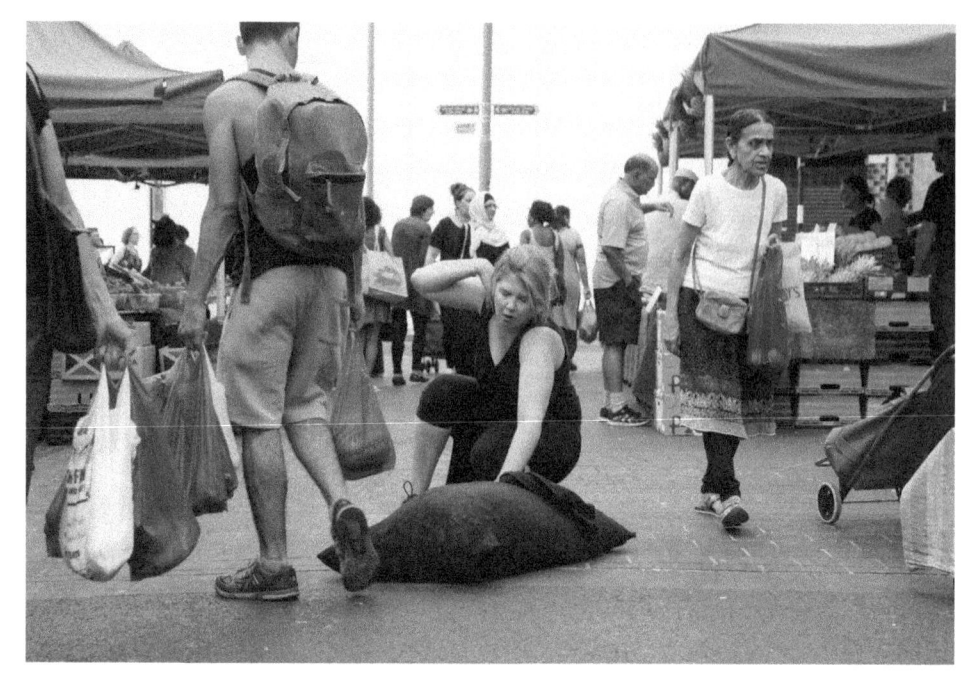

Artist image 26: *The Burden of This.* Tempting Failure 2018. Photo: Julia Bauer.

Heather Sincavage's (she/her) programme notes inform us that this 'is the action of walking while dragging the artist's own body weight in manure [... It] is performed in public spaces as an example of how we always grapple with our trauma, no matter the place or circumstance'.[6]

Embodied Writing
As I turned a corner into a heavily travelled street, I recall feeling almost angry and defiant – like why do people stare, why will no one even try to help? I recall pulling the bag by a bus and staring into it just agitated. I crossed a small street in front of a car and felt defiant, they were going

to wait for me, and I felt unapologetic about it. When I turned into the market area, I recalled how we discussed [with the festival producers] that I would go to the sidewalk of the market but as I arrived, I decided that they were going to have to 'deal with my shit'. I almost wanted to hold the spectators accountable for their compassion or lack thereof. This was the most exciting area for me. While some disregarded me, others at least asked me if I was ok. I could feel people looking. The straps tore on the bag and I continued to pull both sides. I was very hot and felt the stench of manure on me. I pushed the bag down the ramped slope of the final leg and felt the people behind me – again becoming the spectacle through the distance they held. I pulled it to the end. I wanted to dump it all out, but instead laid with the bag before walking away.

Contextual Discourse

Sincavage's *The Burden of This* (2018) witnessed the artist manoeuvre a black sack of faecal matter equivalent to her own body weight through the busy market streets of Croydon in South London. It was a hot July afternoon, and it was curious to witness the encounters she received, from the hilarity of onlookers to complete ignorance, some even praying for her possessed soul. Each relationship the work created between passers-by and the artist were rich and varied, a varying 'intimate connection' (Harries 2009: 13) which held a duality in the empathy we felt for her fatigue, her failures, and the joy of her perseverance, opening a fundierung for the alētheia in her Sisyphean task: a pursuit to reveal a truth.

The lived body of each person present in the streets brought both cause and effect – through the affect of action and inaction – to the event at hand. This allowed for a unique sense of perception at the end of each perspective which would have held individual truths, dependent on each person's reaction/investment. Heidegger says of truth in this regard that it is 'the unconcealdness of that which is as something that is. Truth is the truth of Being' (1971: 79). Therefore, the effect of choice, to experience the action in a specific manner, affected the perceived potential truth of the action, revealing or perhaps provoking an unconcealedness of truth within each person present to the experience. Here the potential

of failure in the task brought an audience closer to felt experience of the artist's exploration of trauma. Of this, Sincavage said that '[t]rauma is an individual experience yet manifests similarly in our bodies often challenging the simplest of tasks. Contending with our trauma is performed in the artwork...by walking while dragging the artist's own body weight in manure [...] Throughout the performance, the artist fights the abject body as she tries to manoeuvre the public sphere' (TF 2018). Encountering her body in the incongruous environment – the smell of manure is not something one would normally find in the city, let alone a woman hauling it on her hands and knees – we were confronted with a locus for her trauma. Her possibility of failing disrupted everyday normality with a refusal to hide, the shit of another's life stinking and permeating our own lived experience – a disruptive punctum of the artist's image intervened in our own. This was Sincavage's truth/value. Beauty does not occur alongside or apart from this truth. When truth sets itself into the work, it appears in reciprocity. Appearance here through the agony, the failure of other/s empathy or their attempts at sympathy was an alētheia (Heidegger 1971: 79). The beautiful in this moment belonged to the event of truth.

Series Notes

Recalling her experiences of the performance in a later interview, Sincavage said, 'I would say the impact of the work has evolved. The piece means something different to me than from the first time I performed it. In the beginning, it was more about my own grappling with trauma but as I performed it more, I was aware of how my trauma affects others and, furthermore, how when others are involved, that provokes empathy. In the end, I feel it became more about others' tolerance and ability to relate or help me. My approach was less about being a victim of trauma and more about provoking a better understanding of mental health. In performing the piece, I have a selected memory of comments people would say to me – mostly, 'are you ok?' In some cases, there seems to be genuine concern while in others, it is said with judgement. I believe that says more about a general attitude towards those who suffer and how some would rather look the other way and others

desire to help in any way they know how. That has left indelible mark on me.' Such indelible marks are significant regarding the truth/value of an artwork. The dis/appearance of them upon the skin echoes the Heideggerian *unconcealdness* (1971: 54). The immediacy of an action stretches across a temporal plane, as scars continue to mutate in both body and landscape. Yet it is the momentary interaction that opens perception. Something we may refer to as the Augenblick in the manner something appears to us.

Augenblick is a temporal point which could be described as a moment of coming forth within an action. First used by Heidegger to describe an unfolding of Being, we propose that for performance art it is the precise

> moment where a multiplicity of Self/s is exposed through an audience's perception [...] Meaning literally eye (augen) and blink (blick) in German, there is commonality to the turn of phrase, 'a blink of the eye', implying that Augenblick, in a phenomenological sense, holds a moment of exposure. A moment in an action, albeit brief, where we (artist and audience) could experience a change in the way we perceive (one another).
>
> (Bacon 2018c: 3)

From this, one cannot merely imply all artwork will find the same truth/value in the Augenblick of alētheia. Perception is subjective, but an exposure to the risk of failure increases the catalytic investment in the moment this may occur. The action and the artist must find harmony within this moment but equally and no less important is the reciprocal fundierung between all Self/s present.

Exercise 17 (Part 1 of 2)

Discovering our relationship to materials can be difficult. Unpacking our shared materiality, let alone our own corporeality can at times seem insurmountable. For this exercise you are going to make a short performance score that uses a single material to say something about your identity today.

To begin, let's think about rice!

Did you know there are more than 40,000 varieties of rice? More than half of the world's population eats rice with at least 20 per cent of their daily calorie intake. Rice is one of the most important commodities in the world and directly feeds more people than any other crop. So, chances are you have some experience of rice, even if you hate it!

Your task is to write out your recipe for how you would typically (1) prepare, (2) cook and, (3) eat rice. Try to capture every detail so that if you were to give this to someone else, they would be able to replicate your experience.

In essence, what you have created is a performance score using a single material that more than likely says something about who you are, as well as your social and cultural histories.

Now, I want you to go on a scavenger hunt in your own home! **You have five minutes (so set an alarm) and turn the page to Part 2.**

Exercise 17 (Part 2 of 2)
With that clock ticking down, you have five minutes to find the following:

1. A food that represents your culture.
2. An object in your house you hate.
3. Your favourite smell.
4. A treasured memory.
5. Something you like to wear that captures who you are.

With these five objects in front of you, I'd like you to take five minutes now to write for one minute each on what each item means to you personally.

Read back what you wrote, pick one of the objects you'd most like to work with based on how the writing makes you feel about who you are.

Now get ready to create a one-minute action that captures your identity – the action should be either destructive or sacred – but like your recipe for rice it should cover three stages: (1) prepare, (2) activate and, (3) remain present.

Now perform the score!

Adaptation: This exercise works just as well in pairs as it can solo. When working with others, take the opportunity to discuss both the rice recipe and the performance score based on identity before moving to the next step. There is an opportunity to hear responses and notice differences. What can be revealed about the materiality of something is based as much on a person's personal histories as it is on the thing itself.

When you finally perform the score – try and perform to either a camera or another person – take time to reflect on how you navigated the three stages, especially the last that asks you to 'remain present'.

Extremis

The final section of this book brings us to the artist in extremis. Here audiences witness the performance artist under physical, mental, or emotional duress or even experiencing extreme environmental or temporal conditions. Due to the extreme nature of these performances the catalyst of risk and investment become fused in the moment of Augenblick, a cohesion that merges all presence/s through the intensity of the action. This type of encounter may often lead to extreme reactions within artist and audience, which tempt, repel, or adhere the truth/value of alētheia with an unapologetic certainty. Performance artists who challenge their normative containment expose a vulnerably that is felt through all lived bodies in the immediacy of the encounter. This is a challenge to an audience's recessive body, as it is uncompromisingly forced to acknowledge the visceral felt and seeing experience of the artist without vicarious safety. The resulting affect is a fusion for our shared empathic perception or on some occasions an uncontrollable fission.

In extremis the material/presence of the artist is similarly intertwined. This is illustrated by the artist who endures, who punctures the skin, who queers hegemony, who anarchically destroys normative convention that scars their flesh, who breaks taboo. In the immediacy of such acts, we are often presented with some biological remnant that is both part of the corporeal body of the artist – despite it separating from where it 'normally" belongs – and something that is arguably becoming a material, be it tissue, blood, sweat, semen, urine, faecal matter, or a more sociologically queering anthropological statement. This witnesses the artist separated and simultaneously completed across both body and artefact, allowing the audience to experience the gestalt of their material/presence in each immediate moment. Through these experiences Kozel writes, 'that we are seeing and seen [...] there is a touch in vision and that we operate according to the touching-touch: just as I see and what I see sees me back, I touch and am touched by objects' (2001: 37). To be touched by a reciprocal truth echoes the fundierung necessary in the origin of the artwork. In seeing what sees me, personal subjectivity affects each perception; images from the past, now in the present, are opened and cross a flux of disembodiment, displacement, and absence, to open the artist's Being to a multiplicity of Self/s. Body and memory are divided, intervening in the present and mediating the immediacy of the action before us. This multiplicity enhances the ways in which an audience can engage with and reductively divide the artist's Being. Each lived body (artist and spectator alike) present to a performance encounter furthers the potential for multiple responses through our shared phenomenological flesh. They may love, resist, embrace, or despise the action, but these responses find their own personal truth, imbued with a personal value. This is the truth/value.

Vulnerability is intrinsically linked to a perceived exposure. As the artist and audience invest in the risk of this public exposure, an alētheia manifests through what Heidegger referred to as 'angst' or 'strife'. A lived body in the extremes of an encounter conflicted with the immediacy of either their own or another's past and present, is in a flux of revealing and simultaneously withdrawing Self/s. Correlating this back to truth, Heidegger says,

> Truth establishes itself in the work. Truth essentially occurs only as the strife between clearing and concealing in the opposition of world and earth. Truth wills to be established in the work as this strife of world and earth. The strife is not to be resolved in a being brought forth for that purpose, nor is it to be merely housed there; the strife, on the contrary, is started by it. This being must therefore contain within itself the essential traits of the strife. In the strife the unity of world and earth is won.
>
> (1927: 188)

Translating this to the performance artist, we discover such strife in the extremis of action. The vulnerability in the potential failure of the artist through our shared worlds is where we confront our hidden Self/s – the painful truth of the emotional, yet beautiful risk the artwork holds through our perception of it.

Exercise 18
For this exercise, it is important to select an edible item that you are **not** allergic to but that you do not like to eat. Ideally the food item is no larger than the palm of your hand and no smaller than a raisin.

1. Sit on the floor, cross-legged or on a comfortable chair if you prefer. Make sure you are not wearing shoes, as this will help to ground your experience. Throughout the exercise stay present and stay upright.
2. Place the edible item in your cupped hands that you rest in your lap.
3. Come into the present moment by taking a few breaths, noticing how you feel physically and allowing your gaze to rest on the item you are holding.
4. Note your impulses as you look at the item, and at each remaining stage of this exercise continue to note your impulses (physically and emotionally) before acting on them.
5. Examine the item through touch. Have a sense of curiosity, as if you've never felt one before. Note textures, size, weight, and temperatures on the inside and outside of your palm and fingers. You may want to even close your eyes while doing this.

6. What colour is the item? How does this colour make you feel?
7. Imagine where the item came from, how it was grown, harvested, and transported to you. Map the journey in your mind's eye.
8. Touch the item on the side of your face.
9. Slowly bring the item to your nose to see what it smells like. Notice how your arm moves to do this.
10. Do you still dislike this item or has your appreciation of it changed?
11. Touch the item to your lips. Notice whether you're anticipating what it will taste like.
12. Depending on the size of the item, bite it or place it in the mouth. Do not swallow or chew. Explore what it feels like in your mouth, notice what your tongue is doing. Notice what it's like to take this time before eating the item.
13. When you are ready, slowly bite into the item. How does the texture change? How does the scent and taste combine?
14. Attempt to stay present with the feeling of disgust.
15. When you are ready, swallow the item. How do you feel?
16. Sit quietly and notice how you are feeling. Take some time to navigate the extreme encounter. How did your embodied experience alter over the entire journey?

Adaptation: As we have explored previously, the necessity of sight should not be foregrounded if you are visually impaired or if you'd like to explore this exercise without that primary sense. The encounter with a food object you hate and how it stimulates other senses and feelings is the focus. Take time after the exercise to consider how this challenge engaged your visceral body from a recessive position.

tjb

Artist image 27: *The Lived Body*. Buzzcut 2013. Photo: Julia Bauer.

tjb (xe/xem) whose practice was performed from 2001 to 2020 under the name Thomas John Bacon described the 2014 version of *The Lived Body: Redux* in the following way:

A 25 minute performance consisting of pre and post space states and a 15 minute action featuring a failed walk across a salt plane in traverse, where a Being experiences major blood loss and is de/constructed through the viscera of extreme live noise, light, blood/salt, and darkness.[7]

Embodied Writing

Microphones hang from the body. The steel in my anus feels more awkward than usual. Maybe it is the wait, maybe it's because this version is going to be different. I can hear the bass tone hum coming from the space and the signal is given that they are ready. Familiar hands lead my own towards the site for action.

I can see nothing. I can feel far more than usual. There is a sense of passing people as I walk to the end of the catwalk of salt. I hope that the space has been laid out as designed; that people could watch the salt being set and smoothed in a wooden frame before it was removed. There is a wisp of Dettol in the air. I can sense two bodies and their tension is palpable. The blade is handed over, checked, and then handed to me again. I focus instead on the sounds coming from our umbilical line to Lee Chaos behind. I gently test that each microphone is working without overly emphasising any shift in stature. I focus inwardly on breath, trying to find a calm. A place in the space to just be. Raising a hand to my head I cue the black out. In darkness, every action is amplifi ed, magnified to thud, pop, and crack through the sound system. I know that this will grow over the course of the action to distort and become painfully extreme. I cut at the ribbon and skin below. A gush of blood floods over my face.

I lean slightly to one side and for the first time can tell this feels very different. The light illuminates my face. Lifting up, the blood is pouring, not pumping, but pouring out of me. It literally waterfalls over my nose and out towards someone. I see them withdraw in horror. My body feels like it is tingling with pins and needles.

Stepping forward the salt crackles intensely through the speakers as it encounters a microphone on my heels. I suck my sphincter against the butt plug and can hear squelches; the copper-plated microphone on my elbows tear against the skin of the torso, I breathe and heave air in through my mouth. Cranial cavities and lungs sighing, I scratch against the microphone in hand. I control the source and leave the signals to be manipulated behind my body by Chaos. The wires connected tangle and catch, I groan to pull back on them and force a way forwards.

People seem to stand or kneel in shock. It is different [than] before [in Glasgow]. I feel my bodily energy dissipating quickly and my legs feel hollow. I see the face of a man staring into my hollow body and a woman cry. I feel I am wobbling and must find a way to reach the end.

The tension and sounds build. If I groan it is because I need to force onwards. It is not through pain but feeling. Pulling my body taut, the lights blind in a flash before darkness and 'chaos' consume us all. The sound is ear-splitting. I rush, breathing fast and hard as I abjectly yell into the void around me.

The blood is still pouring from my face. Spit joins it. It doesn't seem to want to stop the speed with which it is leaving. I am on the floor in the pitch black and tear at these leads. The sounds are all around us and are living on in the speakers even when I try to bring about an end. I rip the last mic free and the sound of feedback is deafening. Mumbling the word 'fuck' under my breath, the sound dies down and people can only hear breathing. No longer through microphones. Somewhere in the darkness before them. Heaving for breath, a body, my body! The bleeding hasn't slowed. I go to stand, a microphone lead trips me mo mentarily and I grab the safety of the hands of an assistant to leave the dark space.

Contextual Discourse

The *Lived Body* was performed by me at Buzzcut in Glasgow (2013) with Llewyn Maire and as *REDUX at Tempting Failure* in Bristol (2014) with Lee Chaos. Both collaborators were sonic artists who offered a means to enhance the projected simultaneity of my lived body beyond a physical form through its wired connection to their amplification and distorting equipment. As Voegelin suggests of extreme soundscapes, it 'demands consideration of itself in its sensorial complexity without recourse to art historical, political, relational, social etc. theories that present it with a language that precedes its encounter and immobilises its present production' (2010: 74). Noise cleans the canvas of our minds, focusing us instead upon its immediacy of the present. It arguably removes the need for any aesthetic a priori, creating a moment in and of itself. In this instance noise offers an intercorporeal experience of my artist's lived body through our shared hearing.

I was witnessed as a Being, corporeally complete. Positioned before an audience who are placed in traverse, with me as artist in the centre. They witness a lived body that is 'reconstructed in the moment of

perception between spectator and [artist ...] A failed body, reformed to encompass all; beyond subject, beyond object, both embodied & disembodied, including you: your presence & perception'. The action of the performance unfolds so that the sound, the light, and the bleeding act as the symbolic splitting of a singular essential self. The body is then reformed through light, noise, and darkness, leaving traces of its blood and movement caught in the salt-covered floor.

Chaos and Maire enhanced the projection of presence/s through their separate sonic collaborations with my body. Audiences witnessed the figure of the artist plugged into meters of wires connected to amplifiers at the start of the performance. Through its distortion, their subjective comprehension was then unpacked through multiple channels of sound originating from the microphones all over the body of the artist. This noise was designed to be projected so loudly that it would consume everything. When a sound is extreme, it can touch your eardrums; it can hurt you, or shake your body, resonating in your sternum and vibrating your limbs. Our bodies in this way became intertwined and blended with everyone in the space.

The sonics were exaggerated further by placing two main parts of the sequence of action in complete black-out: namely the blood-letting cuts at the start and the extreme sound where I tore the microphones from my body at the end. These sequences were extended in the second version subtitled *REDUX*. As the presence of body was fragmented intentionally, darkness was utilised to allow audiences to embrace their own internalised image of the artist they could not see but still perceive as documented in this account by Helena Sands:

In the dark we anticipate xis first baby steps. Breaking the surface. It is unclear exactly what is happening to xis body as the amplified sound distorts – is this xis noise? I am displaced somehow removed from what is happening. Interference breaks xis breath [...] as sounds increase and blur [...] echoing the blood rushing in my ears and chest. Am I now xem? Darkness makes me want to touch more. The sound distorts what I think may be real. May be happening to xis body. Trapped sounds like a wounded animal. Movement's that sound laboured, difficult; as breath turns to groans.

We see a broken mane, a fallen crown laced with blood. There is no victory here.

As light reveals action, I wrestle between sight and sound. I feel exposed now. I was more comfortable in the dark. A collective sigh exposes the debris. The sound is pain. Xe is bleeding. Unstable echoes magnify my discomfort. The louder the screams become the less they appear to be coming from xis body. In the dark it was xem, the light exposes xis/my/our breaking. Fragmented we hold the final explosion of voice, light, noise somehow bringing me whole again, present in the space, a collective unity. Fleeting but there. I don't want to see again. The final coda; repetitive breath, laboured and intense screams that this is really over.

Sands highlights the effect of the soundscape in projecting the presence of the artist through the noise. She notes how the darkness enhanced a sense of touching as the sound palpated her eardrums, affecting her perception of what may or may not be real. In particular, she questions, 'Am I now xem?' the experiential intercorporeal affect of a reciprocal communal encounter fused through us together from the extremis of the action. Voegelin says of noise that it 'fragments its fragments that fragment it ever more' (2010: 75). We typically do not take account of our perceptual reading: its objectiveness, lack thereof, or position (manifested physically or emotionally). However, *The Lived Body* series (2013–14) confronted the recessive nature of audiences so that they may experience 'our own body is in the world, as the heart is in the organism' (Merleau-Ponty 2002: 235). Noise bridges the phenomenological flesh in our perception of presence/s, so my own body as artist manifested through the felt body of each spectator and their perception in turn placed their body within my own. There is no hierarchy here, no Cartesian ideal, and no essential self, only a manifest multiplicity. The use of darkness was therefore a symbolic stage of our shared intercorporeality. In the darkness, we are aware of ourselves, hidden from everyone else, yet unified in this instance through an extreme sound that does not allow for anything other than a single unifying force to dominate the space. As Voegelin concludes of such 'noisescapes': '[It] practices a signifying practice that finds no signification but continually builds a bridge between the structure for the articulation of meaning and process of its experience' (2010: 75). The living sound of the lived body is a journey through the experience of all present, and so by the artworks' denouement it is therefore crucial that we hear the body without any amplification through a sound system. Heaving with weakened breath in the

darkness. A moment where the chaos is replaced with the 'reality' an audience project upon the artist as artwork.

Series Notes

I left the audience in darkness. Alone in the performance space, they experienced time with their own unique individual perspective. As light returned, there was no central focus beyond the horizon of the traverse environment. Individual audience members encountered each other's reactions; their judgements good and bad, as they looked at the multitude of faces in the audience that's survived. It was in this briefest of moments that their Augenblick captured an awareness of the connection between them all. Akin to a moment of survival from a shared experience, Merleau-Ponty describes this becoming awoken – aware of our world and in so being aware of ourselves as follows:

> In the same way, we shall need to reawaken our experience of the world as it appears to us in so far as we are in the world through our body, and in so far as we perceive the world with our body. But by thus remaking contact with the body and with the world, we shall also rediscover our self, since, perceiving as we do with our body, the body is a natural self, and, as it were, the subject of perception.
>
> (2002: 239)

This reawakening was part of the design of this artwork. Having experienced another person through your own body, perhaps shockingly so in sight, but no less intensely through an encompassing soundscape, you are left to confront your own gaze through the eyes of another looking straight back at you. Here one may become aware of a sense of reciprocity in the act of perceiving Self/s. That, as Merleau-Ponty puts it, leads to a rediscovery of yourself through the challenge of what you have had as shared experience.

The bloody waste left at the end of *The Lived Body* was designed not to remain as a permanent artefact. It was momentary and, like the Augenblick between spectators, it was open to change – a material of temporal presence/s much like our body. It is the immediate aftermath of

an act that questions the cohesion of an essential self. Post-performance, the audience is invited to remain, to witness the detritus of the artist's body swept away, so the momentary presence of perception and the de/re/value effectiveness of body as artwork becomes questionable. This left the audience to consider what truth/value they may or may not have found. Sands described the moment as '[r]esidues, painterly malleable stains covering the floor. Momentarily I forget that they were caused through the loss of blood. Altered substance. Balls of red play-dough I wanted to touch'.

What is seen after the main action of the performance is held in the perception of each person who stood before the bloody remains of tjb. The reciprocal combination of the rational and empirical gives rise to something with a quality of 'beauty', perhaps even 'truth' (Harries 2009: 13). It is the unique positioning of the lived body of an artist in action, whose absence (in this moment post-performance) generates unique experiential encounters for those that remain to watch the 'body' cleaned from the space. Something Jones feels may be captured in similar acts of wounding, describing them as holding 'the capacity to defy the absolute binaries of self/other and real/representational. It exposes the impossibility of the self and other being the same [...] and yet also of their being complete opposites' (2009: 55). FK Alexander said of this moment in her reflection, 'tjb was Jesus Christ tonight and xe took the beating and the flogging and xe walked as xe dragged xis cross and xe crucified xyrself [...] It is a huge revelation when I hear myself say I forgive myself for ever being ill, for ever mutilating myself, for all my blood I've wasted for all the pain and problems and heartache. I forgive myself. I forgive the past. I forgive my mom for dying and I forgive all the abuse. I forgive it all. I had tossed it on the floor to mix with tjb's blood, to reconfigure, to be stained red forever, to be like butter on bread, unable to be separate again, soon to be swept up and no more. I sit on the floor of a pub cellar crying and writing in large red pen and I wonder if I will ever cut myself again [...] Away. Gone. I am light. I am light. I am light.' Her account is desperately honest and speaks of the wave of emotion that is evident following the shared survival the experience created. An event, which from Alexander's perspective, opens her and others to a shared trauma through the body of the artist.

[T]here are other landscapes besides my own.

<div style="text-align: right">(Merleau-Ponty 1968: 141)</div>

Hancock and Kelly

Artist image 28: *Gilding the Lily*. Tempting Failure 2014. Photo: Hancock and Kelly – Memorial Polaroid courtesy of Helena Sands.

Richard Hancock (he/him) and Traci Kelly (she/her) state in their programme notes as follows:

> In each performance, the audience member engages in an intimate encounter, their genitals shaved, and sealed in gold leaf. A single polaroid photograph, handed to the audience member, remains the sole trace of this ephemeral exercise in trust, power, and desire.[8]

Embodied Writing

Disinfectant permeates space, cell, and lungs. The fingertips touch the neckline hair as they take grasp of the neck to bow the head, a texture that feels transgressive and intimate. Latex gloves snap at the wrist as a zipper slides down and the visitor is seated. The clippers vibrate in my hand and I concentrate as I shave their pubic hair – 'please no nicks' – floats around in my head as I stretch warm crevices to create flatter surfaces. Lubricant slides around the gloved fingertips allowing them to travel freely, spreading a temporary fixative around the genitals. I am on my knees – cold floor biting the bones, stiffening sets in as I am hunched between another thighs, and afterwards another and another. Fragile leaves of gold glimmer and take their own time to settle on skin – so so fragile – so so vulnerable. Falling and teasing to where they might touch base. Soft strokes of a brush.

Contextual Discourse

Writing on painting rather than performance, Peter De Bolla (2003) reminds us that no matter the form, the subjective interaction with the artwork manifests our experience of it and akin to Dewey's *vehicle of experience* (2005), this is where the discovery of truth/value unfolds through performative action. In *Gilding the Lily* (2014) a parallel between performance artist becoming artwork emerges through an illustrative dissemination (activated as a participant) towards an audience also becoming artwork. This restaging of their 1:1 performance *Gilding the Lily*, reworked the original made for Ron Athey and Lee Adams's *Re-Visions of Excess* at the *Pink Flamingo* lap-dancing bar in Birmingham and located it to the former holding cells of an abandoned police station in Bristol, named *The Island*. Here the 1:1 nature of the piece between artist and audience member extended the fusion of shared extremis as mutual participants in an action that directly encountered exposure and vulnerability. 'The shift in context from a site of commercialised, sexual pleasure to a former institution of police enforcement, heighten[ing] and challeng[ing] the work's complex relationship to economies of power and desire' (Hancock and Kelly 2014). Here the material/presence of participant was as important to the materiality of the artwork as the

artist. Holding a shared becoming, their energy and interaction affected and shaped the reciprocal experience as much as Kelly or Hancock.

As each participant left the cell with their genitals covered in gold leaf and only a Polaroid to remind them of the experience in the future, the artwork extends beyond the intersubjective and is held within a shared fundierung. This becomes an intercorporeal memory, blurred and altering over time, as De Bolla notes, the 'experience of artworks [...] takes place within ritualised social conventions and these may be decisive in how we experience the work.' (2003). These rituals breach the restraints of canvas that are De Bolla's phenomenological world and 'become' through the action of performance art.

Through queering the fine art hegemonies upon which Heidegger based his writing for the origin of the artwork, Hancock and Kelly illustrate an extension to our reapplication of his words, when Heidegger stated, '[t]he question concerning the origin of the work of art asks about its essential source [...] the work arises out of and by means of the activity of the artist. But by what and whence is the artist?' (1978: 143). Without a Cartesian hierarchy, we no longer idolise the artist and their artwork above all else but through the very action of the performance artist's direct interaction with an audience, we find that the origin of the artwork manifests through shared experience, destroying artist-as-origin as the sole possessor of the artwork and similarly dismantles a Cartesian hegemony.

Series Notes

Shifting the artwork from a Birmingham strip club to jail cells in Bristol occupied space/s 'of oppression and pleasure [which permitted the action to] interrogate, activate and problematise [these] shifting permutations' (Hancock and Kelly 2014). Kelly later reflected upon the effect of this on the Bristol performance score, noting 'Upon arrival, the head of the participant is bowed and held over the toilet as an initiation and a power set up. After that they drop their pants and sit on the sparse bed/bench with legs splayed. The performer in the cell then shaves the participants pubic hair and applies lubricant which then holds the gold leaf as it is applied. When the gold leafing is complete a Polaroid image of the genitalia is

taken and given to the owner. They dress and are then shown out of the cell.' The encounter is extreme. The meeting holds a risk of failure for both through shared investment in the moment. Exposure, beyond the physical, becomes held in a catalyst of risk, encapsulating the notional 'strife', that Heidegger clarifies as an important in the exposure of truth, when he wrote that 'Being must therefore contain within itself the essential traits of the strife' (1978: 188).

The Heideggerian evolution, from Kantian aesthetics, leads us past a blinkered concern for aesthetic value. De Bolla notes: 'As Kant remarked, [though] aesthetic experiences are based in the subjective a priori; they are radically singular' (2003: 136–37). Through each act of extreme intimacy and trust between both lived bodies in the moment of interaction, the audience member witnesses themselves becoming an artwork in the hands of the performance artist. In an interview, Kelly explored her relationship to the materiality of the body, suggesting, 'I approach the body as material and site. The materiality may be tangible – piss, skin, sweat, tears – subject to the laws of physics and biology, or it may reside in production – brokered by exchange thus producing the political subject.' Here, the reciprocal insertion between two lived bodies leads them towards a Heideggerian notion of truth/value, where he states, 'Truth establishes itself in the work. Truth essentially occurs only as the strife between clearing and concealing' (1978: 188). The origin of the artwork through performance artist finds its truth/value in the moment of a shared perception of Self/s. Value is held in the becoming that manifests between all present.

The artist is the origin of the work. The work is the origin of the artist. Neither is without the other.

<div align="right">(Heidegger 1978: 143)</div>

Niko Raes

Artist image 29: *This Boy Needs Love.* Tempting Failure 2018. Photo: Julia Bauer.

Niko Raes's (he/him) programme notes describe the action as follows:

> A naked white body hanging in the void [...] with water dripping and penetrating its skin like a Japanese torture [...] washing everything away [...] revealing its true nature [...] waiting to be loved [...] with only the sound of dripping water and an audience walking through it, becoming one with this boy.[9]

Embodied Writing
I close my eyes as the water is turned on. The first drips hit my flesh and instantly make my body shiver. The water is cold and very present. I try

to control the first shivers with my breathing and focus on the sound of my breath, not the dripping … As the performance evolves, I turn deeper in myself and don't recall what's happening. Suddenly I feel extremely cold, cramped, painful … It feels like waking up from anaesthetia. You're there, but not all there. I free my arms out of the ropes and the water is turned open completely: it feels like an assault on my already broken body. Yet it gives me a liberating feeling. I fall from the ropes onto the floor. I feel wasted and broken … but I must get up … Every muscle and nerve hurts as I move. My breathing doesn't help anymore. Slowly I stumble out of the space … Broken and cold to the bone.

Contextual Discourse

This Boy Needs Love (2018) is described by Raes as an endurance performance/installation. We witness a body suspended horizontally in the air, painted white, attempting to maintain a sculptural form as cold water gently rains down upon him. He described it as a state that 'investigates and questions the paradox of aesthetics and pain in the search for a new beauty' (TF 2018). The only soundscape in the darkened studio is the trickle of falling water alongside Raes's shivering breath; it captivates the audience, there is a pain in this peacefulness. As his body is washed away, the work ends with him falling from his restraints in a suddenly intense shower of rain.

Echoing Badiou writing on the notion of love, this performance holds a painful sense of longing, 'love is a thought and that the relationship between that thought and the body is quite unique, and always marked, as Antoine Vitez said, by irrepressible violence' (2012: 87). Raes's body is sculpturally traditional, muscular, and painted white. However, these Cartesian norms of aesthetic beauty are disrupted through subdued violence as it volatilely shakes against the cold, queering the classical image captured in Renaissance artistry. The origin of the artwork in this single moment is rewritten; tradition is transgressed in a futile attempt to maintain a stress position that convention suggests holds the alētheia of an artwork. Here we find a new truth/value in the beauty of the artist's failure; as he falls in a shower of water hitting the concrete below, his

suffering eases and there we share in the beauty, an Augenblick we perceive through the performance artist as artwork for twenty-first century.

Series Notes

The fragility of Raes's vulnerability was magnified through each shiver and quake of breath. Our empathy connects us, as Jones suggests,

> The wound we perceive as actually violating the body of the other, ripping into the skin, making it bleed, penetrating its orifices or forging new holes, pricks us with fear and desire. It makes us smart and wince with recognitions [...] and it is this empathetic response that gives such wounds the potential to move and change us.
>
> (2009: 51)

Raes later said in an interview that his exposure opened our shared risk of failure,

> During these moments the body is missing the sense of agency, as it has no longer control over its own movements and actions. Here we might implicate that the [...] audience becomes the owner of these movements or even of the body itself. Thus shifting the sense of agency from the performer's body.

Merleau-Ponty refers to this when he speaks of how our presence, our history, our past affects our present: 'The person who perceives is not spread out before himself as a consciousness must be; he has a historical density, he takes up a perceptual tradition and is faced with a present' (2002: 277). The artist in extremis confronts our shared mortality and we perceive shared Self/s through the immediacy of the experience before us. This is the application of a queered phenomenology where the transgressive performance artist exists as artwork and equally its origin.

Exercise 19

This final exercise draws together notions of vulnerability, failure, and extremis by setting you a group workshop about the risk of exposure!

It is very important that before proceeding you ensure you are working with others who will maintain a safe space. One person is required to act as facilitator, and they must supply their phone number to an answer machine – which will remain available for seven days – that will only ever divert to the answer machine during that time.

Everyone participating must agree before proceeding that the recordings the facilitator captures will be destroyed and not shared beyond the workshop.

You must then agree that the following challenge will be completed on your own at some point over the next seven days before you meet again:

1. Run to the 'highest point'
2. Call the number.
3. Leave an *anonymous* message to the one person or thing that got away.

When you meet again, the facilitator should ask you to take time to reflect as a group on how you felt before the challenge, how you felt immediately after the challenge, and how you have felt since.

Consider the following prompts:

1. Why is exposure in this way important?
2. What was the role of vulnerability, of investment, extremis through exhaustion, or the risk of failure?
3. Why was it necessary?

The facilitator should now ensure the recordings are gifted to different participants (but they should not listen to them until instructed). If anyone is gifted their own recording it is important to redistribute these.

- With these recordings, you are now going to go on a solo walk of no more than fifteen minutes (in silence) to try and locate the quietest outdoor space.
- Once there, respectfully listen to the recording.
- Now find a hidden place in that location, small enough to be able to seal with whatever is to hand (i.e. a gap in a fence with some fallen leaves).

- At that place, listen to the message once more and (verbatim) whisper the message into the hidden place and seal it shut.
- Take a closeup photo of the sealed place that does not reveal the location.
- AND delete the recording.
- When the group returns, share the images with each other. Take time to reflect on how it feels to have shared this exposure, to have gifted it away and to have a sense of its final resting place. What did it feel like taking part?

Adaptation: This is the most complicated of the exercises in the book so adaptation to all needs is vital. A simple rule of thumb is that reasonable adjustment should be made throughout – for example, if running isn't possible then please do not do it, but think about how the focus is to share a vulnerability without too much thought to editorialise beforehand!

Importantly, it is useful to remember that choice and opting out is ok but if that happens then explore why it happened and use this as a means to reflect upon artistic practices in this final section of this book.

Postface
The Argument for Queering 'The Origin of the Work of Art'

As noted by Julian Young, Heidegger's philosophies are contaminated with his own political perversions. Young suggests that 'a defence of any aspect of the being of someone who had any kind of association with Nazism can readily be taken as a discounting of the horror, as evincing the defenders own moral blindness' (1997: 9). This book's use of language originating through Heidegger arrives through a necessity to understand Merleau-Ponty's extraction and evolution of the phenomenological thought that began with Husserl, followed by Heidegger, and was subsequently authored by Merleau-Ponty. It is not intended to raise the significance of Heideggerian notions above Merleau-Ponty but it is necessary to understand these when introducing readers to a phenomenological lineage of thought that evolved the language originated through Heidegger.

Heidegger's anti-Semitic thoughts revealed in the *Black Notebooks* series published over 2016–17 became crucial in re-evaluating any application of his phenomenology that does not acknowledge his fascist ideologies. Tom Rockmore suggests that 'once one admits that it is present anywhere in Heidegger's theories it almost immediately becomes visible elsewhere, in fact everywhere or almost everywhere' (2017: 154). Andrew Mitchell and Peter Trawny's (2017) collection of responses held in *Heidegger's Black Notebooks: Responses to Anti-Semitism* significantly help to recontextualise a wider understanding of his writing.

Where Trawny (2016) and Victor Farias (1989) were significant in highlighting Heidegger's radicalisation, it is the writing of Rockmore (1992, 1997) that has helped to reposition Heidegger's anti-Semitism as evident earlier than World War II.

For Trawny, Heidegger's turn to anti-Semitism is not a mere accident, nor attributable to his Nazism, nor even due to the ongoing deterioration of the political

situation. It is rather the result of an incessant, obsessive pursuit over decades of the meaning of being.

(Rockmore 2017: 158)

This book's queered dis/orientation of Heidegger's (1927) essay 'The origin of the work of art' (2009b), will potentially draw criticism from those who wish to defend the original text. Yet the biased principals of artistic hegemony within that essay, which indisputably are close to the Cartesian hegemony it sought to critique, are based on exclusion. It suggests what good art is through a process of othering, raising (a misplaced) divinity of the artist above all else. However, though it is important not to ignore the fascism evident in most Heideggerian thought, there are phenomenological resonances that remain significant to us today, such as the nature of the origin of the artwork's own becoming.

If the perception of an artwork's alētheia, as we have demonstrated in this book, is no longer held in a hierarchical system of dominance that confirms artistry through sublimate authority but rather a reciprocal fundierung of Self/s, we may subvert the language of Heidegger's writing towards a more egalitarian process of perception. Resisting the fascistic subtext now evident in notions of a Dasein or being-in-the-world, we have demonstrated how a lived body and being-towards-the-world share the origin of the artwork through their felt experience of it.

According to Derrida (1995: 48), when 'Heidegger discusses concepts of world and worldlessness in the lecture course *Fundamental Concepts of Metaphysics* (1929), he makes three basic claims. A thing, for example, a stone, has no world. An animal is world poor (*weltarm*). A human being is world forming (*weltbildend*). Heidegger again makes roughly the same triple distinction in 'The origin of the work of art', 'This philosophical view of "world" is not harmful but harmless. But it loses it harmless character when it is combined with non-philosophical, garden-variety, philosophic anti-Semitism, for instance the view that only "real" Germans can be authentic' (Rockmore 2017: 163). Heidegger's language at first seems logical and innocent, but within this poiesis found in the poetry of the written word, is actually something quite dangerous. When Heidegger suggested that Dasein was the only entity self-aware enough to rise above its own thingness and makes distinctions between its self and others, we now understand he was not simply laying a phenomenological foundation of referent positions but highlighting an exclusivity for authentic Germans and defining difference not based on the phenomena of experience but rather something anthropological. Rockmore clarifies as follows: 'Heidegger's conception of authenticity for "real" Germans depends on the repetition of the past in the future, hence in reinforcing their intrinsic status or who they always already are' (2017: 166). A conservative notion of 'returning to old traditions of the past' is found within the 'authentic' and his correlation of

this to 'soil'. A notion that infers homeland, belonging of a particular State, perhaps even exclusively German, but certainly othering those 'things' that are not of the soil.

> Understood in this way, Heidegger's strong opposition to Descartes is not merely an instance of the familiar philosophical struggle about which view of the subject as either Dasein or the *corgito* is acceptable, nor merely another chapter in widely known antipathy in this era between the French and the Germans. It rather points to a fundamental disagreement between a conception of the subject as transcendent to, hence not rooted in, or, on the contrary, like Dasein, rooted in the world, the community and the soil. The social distinction Heidegger establishes, between those who are rooted in and hence belong to the world and those who are not rooted in and hence simply cannot belong to this world, is absolute. Only Germans in the full sense of the term, those who are rooted in their native soil, can possibly be authentic.
>
> (Rockmore 2017: 166)

Through this abstraction, we can argue how Heideggerian language others more than just inanimate objects to be defined outside of Dasein, but also through this context it correlates Jewish and other people deemed unworthy or insignificant to this realm as thing: equatable to a weltarm animal (world-poor) or at worse, a stone who has no entitlement to world. This is unforgivable and is exactly why such language needs to occupied through a queer phenomenology in order to find any part of it acceptable to use!

Authenticity, origin, and alētheia for the statement that '[t]he artist is the origin of the work. The work is the origin of the artist. Neither is without the other' (Heidegger 1978: 143) becomes perverted if it remains unchallenged. Merelau-Ponty had evolved our phenomenological language away from the positions of Dasein and being-in-the-world, towards instead a lived body and being-towards-the-world, this book has, with a knowing pride, used the exposure of risk in the transgressive and queer practices of noise and performance art to bring new meaning, to subvert the fascist implications of Heidegger's original text through the study of art practices he almost certainly would have categorised unacceptable, and certainly not as art.

Where a multiplicity of Self/s has demonstrated the Cartesian essential self is no longer a guiding principal in the shared experience of art, my own poiesis reclaims the origin of the artwork for performance art to be non-hierarchal – held in the shared experiences of artist, audience, and space, across time and memory. These artistic practices suitably transgress commodification, resisting traditional notions of truth/value, centring instead upon an embodied experience as becoming artwork and bringing new thought to the perception of alētheia through Self/s for the performance artist.

MANIFESTO FOR PERFORMANCE ARTIST AS ARTWORK

The artwork is dead.
The artwork is found through presence/s.
The artwork is temporary.
The artwork feels.
The artwork is immediate.
The artwork survives.
The artwork is permanent.
The artwork is an argument.
The artwork is forgotten.
The artwork exists in every/one and no/one.
The artwork is un/loved.
The artwork is un/seen.
The artwork risks.
The artwork has had a bad day.
The artwork has been fucked and it likes it.
The artwork is a fading memory.
The artwork fails.
The artwork is an anecdote.
The artwork hurts.
The artwork is un/heard.
The artwork is [not] an investment.
The artwork is ailing.
The artwork says something or nothing at all.
The artwork is in the future/present/past.
The artwork contradicts.
The artwork is a conversation.
The artwork is mis/remembered.
The artwork is disorientating.
The artwork has no/point.
The artwork is alive.
The artwork is Self/s.

Notes

FOREWORD

1 Genesis Breyer P-Orridge, *DISCIPLINE: The Art of Psychic TV 2003-2016*, 2017. Book Release Launch: *Lethal Amounts*, Los Angeles. Book Release Lecture by Genesis Breyer P-Orridge on the work of Edley Odowd at *Monty Bar*, Los Angeles on September 23, 2017. For more on the event, also see: Frater Lux Ad Mundi, 'Lethal Arts Gallery in L.A. Announce Art of Psychic TV Exhibition'. Zero Equals Two. Published: 13 September 2017. Accessed: 12 March 2020. http://zeroequalstwo.net/lethal-arts-gallery-in-l-a-announced-art-of-psychic-tv-exhibition/.

CHAPTER 1

1 https://www.iamloribaldwin.com/the-villages.

2 http://annebeanarchive.com/2016-strangers/.

3 https://www.rosanacade.co.uk/the-origin-of-the-world.

4 https://estherneff.wordpress.com/performance-work/.

5 https://www.temptingfailure.com/tf2018.

6 https://harewooo.com/work/the-privileged/.

7 http://www.reginajosegalindo.com/en/home-en/.

8 https://glasgowbuzzcut.wordpress.com/katherine-araniello-the-araniello-show/.

9 https://incidentmagazine.wordpress.com/tag/kamil-guenatri/.

CHAPTER 2

1 https://www.attenboroughcentre.com/events/1072/rocio-boliver-beauty-by-design.

2 https://louisfleischauer.com/wp4/index.php/about/.

3 https://weeksandwhitford.co.uk/insult-to-injury/.

4 http://www.traumata.org/performance/kintsukuroi-golden-seams/.

5 https://www.temptingfailure.com/tf2018.

6 https://tjb.org.uk/passionflower.

CHAPTER 3

1 https://www.temptingfailure.com/tf2016.
2 https://www.temptingfailure.com/tf2014.
3 https://www.temptingfailure.com/tf2018.
4 https://www.fkalexander.com/2014-1.
5 The syntax of FK Alexander's writing is structurally reproduced here as the artist intended the words to be presented.
6 https://www.temptingfailure.com/tf2016.

CHAPTER 4

1 https://www.helenagoldwater.co.uk/embed.
2 https://www.natalieramus.com/16000-acl2.
3 https://www.manuelvason.com/salento-with-helen-spackman/.
4 https://currentsjournal.net/Space-Time-and-Excessive-Performances-of-Endurance.
5 https://www.temptingfailure.com/tf2016.
6 http://www.heathersincavage.com/the-burden-of-this.
7 https://tjb.org.uk/the-lived-body-redux.
8 https://www.hancockandkelly.com/other-work/.
9 https://www.temptingfailure.com/tf2018.

Bibliography

Ahmed, S. (2006), *Queer Phenomenology: Orientations, Objects, Others*. Durham: Duke University Press.

Araniello, K. (2018), 'Artist statement', https://www.araniello-art.com/. Accessed 13 February 2018..

Ashby, I. (2000), 'The mutant woman: The use and abuse of the female body in performance art', in P. Campbell (ed.), *The Body in Performance*, London: Routledge pp. 39–52.

Atkins, K. (2010), *Narrative Identity and Moral Identity*, London: Taylor and Francis.

Kershaw, B. and Piccini, A. eds (2009), *Practice-as-Research: In Performance and Screen*, United Kingdom: Palgrave Macmillan, pp. 18–33.

Bacon, T. J. (2011), 'Traces of being: A document of absence in words', Roehampton University, *Activate*, 1:1 (Spring), pp. 1–19

Bacon, T. J. (2016), 'Experiencing a multiplicity of self/s', https://ethos.bl.uk/OrderDetails.do?uin=uk.bl.ethos.705460. Accessed 14 February 2020.

Bacon, T. J. (2018a), *Tempting Failure: Firestorm*, London: Exeunt Magazine, http://exeuntmagazine.com/features/tempting-failure-croydon-2018/. Accessed 10 November 2019.

Bacon, T. J. (2018b), 'Performance artist, Thomas John Bacon: Public money should fund art for everyone, even if some hate it', London: The Stage, https://www.thestage.co.uk/opinion/2018/performance-artist-thomas-john-bacon/. Accessed 1 January 2020.

Bacon, T. J. (2018c), 'Foreword', in C. Coon (ed.), *No One Thing is the Root of All Anything*, Los Angeles: Not a Cult Media, pp. 1–7.

Badiou, A. (2005), *Handbook of Inaesthetics*, Redwood City: Stanford University Press.

Badiou, A (2012), *In Praise of Love,* London: Serpent's Tail.

Barad, K. (2007), *Meeting the Universe Halfway: Quantum Physics and the Entanglement of Matter and Meaning,* Durham: Duke University Press.

Barthes, R. (1981), *Camera Lucida*, London: Vintage Classics.

Bataille, G. (1977), *Story of the Eye*, Urizen Books.

Bataille, G, (1985), *Visions of Excess: Selected Writings, 1927–1939,* Minneapolis: University of Minnesota Press.

Baugh, B. (1989), 'Heidegger on Befindlichkeit', *Journal of the British Society for Phenomenology,* 20:2, pp. 124–35, doi: 10.1080/00071773.1989.11006835.

Baumgarten, A. (2013), *Metaphysics: A Critical Translation with Kant's Elucidations, Selected Notes, and Related Materials,* London: Bloomsbury.

Bean, A. (2018), *Self ETC,* London: Live Art Development Agency & Intellect Live.

Bean, A. (2016), *Strangers,* http://annebeanarchive.com/2016-strangers/. Accessed 14 March 2019.

Benjamin, W. (1999), *Illuminations,* New York: Random House.

Berardi, 'Bifo', F. (2009), *The Soul at Work: From Alienation to Autonomy,* F. Cadel and G. Mecchia (trans.), Los Angeles: Semiotext(e).

Bergson, H. (1991), *Matter and Memory,* New York: Zone Books.

Blanchot, M. (1992), *The Step Not Beyond,* New York: SUNY Press.

Blocker, J. (2004), *What the Body Cost: Desire History and Performance,* London: University of Minnesota Press.

Boltanski, L. (1993), *La souffrance à distance,* France: Gallimard.

Bouchard, G. (2012), 'Skin deep: Female flesh in UK Live Art since 1999', *Contemporary Theatre Review,* 22:1, pp. 94–105.

Burrough, H. (2016), 'Artist statement', http://www.traumata.org/performance/kintsukuroi-golden-seams. Accessed 10 December 2017.

Butler, J. (1990), *Gender Trouble and the Subversion of Identity,* London: Routledge.

Butler, Judith (2020), *The Force of Non- Violence,* London: Verso Books.

Cahoone, L. (1988), *The Dilemma of Modernity: Philosophy, Culture, and Anti-Culture,* New York: SUNY Press.

Carel, H. (2016), *Phenomenology of Illness,* Oxford: Oxford University Press.

Carlson, M. (1996), *Performance: A Critical Introduction,* London: Routledge.

Carman, T. (1999), 'The body in Husserl and Merleau-Ponty', *Philosophical Topics,* 27:2, pp. 205–26.

Chabert, P. (1983), *Samuel Beckett: lieu physique, théâtre du corps,* France: Gallimard.

Clarke, P. (2013), 'Performing the archive: The future of the past', in G. Borggreen and R. GADE, ed. *Performing Archives/Archives of Performance, Volume 1 of Between States,* Copenhagen: Museum Tusculanum Press, pp. 363–385.

Coon, C. (2018), *No One Thing is the Root of All Anything,* Los Angeles: Not A Cult Media.

Counsell, C. and Wolf, L. (2001), *Performance Analysis an Introductory Coursebook,* London: Routledge.

De Bolla, P. (2003), *Art Matters,* Cambridge: Harvard University Press.

Deleuze, G. and Guattari, F. (2004), *A Thousand Plateaus: Capitalism and Schizophrenia,* London: Continuum Publishing.

Derrida, J. (1988), 'The death of Roland Barthes', in H. Silverman (ed.), *Philosophy and Non-Philosophy since Merleau-Ponty,* London: Routledge, pp. 259–96.

Derrida, J. (1995), *Points . .: Interviews, 1974-1994,* Redwood City: Stanford University Press.

Derrida, J. (2009), *Writing and Difference,* London: Routledge.

Dewey, J. (2005), *Art as Experience*, New York: Pedigree Books.

Dickenson, D. (2007), *Property in the Body: Feminist Perspectives,* Cambridge: Cambridge University Press.

Dolan, J.(2012), *The Feminist Spectator as Critic*, Ann Arbor: University of Michigan Press.

Eldridge, R. (2014), *An Introduction to the Philosophy of Art*, Second Edition, Cambridge: Cambridge University Press.

Etchells, T. (1999), *Certain Fragments: Contemporary Performance and Forced Entertainment,* London: Routledge.

Etchells, T. (2013), 'By word of mouth: Ron Athey's self-obliteration', in D. Johnson (ed.), *Pleading in the Blood: The Art and Performances of Ron Athey*, London: Live Art Development Agency, pp. 226–33.

Farias, V. (1989), *Heidegger and Nazism*, Philadelphia: Temple University Press.

Fichte, J. G. (1964), *Werke 1791–1794: J. G. Fichte-Gesamtausgabe der Bayerischen Akademie der Wissenschaften, Reihe 1*, Stuttgart: F. Frommann.

Fleischauer, L. (2017) 'Artist statement', http://louisfleischauer.com/wp4/. Accessed 15 November 2017.

Fortenberry, D. and Morrill, R. (2015), *Body of Art,* Italy: Phaidon.

Gallagher, S. and Zahavi, D. (2008), *The Phenomenological Mind: An Introduction to Philosophy of Mind and Cognitive Science,* London: Routledge.

Garner (Jr.), S. B. (1994), *Bodied Spaces: Phenomenology and Performance in Contemporary Drama,* Ithaca: Cornell University Press.

Gladwell, A. O. (1995), *Catamania: The Dissonance of Female Pleasure and Dissent*, Michigan: University of Michigan Press.

Grant, S. (2012), 'Genealogies and methodologies of phenomenology in theatre and performance studies', *Nordic Theatre Studies*, 24, pp 8–20.

Grosz, Elizabeth (2004), *The Nick of Time: Politics, Evolution, and The Untimely*. Durham: Duke University Press.

Gund, C. (2013), 'There are many ways to say Hallclujah!', in D. Johnson (ed.), *Pleading in the Blood: The Art and Performances of Ron Athey,* London: Live Art Development Agency, pp. 54–63.

Hancock, R. and Kelly, T. (2014), 'Artistic statement', https://www.hancockandkelly.com/other-work. Accessed 1 November 2014.

Harries, K. (2009), *Art Matters: A Critical Commentary on Heidegger's 'The Origin of the Work of Art'*, Volume 57 of Contributions to Phenomenology, Berlin: Springer Science and Business Media.

Heathfield, A. (2009), *The Lifeworks of Tehching Hsieh*, London: Live Art Development Agency.

Hegel, G. W. F. (1977), *Phenomenology of Spirit*, A. V. Miller (ed.), Oxford: Oxford University Press.

Heidegger, M. (1977), *The Question Concerning Technology and Other Essays,* W. Lovitt (ed). New York: Garland Publishing.

Heidegger, M. (2001), *Poetry, Language, Thought*, London: HarperCollins.

Heidegger, M. (2009a), *Basic Writings*, D. F. Krell (ed.), London: Routledge.

Heidegger, M. ([1927] 2009b), *Being and Time*, Oxford: Blackwell Publishing.

Heidegger, M. ([1978] 2009c), 'The origin of the work of art', in D. F. Krell (ed.), *Basic Writings*, London: Routledge, pp. 139–212.

Hemberg, K. (2006), *Husserl's Phenomenology: Knowledge, Objectivity and Others*, London: Continuum International Publishing.

Hemispheric Institute (2014), 'Rocío Boliver: Between menopause and old age, alternative beauty', https://hemisphericinstitute.org/en/enc14-performances/item/2350-enc14-perfo rmances-boliver-menopause.html. Accessed 10 March 2018.

Henriksson, C. and Saevi, T. (2009), 'An event in sound. Considerations on the ethical-aesthetic traits of the hermeneutic phenomenological text', *Phenomenology and Practice*, 3:1, pp. 35–58.

Husserl, E. (2012), *Ideas: A General Introduction to Phenomenology*, London: Routledge Classics.

Irigaray, L. (1985), *The Sex Which Is Not One*, Ithaca: Cornell University Press.

Johnson, D. (2013), *Pleading in the Blood: The Art and Performances of Ron Athey*, London: Live Art Development Agency

Johnson, D. (2015), *The Art of Living: An Oral History of Performance Art*, London: Palgrave Macmillan.

Johnston, D. (2017), *Theatre and Phenomenology: Manual Philosophy*, London: Macmillan International Higher Education.

Johnson, Dominic W (2019), *Unlimited Action: The Performance of Extremity in the 1970s*, Manchester: Manchester University Press.

Jones, A. (1998), *Body Art: Performing the Subject*, Minneapolis: University of Minnesota Press.

Jones, A. (2003), *The Artist's Body*, London: Phaidon Press.

Jones, A. (2009) 'Performing the wounded body: Pain, affect and the radical relationality of meaning', *Parallax*, 15:4, pp. 46–67.

Jones, Amelia (2012), *Seeing Differently: A History and Theory of Identification and the Visual Arts*, New York: Routledge.

Jones, S. (2009), 'The courage of complimentary: Practice-as-research as a paradigm shift in performance studies', in L. Allegue and S. Jones, B. Kershaw. A. Piccini (ed.). *Practice-as-Research in Performance and Screen*, London: Palgrave Macmillan, pp. 19–32.

Juno, A. and Vale, V. (1989), *Modern Primitives: An Investigation of Contemporary Adornment & Ritual*, San Francisco: Re/Search Publications.

Kant, I. ([1790] 2000), *Critique of Judgment of the Power of Judgement*, P. Guyer and E. Matthews (ed.), Cambridge: Cambridge University Press.

Kant, I. (2006), *Anthropology from a Pragmatic Point of View*, Cambridge: Cambridge University Press.

Klein, J. (2001), 'Paul McCarthy: Rites of masculinity', *PAJ: A Journal of Performance and Art: A Journal of Performance and Art* 68, 23:2 (May), pp. 10–17.

Kozel, S. (2007), *Closer: Performance, Technologies, Phenomenology*, Cambridge: MIT Press.

Kozel, S. (2015), 'Process phenomenologies', in M. Bleeker, J. F. Sherman, and E. Nedelkopoulou (eds), *Performance and Phenomenology: Traditions and Transformations Volume 32 of Routledge Advances in Theatre and Performance Studies*, London: Routledge, pp. 54–74.

de Guevara, V. R. L. (2011), 'Any body? The multiple bodies of the performer', J. Pitches and S. Popat (ed), *Performance Perspectives: A Critical Introduction*, p. 21.

Lanz, J. (2015), *Stunt Rock #2: Foot Noise*, Oslo: Marhaug Forlag.

Le Feuvre (2010), *Failure: A Document of Contemporary Art Series*, London: Whitechapel Gallery.

Leder, D. (1990), *The Absent Body*, Chicago: University of Chicago Press.

Lepecki, A. (2006), *Exhausting Dance: Performance and the Politics of Movement*, London: Routledge.

Lepecki, A. (2010), 'The body as archive: Will to re-enact and the afterlives of dances', *Dance Research Journal*, 42:2 (Winter), pp. 28–48.

Lewis, M. and Staehler, T. (2010), *Phenomenology: An Introduction*, New York: Continuum International Publishing Group.

Mackendrick, K. (2004), 'Embodying transgression', in A. Lepecki (ed.), *Of the Presence of the Body: Essays on Dance and Performance Theory*, Middletown: Wesleyan University, pp. 140–57.

McMillan, U. (2015), *Embodied Avatars: Genealogies of Black Feminist Art and Performance*, New York: New York University Press.

Merleau-Ponty, M. ([1945, 1962] 2002), *The Phenomenology of Perception*, London: Routledge Classics.

Merleau-Ponty, M. (1968), *The Visible and the Invisible*, Evanston: Northwestern University Press.

Miglietti, F. A. (2003), *Extreme Bodies: The Use and Abuse of the Body in Art*, Michigan: Skira.

Mitchell, A. J. and Trawny, P. (2017), *Heidegger's Black Notebooks*, New York: Columbia University Press.

Musser, Amber Jamilla (2014), *Sensational Flesh: Race, Power and Masochism*, New York: New York University Press.

Nemser, C. (1971), 'An interview with Vito Acconci', *Arts Magazine*, 45:5, pp. 21–23.

Pakes, A. (2011), 'Phenomenology and dance: Husserlian meditations', *Dance Review Journal: DRJ*, 43:2, pp. 33–49.

Phelan, P. (1992), *Unmarked the Politics of Performance*, London: Routledge.

Piccini, A. and Rye, C. (2009), 'Of fevered Archives and the quest for total documentation', in L. Fuschini (ed.), *Practice-as-Research: In Performance and Screen*, California: Palgrave Macmillan, pp. 34–49.

Pitches, J. and Popat, S. (2011), *Perspectives: A Critical Introduction*, New York: Palgrave Macmillan.

Rendell, J. (2010), *Site-Writing: The Architecture of Art Criticism*, London: I. B. Tauris.

Riecke, L., Opstal, A. J., and Formisano, E. (2008), 'The auditory continuity illusion: A parametric investigation and filter model', *Perception & Psychophysics*, 70, pp. 1–12.

Rockmore, T. (1992), *The Heidegger Case: On Philosophy and Politics*. Philadelphia: Temple University Press.

Rockmore, T. (1997), *On Heidegger's Nazism and Philosophy*, Berkeley: University of California Press.

Rockmore, T. (2017), 'Heidegger after Trawny: Philosophy or worldview?' in A. J. Mitchell and P. Trawny (eds), *Heidegger's Black Notebooks*, New York: Columbia University Press.

Sartre, J-P. (1965), *Nausea*, London: Penguin.

Scarry, E. (1987), *The Body in Pain: The Making and Unmaking of the World*, Oxford University Press.

Schaub, M. (2005), *Janet Cardiff: The Walk Book*, Kèoln: Walther Kèonig.

Schneider, R. (2011), *Performing Remains: Art and War in Times of Theatrical Reenactment*, London: Taylor & Francis.

Seibers, T. (2006), 'Disability aesthetics', *Journal for Cultural and Religious Theory*, 7:2 (Spring/ Summer), pp. 63–73.

Serres, M. and Latour, B. (1995), *Conversations on Science, Culture and Time*, Cambridge: MIT Press.

Shalson, Laura ([1991] 2016), *Performing Endurance: Art and Politics since 1960*, London: Routledge. 2018. Varela, Francisco J., Thompson, Evan and Rosch, Eleanor, 'The Cartesian anxiety', *The Embodied Mind: Cognitive Science and the Human Experience*, Cambridge: MIT Press.

Smith, B. T. (1979), 'Paul McCarthy', *LAICA Journal*, January–February, n.pag..

Smith, G. (2018), *The Artist-Philosopher and New Philosophy*, New York, New York: Routledge.

Smith, J. (n.d) 'About IPA', http://www.ipa.bbk.ac.uk/about-ipa. Accessed 14 February 2020.

Sobchack, V. (1998), 'Is any body home? Embodied imagination and visible evictions', in H. Naficy (ed.), *Home, Exile, Homeland: Film, Media, and the Politics of Place*, New York: Routledge, pp. 45

Stewart, N. (1998), 'Re—Languaging the Body: Phenomenological description and the dance image', *Performance Research: A Journal of the Performing Arts*, 3:2, pp. 42–53.

The Yard (n.d), Araniello Statement, https://theyardtheatre.co.uk/theatre/events/now-18/now-18-week-3/. Accessed 13 February 2018.

Trawny, P. (2016), *Heidegger and the Myth of the Jewish World Conspiracy*, Chicago: Chicago University Press.

Vergine, L. (2000), *Body Art and Performance: The Body as Language*, Milan: Skira.

Voegelin, S. (2010), *Listening to Noise and Silence: Towards a Philosophy of Sound Art*, London: Bloomsbury Publishing.

Waldenfals, B. (2012), 'The aporia of expression', in F. Evans and L. Lawlor (eds), *Chiasms: Merleau-Ponty's Notion of Flesh,* New York: SUNY Press, pp. 89–102.

Wheeler, M. (2018), 'Martin Heidegger', *The Stanford Encyclopaedia of Philosophy*, Winter 2018 edition, Edward N. Zalta (ed.), https://plato.stanford.edu/archives/win2018/entries/heidegger/. Accessed 12 December 2019.

Young, J. (1997), *Heidegger, Philosophy, Nazism*, Cambridge: University Press.

Zahavi, D. (2003), 'Phenomenology and metaphysics', *Metaphysics, Facticity, Interpretation, Phenomenology in the Nordic Countries*, 49, pp. 3–22.